# A WOMAN ON PAPER

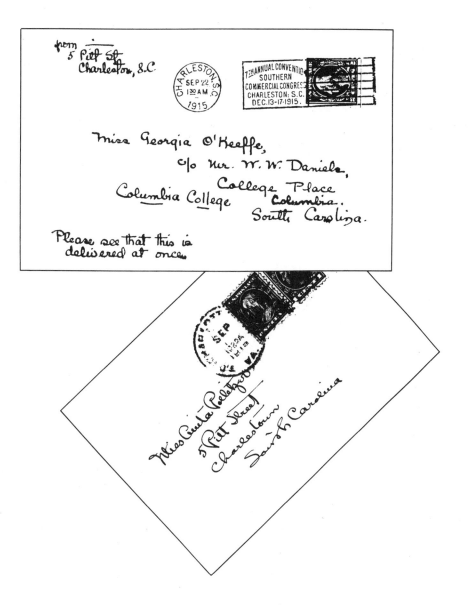

Frontispiece: GEORGIA O'KEEFFE BY PETER JULEY

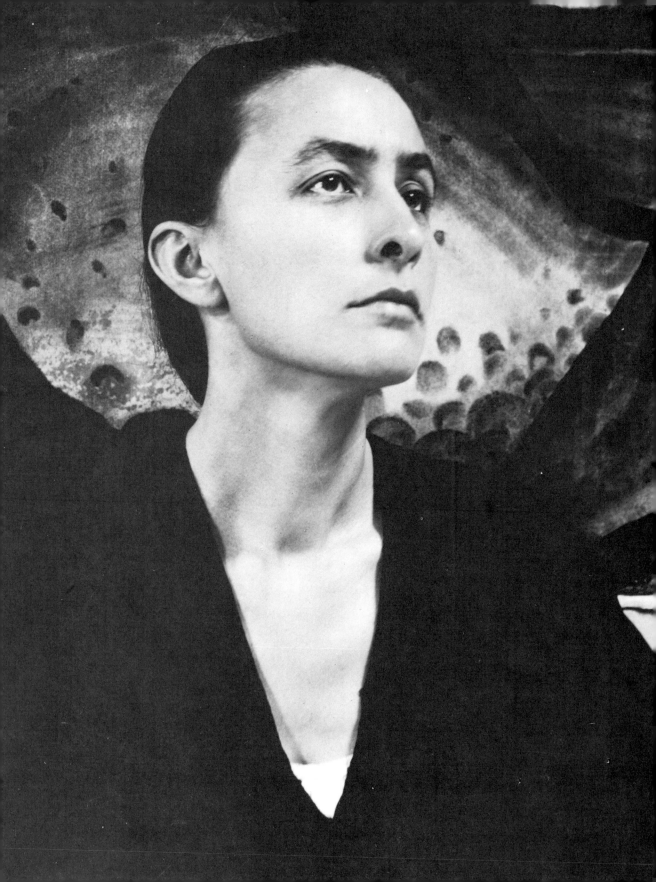

# A WOMAN ON PAPER:

*Georgia O'Keeffe*

by Anita Pollitzer

Introduction by Kay Boyle

## A TOUCHSTONE BOOK

Published by Simon & Schuster Inc.

NEW YORK ☐ LONDON ☐ TORONTO ☐ SYDNEY ☐ TOKYO

TOUCHSTONE
Simon & Schuster Building
Rockefeller Center
1230 Avenue of the Americas
New York, New York 10020

Produced for **TOUCHSTONE** by

**TENTH AVENUE EDITIONS, INC.**
625 Broadway
New York, New York 10012

Managing Editor: Rose Hass
Executive Editor: Clive Giboire
Editorial Consultant: Ben Raeburn
Editorial Assistant: Donald Wayne Hunt
Art Assistant: Robynne West Perkins
and Naomi Minkoff
Calligrapher: Lydia Gershey

Manufactured in the United States of America

10 9 8 7 6 5 4 3 2 1

10 9 8 7 6 5 4 3 2    PBK.

ISBN 0-671-66431-X
     0-671-66242-2 PBK.

*Qu'est-ce que l'art pursuivant la conception
moderne? C'est créer une magie suggestive content
à la fois l'objet et le sujet, le monde extérieur
à l'artiste et l'artiste lui-même.*

What is the modern conception of pure art?
It is to create a suggestive magic that contains
both subject and object, the external world
and the artist himself.

Baudelaire in *L'Art Philosophique*

# CONTENTS

# HEROINES AND ALSO HEROES

## BY KAY BOYLE

Oakland, California
January, 1988

IF you pay undue attention to the dates of the letters that are a vital supplement to Anita Pollitzer's splendid book, letters that two women wrote each other over a period of several years, you might come to the conclusion that it was a long time ago when all they were writing about took place. But this would be a mistake. Georgia O'Keeffe's and Anita Pollitzer's exchange of thoughts on painting, on women and men, on books, as well as on the sun, the moon, the wind and the varying facets of music, is as relevant today as if they had set their words down on paper just a moment or two ago. And this is true as well of the biography of Georgia, which provides us with the disarmingly simple history of an artist who has remained (largely by her own choosing) a legend rather than a woman whose private life we have known very little about. In its sensitivity and generosity, this book about Georgia illuminates areas where before there had been shadows, and even obscurities. We have known that Georgia's canvases would, beyond any doubt, remain unfading and undaunted forever, and now Anita has given us the story of how Georgia's brilliant flowers, cavernous valleys, parched mountains, wide skies, and even the artist herself, achieved their undisputed domain.

In writing in later years of Georgia (*The Saturday Review*, November 4, 1950), Anita has described her as the twentieth-century personification of a poem by the ancient Chinese sage Sou Tsen-tsan:

> I forgot wealth and glory
> I love calligraphy
> I think of neither life nor death
> I honor painting.

And Anita adds that "Fame does not seem to be as meaningful or real
to Georgia as the mesas of New Mexico or the petals of a white rose." But
it would be a serious misjudgment if one were to look upon Anita, twenty
at the time the two women met, as the humble devotee to Georgia's talent
and personality; and by the same token it would be an error to consider
Georgia, then twenty-seven, as the avid (although frequently humorous)
acceptant of that devotion. A close reading of their letters makes amply
clear that the two opposed roles remained interchangeable throughout
their lives, and that, in any relationship, is a great and rare triumph. As
an example of this, in one of her earliest letters to Georgia, Anita wrote,
"I thought that your two lowest big poppies made a rather bad design. I
thought one left out [would have made] it better." And also at the outset
of their correspondence, Georgia wrote enthusiastically to Anita, "Thanks
for your ladies and cats—They are lovely—they have such a funny little
way of tickling one—and those bright colored papers—Anita—I wonder
if I am a lunatic—but they even *say* things—Imagination certainly is an
entertaining thing to have —and it is great to be a fool."

They were students at the same time at the Art Students League on
West 57th Street in New York, but as they were enrolled in different classes
their acquaintance was no more than an occasional glance of recognition
as they passed each other in the hall. Anita, the youngest of three sisters
and a brother, had set out the year before from the comfortable Pollitzer
family home in Charleston, South Carolina, to make her own way in the
art world. In the years that followed, she received not only a B.A. in art
and education from Columbia University, but also an M.S. in international
law. It was then, in the art class, that the two women met. In that retro-
spective, 1950 article, Anita tells of the painting instructor isolating Geor-
gia, a third student, and herself behind a screen so that they would be
free to work in oils at their still-life and flower studies, while the rest of
the class sketched plaster casts and other inorganic objects.

It was clearly a recognition of Anita's talent as an artist that she was
chosen to be so closely associated with Georgia, but in the years of Anita's
and my close friendship, she never spoke to me of her own painting. She
has pointed out that "Unlike those of us who were undergraduates, fresh
from high school," Georgia's work had already received prestigious hon-

ors: as a student of the famous academic artist William Chase she had won the signal accolade of first prize, and after a year of study with the demanding and eminent draftsman John Vanderpoel, was hailed by him as the most gifted student he had ever had. Moreover, while the others in the class were dependent on their families for their living, Georgia had been supporting herself in Chicago by her work as a commercial artist—that is, until she acted on the ceaseless, troubling doubt that she would be unable to live the life of freedom she had chosen, or to do her own painting, if she remained a captive of the advertising world. So she had returned to New York and, as if seizing on an antidote to the poison of materialism, she had joined the art class at Columbia without delay.

A great deal has been written in fact and fiction about the period in which these two high-spirited, committed young women grew up. But there is no evidence—or at least there is no evidence coincidental with the time they met—that they were even so much as aware of the serious difficulties women faced in achieving independence in a society designed for and controlled by men. "It was a time when feminism was as alien as space travel," one commentator has written of the decade when Georgia and Anita were in their teens. It was a time when people said, "Woman's place is in the home" and almost everyone believed it." But Anita and Georgia accomplished their liberation as individuals through the power of the choices they made, a power like an explosion of vision and conviction within each of them, dissimilar as those choices later proved.

While I was still quite young I became familiar with that statement concerning women's place, due to the fact that my Aunt Nina, my mother's older sister, used to tell me stories of the different occasions when men (always men) had made that same recommendation to her. She had studied to be a painter when she was young—as Georgia and Anita were to do some twenty years later—probably because activities, and even interests, outside of the home were strictly limited for women; and the study of art and music was considered sufficiently ladylike for general approval. I did not know Aunt Nina as a painter, but as a government employee in Washington, underpaid and overworked, as her mother had been for the last thirty-five years of her life.

But at the time that Aunt Nina was a nine-to-five office worker, she was also the official cartoonist for Alice Paul's National Woman's Party weekly *The Suffragist*. One of her drawings was of Susan B. Anthony, a little red shawl about her shoulders, mounting the steps of the U.S. Capitol, in her hand the scroll of a petition signed by twenty thousand American citizens, a petition asking that a federal amendment to the Constitution grant women the vote. (In 1936 this drawing was made into a U.S. postage stamp, twenty-four years after the suffrage franchise had been won in six states, and sixteen years after the Suffrage Amendment had been ratified.) But the day that Susan B. Anthony, a small, solitary figure, climbed those steps, almost dwarfed by the structure of the most dominating building in Washington, yet somehow not diminished by it, the petition was not accepted by the Congress because the twenty thousand signatures were those of women.

At the end of her working day, Aunt Nina would set out with a like petition and ring doorbells in Washington's residential neighborhoods. One night it was a minister who opened the door, and when she had explained to him her mission, he responded with the same six words: "Woman's place is in the home." My aunt told me she was very tired that night and she had not had supper, and there was only one signature to show (and it was a woman's) after two hours of canvasing. So she asked the minister very quietly whose home he would suggest she stay in, and then she fiercely held back her tears so that, as he closed the door, he would not see that she was crying.

It was Aunt Nina who introduced me to Anita. I have never forgotten the meeting, nor exactly where it took place. I was nineteen, and I had come by train from New York to visit my aunt and grandmother in Washington. Aunt Nina and I went directly from the station to the National Woman's Party headquarters where she would deliver the cartoon she had just finished for next week's edition of *The Suffragist*. She had told me that Anita Pollitzer was now legislative secretary of the Woman's Party and that if it had not been for her organizing and campaigning in the six years she had been working as Alice Paul's right hand aide, the cause of women would never have progressed with the same momentum. I knew little about the organization, for facts and figures have a way of becoming incomprehensible to me five minutes after I have heard them. "The vote,

equal rights," I once wrote in my adolescent diary, "these words mean to me the grace and courage of my grandmother, and of my mother, and of my aunt (none of them Boyles, of course) who sought to follow in every act of their lives where Susan B. Anthony led."

Aunt Nina took care to provide a recommendation of Anita that I would better understand. "She is a great friend of Alfred Stieglitz," she told me, knowing that I had looked up to Stieglitz as my mentor since I was eight or nine years old, and that both my sister's and my own paintings had been in his children's art shows at his studio at 291 Fifth Avenue. I was eager to meet this close friend of Stieglitz who had left a position as director of the art department at the University of Virginia to work (without salary) for women's rights in every state that had not yet given women the franchise. And suddenly there she was, small and as delicately-boned as a child, running down the steps of the party's headquarters as Aunt Nina and I climbed up. She was not wearing a hat—an unusual thing in itself in those days—and her dark hair, neither too short nor too long, was blowing softly back as she ran. When she recognized my aunt, she stopped short and laughingly decided to stand two steps above us so that the three of us would be the same height. William Pollitzer, her nephew, has described her as "the darling of the family . . . tremendous, vivacious, a little whirlwind of energy." Add to this a quality that I felt in her that first day we met: she was free of any small, cramped conjecturings, from any kind of subterfuge, and I knew I would always believe in her and in every action she took, and I knew that she would always believe in me. That, I am certain, was the amazing quality others felt in her and in many documented cases it disarmed the obdurate and the bigoted. It was not for a moment a matter of virtue or morality that caused legislators, senators, congressmen (and even President Wilson) to change their views after Anita had discussed the question of suffrage with them. It was a long-delayed acceptance of the fact that clarity is courage and dissemblance a tortuous way for anyone to take.

It was not until much later that I came to know Anita well. I had been living in Europe with my husband and children, and when we returned—having spent nineteen years abroad—Anita and I became close friends. Anita had married Elie Charlier Edson in 1928 (but kept her maiden name), and succeeded Alice Paul as director of the National Woman's Party. In

1949 she had retired from active work in the party, but never ceased writing articles on and speaking publicly for the Equal Rights Amendment (which to this day has still not become an amendment to our Constitution). Her indefatigable energy was turned now to family and friends, to cooking her generous dinners for six or eight guests, to caring for her nephew, then a graduate student at Columbia, who says he was "lost and lonely in the early years in the big city, and Anita made a home for me."

Elie was the son of a naval doctor and of Charlier Edson, and he was proud of his French background on his mother's side. He had been press agent for a number of French theatrical celebrities, among the first, Sarah Bernhardt and among the last, Louis Jouvet. (One evening at dinner I asked him if it was true that Sarah Bernhardt had slept in her coffin every night, and he said it was indeed true, and that he had often helped her into it before leaving her villa near the Bois de Boulogne). He had lived in Paris for a great part of his life and spoke the language beautifully and gently, like a Frenchman of another century. He was ready to defend France, quietly and wisely, at every opportunity, and he was proud of the fact that Louis Jouvet had taken his theater troupe to South America, after the fall of France in World War II, rather than collaborate with the Germans as a number of other actors did (including Maurice Chevalier). He believed heart and soul in the women's movement and was proud of the active role Anita had played in the fight for woman's suffrage and proud as well of the biography she had written of Georgia.

Anita and Elie did not have much money, and Elie—when we met— was giving French lessons to add to the small legacy his mother had left him, while Anita contributed the modest sums given her by relatives from securities they had invested in. They lived in New York on West 115th Street, just around the corner from Columbia University, where in previous years both of them had taught at Teachers College. Their apartment, every corner and alcove piled high with stacks of books and neatly folded news-papers, had become a meeting place for artists and writers and former university colleagues. It was there one evening I met Georgia for the second time, and also Elie's nephew, Pete Seeger, who wrote me recently that he would always remember the bright-eyed Anita he had met at age six, when Elie brought his bride to meet his sister's family. "And it was an early lesson in women's lib," he added, "when it was explained to me

why she was keeping her own name after her marriage." To Pete, his Uncle Elie "was very much his father's son," which meant that he was an essentially conservative man—but a man who was "proud of Anita's achievements with the National Woman's Party. They stuck together," Pete wrote. "Love conquers all." That love and hospitality embraced us as well.

So great was Anita's devotion to friends and relatives who came (including a ninety-year-old aunt) that on the mornings when I took the train from Connecticut to talk business with my agent in New York, I would hurry to 419 West 115th Street in the evening to be restored from the worries and frequent disappointments of the day. It was a difficult time in America, the time of Senator Joseph McCarthy, a time that Pete Seeger and both my husband and I (and how many others) knew all too well. William Pollitzer has written of his aunt: "I can see her now, small in stature, big in brains and spirit, brushing her dark hair away from her face . . . always kind-hearted, without malice or guile, easily moved by beauty everywhere, in a painting or in nature, and deeply touched by sadness or injustice in the lives of others." Words such as these were not what the dictionary calls "idle talk." They expressed a cherishing of Anita that many of us shared. It is even possible that when we spoke of her it was with a certain tentative, inchoate longing, as if the tributes that we paid her defined in essence how we ourselves might wish to be spoken of. More often than not I would spend the night at Anita's and Elie's apartment, sleeping on the wide sofa in their living room, and sometimes, in the same room, Anita would play the piano softly, her small hands reaching across the keys.

On the other side of the glass doors that separated the two rooms, Elie would sit at the dining room table, a green visor shading his eyes from the hanging light overhead, his shirt sleeves rolled up, working at his students' papers as a newspaper reporter works on a story late at night, putting the pieces of it together in the newsroom. And on the walls around us were three large O'Keeffe canvases that Georgia had given to Anita. (The two still lifes and the mountains of New Mexico, as I recall, were hung as follows: the red canna lily was in the dining room, warm and eager as a human face turned toward one, the open mouth of its petals seemingly about to speak; the painting on the left wall of the living room, as one entered from the long, narrow hall, was of faded purple mountains,

time-worn and bleak, with a dark divide between them, moribund against a somber sky; the painting on the right wall, above the sofa on which I slept, was of a white calla lily, as brilliantly white and pure as alabaster. These three contrasting moods of Georgia are present in her letters and in the biography as well.)

The answer as to why Anita had given up her painting to work for the liberation of women from their traditional role is quite simple. It was not that she feared it would be useless to compete with Georgia's already recognized talent, and it was not that she had come to the realization that she would not be able to support herself as an artist. The words "fear," "envy," and "competition" were to Anita words of an alien language. And it should be remembered that it was Anita who brought about the true beginning of Georgia's fame when she carried Georgia's drawings to Stieglitz, despite the edict that she was to show them to no one; and it was not for profit that Anita worked for over thirty years for a woman's organization that was unable to pay its dedicated volunteers more than traveling expenses. In Anita's case this included meetings at the Sorbonne in Paris and talks given in England and Switzerland and Germany. The explanation for the decision Anita came to, while still a young woman, was an expanding of that commitment in understanding and devotion she had given to Georgia, a far wider commitment (that embraced Georgia as well) in the cause of women throughout the world.

Anita did not speak of these things to me, for her interest was always in the experience of others, whether they were women or men. With so much to do in life, she had no time to dwell on the antagonism of the majority of men (and also women) who were in opposition to all her beliefs. Anita's eldest sister, Carrie, was quoted in the Charleston *News and Courier/The Evening Post* as having once said "that getting men to listen to a woman in 1918 was quite a feat. . . . You should have seen the expressions when I asked that women be admitted to the College of Charleston." And she added: "I felt like Henny Penny telling them the sky was falling." Yet Anita and her sisters never failed to speak out.

There were other times with Anita and Elie. They came now and then to Connecticut to spend weekends with us in the old-fashioned boathouse on the grounds of the girls' school where we, as faculty members, lived with our children. Anita would step down from the train holding carefully

with both hands a saucepan containing a special dish she had cooked the night before to add to our Sunday dinner. In summer, we would eat at the weathered table under the maple trees, with the water of Long Island Sound lapping just below the seawall. Elie would tell the children stories of the seacoast places in France he had known as a child: of Caen and of Saint-Malo and of Mont-Saint-Michel, the most exciting of them all, where the tide came in twice every twenty-four hours and fifty minutes at "three times the speed of a galloping horse." He told them it was the attraction of the sun and the moon that created the tide of the Atlantic and other oceans, but that the Mediterranean had no tides, and the Pacific Ocean was usually so tranquil, so calm that "Magellan had given it that name."

And there were times in New York when Anita and Elie and I had dinner at The Players, where members constantly came to our table to speak with Anita, and where Elie shone like a planet in a clear night sky. Often we shared champagne with their friends and after dinner it was customary for actors or directors or theatrical producers to speak from a podium at the far end of the club's main hall. These evenings changed the look of the real world outside and I wanted to sing like a lark. With one hand holding Anita's small hand and the other holding Elie's, I knew that everything we wished and worked for could be accomplished and that all doubt was cowardice.

I was aware that Anita had been arrested, perhaps more than once, with other Woman's National Party members who picketed the White House during Woodrow Wilson's presidency. But I did not know (due to her own reticence) how long she had remained in prison or what her experiences there had been. I did not know until one day she gave me a book (*Jailed For Freedom* by Doris Stevens, Boni & Liveright, 1920) to take back to Connecticut with me; yet even now I am not sure she wanted to tell me of the experiences of other pickets, or of those she herself had endured.

Anita had marked several pages with slips of paper, numbering them one, two, and three; and as soon as I was seated in the commuter train I opened the book at the first section she wanted me to read. It dealt with the hunger strike the pickets had resorted to in protest against the injustice of the seven months' sentences earlier groups of women had been given,

to be served at the Occoquan workhouse in Virginia. "So we embark [from the Pennsylvania Station], "writes Doris Stevens," for the unknown terrors of the workhouse, driven on by our 'keeper', who resembles Simon Legree, with his long stick and his pushing and shoving to hurry us along. . . . Friends try to bid us a last farewell and slip us a sweet or fruit, as we are rushed through the iron station gates to the train. "Quoted are fragments of letters written by a young woman (Rose Winslow)" whose parents had brought her in infancy from Poland to become a citizen of 'free' America." These graphic messages had been written on scraps of paper and smuggled out." Alice Paul . . . dreaded forcible feeding frightfully. I had a nervous time of it, gasping a long time afterward, and my stomach rejecting the process. . . . The poor soul who fed me got liberally besprinkled during the process. I heard myself making the most hideous sounds. . . . One feels so forsaken when one lies prone and people shove a pipe down into one's stomach." And another message reads in part: "Don't let them tell you we take this well. Miss Paul vomits much. I do too, except when I'm not nervous, as I have been every time they've fed me against my will."

The second place that Anita had marked described the arrival of the women at the workhouse in Virginia. In these pages, the deposition of Mary Noland, then seventy-three years old, was printed in full (a deposition that was dictated at a later time in the presence of Dudley Field Malone, a prominent New York lawyer and a member of President Wilson's administration as collector of the Port of New York, who had offered to defend the women). The prisoners arrived at Occoquan at seven-thirty in the evening, and, worn and wary, some of them lay down on the floor of the admitting office. When "the superintendent of the place" finally appeared, followed by a crowd of men not in uniform who "seemed to come in—and in—and in" one of the women stood up and asked that they be treated as political prisoners. The head jailer then shouted her down and ordered his men to seize her, which they did, and admonished the other women not to dare to speak or he would "put the brace and bit in [their] mouths" and "straitjackets on their bodies."

The third section marked in the book was alive with the recorded words of Dudley Field Malone, who described his final meeting with President Wilson. The voice of Malone began by saying that he had been present throughout the trial of the sixteen women sentenced to serve time in the

Occoquan ·workhouse on an alleged traffic violation and that he had "telephoned President Wilson at the White House and asked to see him at once. It was three o'clock," Malone continued. "I called a taxicab, drove directly to the executive offices and met him. I began by reminding the President that in the seven years and a half of our personal and political association we had never had a serious difference. He was good enough to say that my loyalty to him had been one of the happiest circumstances of his public career. But I told him I had come to place my resignation in his hands, as I could not remain a member of any administration which dared to send American women to prison for demanding national suffrage. I also informed him that I had offered to act as counsel for the suffragists on the appeal of their case. He asked me for full details of my complaint and attitude. I told Mr. Wilson everything I had witnessed . . . [and he] reminded me that the women had been unmolested at the White House gates for over five months, adding that he had even ordered the head usher to invite the women on cold days to come into the White House and warm themselves and have coffee.

. " 'If the situation is as you describe it, it is shocking,' said the President. 'The manhandling of the women by the police was outrageous and the entire trial (before a judge of your own appointment) was a perversion of justice,' I said. This seemed to annoy the President and he replied with asperity; 'Why do you come to me in this indignant fashion for things that have been done by the police officials of the city of Washington?' 'Mr. President,' I said, 'the treatment of these women is the result of carefully laid plans made by the District Commissioners of the city of Washington, who were appointed to office by you. Newspaper men of unquestioned information and integrity have told me that the District Commissioners had been in consultation with your private secretary . . . when the policy of these arrests was being determined. The President asserted his ignorance of this. 'Do you mean to tell me,' he said, 'that you intend to resign, to repudiate me and my Administration and sacrifice me for your views on this suffrage question?'

"His attitude then angered me and I said, 'Mr. President, if there is any sacrifice in this unhappy circumstance, it is I who am making the sacrifice. I was sent twice as your spokesman in the last campaign to the Woman Suffrage States of the West. You have since been good enough to say

publicly and privately that I did as much as any man to carry California for you. After my first tour I had a long conference with you here at the White House on the political situation in those states. I told you that I found your strength with women voters lay in the fact that you had with great patience and statesmanship kept this country out of the European war. But that your great weakness with women voters was that you had not taken any step throughout your entire Administration to urge the passage of the Federal Suffrage Amendment . . . which alone can enfranchise all the women of the nation. . . . I told you that I promised the women voters of the West that if they showed the political sagacity to choose you as against Mr. Hughes, I would do everything in my power to get your Administration to take up and pass the suffrage amendment. You were pleased and approved of what I had done. I returned to California and repeated my promise, and so far as I am concerned, I must keep my part of that obligation.'

"The President was visibly moved as I added: 'You are the President now, reelected to office. You ask if I am going to sacrifice you. You sacrifice nothing by my resignation. But I lose much. . . . I give up a powerful office in my own state. I, who have no money, sacrifice a lucrative salary and go back to revive my law practice. But most of all I sever a personal association with you of the deepest affection which you know has meant much to me these past seven years. But I cannot and will not remain in office and see women thrown into jail because they demand their political freedom.' The interview closed with the President saying, 'If you consider my personal request and do not resign, do not leave Washington without coming to see me.' I left the executive offices and never saw him again."

<center>□ □ □</center>

When I returned the book to Anita the following week, I was still thinking of Doris Stevens's words: "His sacrifice lightened ours." And when Anita asked me if I had read every word of the book, I answered that I had and that I learned many things I had not known before.

"There were heroines and there were also heroes," Anita said quietly, and she put the book back in its place in her desk drawer as if putting away the past. And she did not speak of herself.

# EDITOR'S NOTE

IN January 1956, while working on *A Woman on Paper*, Anita Pollitzer wrote to Georgia O'Keeffe; "[Your early] letters jump up and waltz around my room." That statement echoes the feeling I had when I first read Pollitzer's manuscript which draws so much of its energy from the actual correspondence between the two old friends. While this correspondence and Pollitzer's hitherto unpublished memoir of O'Keeffe—peopled with such key figures in the modernist movement as Stieglitz, Steichen, Marin, Hartley and Dove—had long been available to scholars writing about twentieth-century art, it was obvious that they deserved a wider audience.

From the start, O'Keeffe had encouraged Pollitzer in the writing of the manuscript. At one point in December 1950, she wrote in a letter, "You seem to be on the way to becoming an authority on me." O'Keeffe reviewed various portions of the work in draft, and offered suggestions for changes and further avenues of research, including other people Pollitzer might interview. Nevertheless, when the completed manuscript was presented to her, O'Keeffe refused to grant permission for its publication. Pollitzer's efforts to correct minor factual errors and overcome O'Keeffe's reservations proved futile.

What caused O'Keeffe to object so strongly to the book's publication? One explanation might be that Pollitzer's innate optimism so permeated the manuscript that it clashed with O'Keeffe's own more austere and controlled approach to life and work. This dichotomy is reflected in O'Keeffe's critique of the manuscript, in which she wrote, "I do not like the idea of

happiness—it is too momentary—I would say that I was always busy and interested in something—interest has more meaning than happiness." In spite of O'Keeffe's objections, *A Woman on Paper* presents a fascinating first-hand account of the formative years of two important modern woman who were part of the milieu that set the intellectual and artistic course for twentieth-century America.

Anita Pollitzer did not plan her book to be a formal, scholarly biography; rather she aimed to share with the reader her friendship with O'Keeffe and deep appreciation of the artist's work. After all, she was the first person to realize the full implication of her friend's talent. So intent was Pollitzer in her efforts to further O'Keeffe's reputation that she downplayed her own voice in the book. In the original manuscript, she included no extracts from her letters to O'Keeffe. The editorial decision to recreate the dialogue between the two women overrode Pollitzer's modesty. Extracts from many more of O'Keeffe's letters were also added.

Pollitzer's style of transcription tended to formalize grammar and omit ellipses. Her style has been retained, for the most part. Transcription of the additional letters (found largely in chapters one, two, twelve and fourteen) follows as nearly as possible the idiosyncratic spelling and punctuation of the originals, although, for clarity, minor changes have been made. Certainly, every effort has been made in this published version to honor the spirit of Pollitzer's original intention. Every effort was made to retain the personal nature of the memoir, and all changes have been approved by William S. Pollitzer, Anita Pollitzer's nephew and literary executor.

For the reader's convenience all extracts have been clearly identified within the text. Sources for quoted material including letters and illustrations are given in the back of the book.

When this memoir was written, Georgia O'Keeffe was still alive. Therefore the author consistently speaks of her in the present tense. As Pollitzer's manuscript is such a personal and subjective account of her friend's life, it was decided to retain the present tense though both author and subject are no longer living.

Clive Giboire

THE paintings of Georgia O'Keeffe have deep meaning for countless people and have achieved a recognition given to few artists of our time. The place as America's foremost woman painter has been accorded her, but O'Keeffe the person has remained legendary to all but a few of her contemporaries. Many questions have been asked about the woman whose work portrays a sense of the moment as well as of the vastness of nature, of the excitement as well as the tranquility of the out-of-doors. Even in the most abstract of her canvases the boundless presence of life itself is conveyed.

Before her work was publicly known, the drawings of this young artist (of whom he had never heard) were shown to Alfred Stieglitz, leader of the introduction to modern art in America at his pioneer gallery 291 Fifth Avenue in New York, and he exclaimed: "Finally, a woman on paper!" This was the day before the New Year of 1916.

Through the subsequent years of solo exhibits, Georgia O'Keeffe's work has been shown throughout the United States, beginning at 291 in 1916, then at The Intimate Gallery and at An American Place, large retrospective showings at the Art Institute of Chicago in 1943, the Museum of Modern Art, New York, in 1946, the Worcester Art Museum, Worcester, Massachusetts, in 1960, and in other leading museums and private collections. When the Metropolitan Museum of Art held an exhibition in 1958, entitled "Fourteen American Masters, Paintings from Colonial Times to Today," Georgia O'Keeffe was chosen as one of these fourteen masters, with a

room devoted to her canvases.

I have long wanted to tell the story of this extraordinary person whom I knew well since our days together as art students. Since that time, I visited her often in New York, at Lake George and in the later years, at her Abiquiu, New Mexico, home and at her ranch in New Mexico.

From that first time when Stieglitz saw Georgia O'Keeffe's drawings, neither the lives nor the work of either of them could be considered without mention of the other. My many talks with Stieglitz and the hours spent listening to him over a long period of years, gave me a greater understanding of O'Keeffe's paintings. I was at college and an art student when I first met Stieglitz, at the time I began going to his famous gallery at 291 Fifth Avenue. He was then America's chief protagonist for the right of the artist to express his ideas in his own way and to me as to many others, he was America's greatest voice in the arts.

In this book, I have tried to tell of the events and achievements in a life that for half a century produced the notable canvases that, in Stieglitz's words, "could only have come from a woman and from America."

Hers is a story out of America. The qualities associated with our land since its pioneer days are her own: freshness of vision, individuality and the tenacious pursuit of a goal. When her work was first exhibited by Stieglitz, painters in America with few exceptions were patterning their work on that of their predecessors in this country or on that of the leaders in Paris at the turn of the century. When O'Keeffe began to paint, no American woman, except Mary Cassatt, whose work is identified with the French Impressionists, had broken through to the top rank of creative painting.

The period in which O'Keeffe's painting was first seen was the one which established the fact that there was an American visual art with its roots in our own soil, that needed no other land for its inspiration. O'Keeffe's work followed no fashions. She had not seen the Armory Show of 1913 which so greatly changed the art tradition in America. Until 1953, she did not see Europe or its galleries. Through succeeding decades, her paintings continued to make an inestimable contribution to the culture of our time and enabled us to break the boundaries of our customary seeing.

Georgia O'Keeffe is a solitary person and does not speak readily of the things that matter to her. Thus, her letters are of particular value because

they reveal the inner person. Her hidden feelings serve as clues to the very personal paintings. Although the essence of a work of art can never be explained, our awareness of the experiences in Georgia O'Keeffe's life that contributed to her creativity brings her work more intimately to us.

Anita Pollitzer

## COLUMBIA UNIVERSITY: 1914–1915

T was in Charles J. Martin's oil painting class at the Art Students League in New York that I first came to know Georgia O'Keeffe. At first I had only seen O'Keeffe as she passed in the corridor to and from classes. Then, from his other twenty-five or more students, Martin separated three of us—Georgia O'Keeffe, Dorothy True, and myself—and while the other students drew casts and studies that he set for them, we three, behind a screen, were allowed to select and paint our own still-life and flower studies.

When students peered behind the screen, curious to see what we were painting, O'Keeffe informed them that we did not wish to be disturbed, and put them out. Such was her force and purposefulness. All of us who were undergraduates looked up to her; she had already made a success of commerical art and teaching, and what she said was worthwhile—with an air of authority and no words wasted. Her presence seemed to lift us up to immediate adulthood in our own art, not only because her own work was exceptional, but because the standards she set for herself were exacting. She was, however, utterly without conceit or concern for the superiority of her work.

Even in those days O'Keeffe was different. Dignified, haughty without meaning to be, she looked neither to right nor left unless it furthered the work she had come to New York to do. There was never an idle moment or gesture. She stood apart, too, in the way she dressed—her coat suit of excellent material and the crisply-starched white blouses that she herself

had made. She lived on very little, we were sure, but her colors were always the brightest, her palette the cleanest, her brushes and paints the best.

From the beginning of the fall 1914 semester, O'Keeffe also attended Teachers College, Columbia University, in New York, where she enrolled in Professor Arthur Wesley Dow's classes. Dow, the first teacher of importance in the United States to emphasize the Oriental masters, had become an extraordinary influence in the life of many American art teachers. Early in life, he had studied at Pont Aven in Brittany, where he knew Gauguin, whose design and freedom of color had had a decisive effect on him. He had also come under the spell of the great color experiments of the period in wood block printing and art derived from Japanese prints.

In a day when representational painting was the exclusive objective in American art schools, Dow minimized the emphasis that had forced composition into the background. He stressed original arrangements emphasizing fine proportions as sufficient reason for each design. Beauty was its own raison d'être.

Since her first summer drawing classes at the University of Virginia, Charlottesville, in 1912, it was this nonrepresentational approach that had so interested O'Keeffe. Alon Bement, a spokesman for Dow's revolutionary ideas, taught summers at Virginia. He had been urging O'Keeffe to go to Columbia University to study with the professor. It was this stressing of originality and finer composition that had made her decide to begin to paint again. To use her own words: "[A]rt like that is worth giving one's life to." So she had come to Columbia.

But instead of producing the refined and restrained exercises that Professor Dow's pupils for the most part were evolving, O'Keeffe produced rectangles and circles with a quite different feeling. They were daring, imaginative designs, quite unrelated to Dow's own work or to the work of his students; or they were extraordinarily quiet, completely nonobjective divisions of space. Week after week her imaginative work received highest praise from her gifted teacher.

While at Columbia, in addition to studying composition with Dow, O'-Keeffe worked at life drawing with Bement, jewelry design with Thatcher, and oil painting with Charles J. Martin.

O'Keeffe lived around the corner from Columbia, in a little four-dollar-

a-week rented room in which there was a bed, a small dresser, a table and a chair. A pot of bright red geraniums on the fire escape was the only supplement to her bare walls. There was something spartan about her, as direct as an arrow, and completely independent.

During the summer of 1915, when Georgia returned to Virginia to teach drawing at the University of Virginia, and I went on vacation with my family in South Carolina, we began to write each other frequently about everything in art that we were discovering—almost daily letters—as our lives were full of discoveries. Through letters we came to know each other far better, probably, than we would have otherwise:

**Anita to Georgia, Charleston, S.C., June 10, 1915**

> Dear Miss O'Keeffe: I feel just like writing to you—and as all the other paper is upstairs I decided that a letter on this [notebook paper] would be just as nice.
>
> I don't know where you are or anything like that of course but U.S.A. will reach you I suppose.
>
> I've got lots to tell you. So much has happened since I've seen you. I spent the weekend after I saw you in the country around New York. I came back on Tuesday and flew up to Brentano's to get our Life and Letters of Vincent van Gogh [as a present for Mr. Martin], only to find much to my horror that it had just gone out of print! They had another book there called Personal Recollections of V. van Gogh which I glanced over, but it certainly wouldn't have been particularly suitable for Mr. Martin. It simply talked about the man and the clothes he wore, what kind of canvas he bought, what he ate for breakfast and such things, so I wouldn't get it. I looked over all the other books and art magazines and didn't see anything at all suitable. I felt like yelling to you to come back and pick out the things.—Then I had a brilliant idea. I went to the Photo Secession and asked Mr. Stieglitz to show me some old numbers of Camera Work—He said "why?". I said "I want to buy one." He said "Let me pick out the most wonderful one we have" and it was an old Rodin number—the most exquisite

Charleston S.C.
5 Pitt St.
June 10 –
1915

Dear Miss O'Keefe.

I feel just like writing to you – and as all other paper is upstairs I decided that a letter on this would be just as nice.

I don't know where you are or anything like that of course but U.S.A. will reach you I suppose.

I've got lots to tell you. So much has happened since I've seen you – I spent the week end after I saw you in the country around N.Y. – I came back on a Tuesday and flew up to

*Dear little Pollitzer :* — *Don't you like little spelled with three t's.* — *but you are little you know and I like you little but I also like you a lot.*

*I can't begin to tell you how much I enjoyed your letters* — *write me another* — *won't you? I'm sure the Camera Work was great* — *why don't you lend me yours for a few days. I'll be very good to it.*

*I'd tell you the things I have done that would rate* — *I have painted three portraits* — *I hate to use that word* — *I should have said people* — *or heads or something* — *but I don't have much time to work* ~

thing you can possibly imagine. Oh I wish you might see
it. It has four fine Steichen photographs in the front and then
marvelous color reproductions of about 8 or 9 of Rodin's col-
ored drawings—magnificent nudes with color touched in. So I
bought it. It was three dollars, but worth a million. I didn't
know they sold back numbers for whatever price they wanted
to, did you? Mr. Stieglitz said—you can sell this Rodin number
for $25 whenever you want to—we haven't many more in
print—I asked him if it would be fair for me to buy two and he
said "yes", so I got one exactly like it for myself. I hope I can
show it to you next year. I love it. I'm sure Mr. Martin loves
his.

    . . . I've been practising a lot of things too. My old music
mostly. I bought some new pastels from the Palette Art before
I left New York.

**Georgia to Anita, Charlottesville, Va., June 1915**

Dear litttle Pollitzer—Don't you like little spelled with three ts—
but you are little you know and I like you little but I also like
you a lot.

    I can't begin to tell you how much I enjoyed your letter—
write me another—won't you? I'm sure the Camera Work was
great—why don't you lend me yours for a few days. I'll be
very good to it.

    I sent you the things I have done that would roll—I have
painted three portraits—I hate to use that word—I should
have said people—or heads or something—but I don't have
much time to work—All the things I sent you are only about
half done—I'm ashamed of them—guess I didn't spend more
than an hour on any of them—Tell me—do you like my [*Mu-
sic*]—I didn't make it to music—it is just my own tune—it is
something I wanted very much to tell someone—and what I
wanted to express was a feeling like wonderful music gives
me—Mr. Bement liked it very much. I am going to try those
hollyhocks again—and not have it so realistic—they are al-

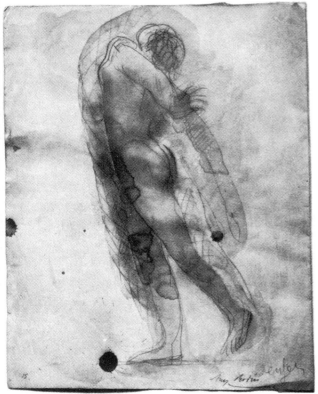

THREE OF THE RODIN COLORED
DRAWINGS FROM *CAMERA WORK*,
APRIL/JULY 1911, THAT POLLITZER
CALLED TO O'KEEFFE'S ATTENTION
IN HER FIRST LETTER

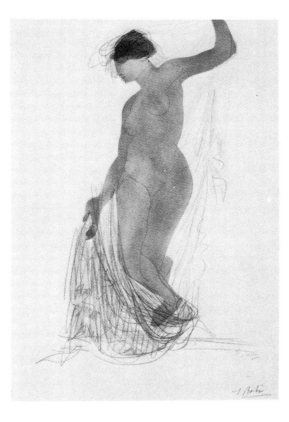

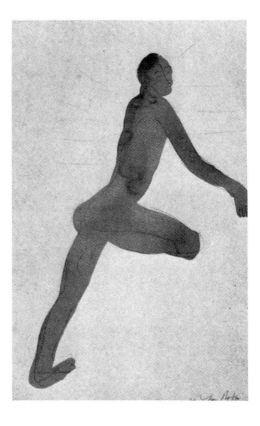

most gone now so I will have to make them up. . . .

The last time I went up to 291 there was nothing on the walls—chairs just knocked around—tracks on the floor—and talk behind the curtain. I even liked it when there was nothing.

Isn't it nice to be a fool——.

Anita to Georgia, Hendersonville, N.C., July 26, 1915

. . . I want to talk to you about the drawings—they were a gorgeous surprise. I have fixed up one of the rooms in our big old barn [in Hendersonville, North Carolina] as a kind of studio—and I took them up—thumb-tacked them on the walls and had a real exhibit. I was perfectly crazy about your small flower study, the one with the dark redish background—I think it's *good!* Your music was beautiful in color—I like the blue and yellowish steps picture ever so much, also the redish purplish brick building picture—the one in which the building went clear out to the top of the paper. You certainly have done lots of work.

My family came up several times to see your exhibit and they were the only visitors I allowed. My sisters were in love with the poppies—I like their big feeling and thought the color very lovely, but I thought that your two biggest poppies made rather a bad design. I thought one left out made it better—Remember? I'm all wrong perhaps—I wish you'd write me what you thought of all of them. I really couldn't do any work at home—it was too hot. . . . I've done several sketches the way Mr. Martin told us to. I've taken my pastels with me—hope now I can do something—I'll send you some when I do.

. . . Did you get the 291 number? The little monthly magazine they publish. . . . I *loved* my [John] Marin cover, so I ordered one for you from Mr. Stieglitz. I hope he had some left—and sent it. . . .

At this time Georgia had as a good friend a young man of great intellect,

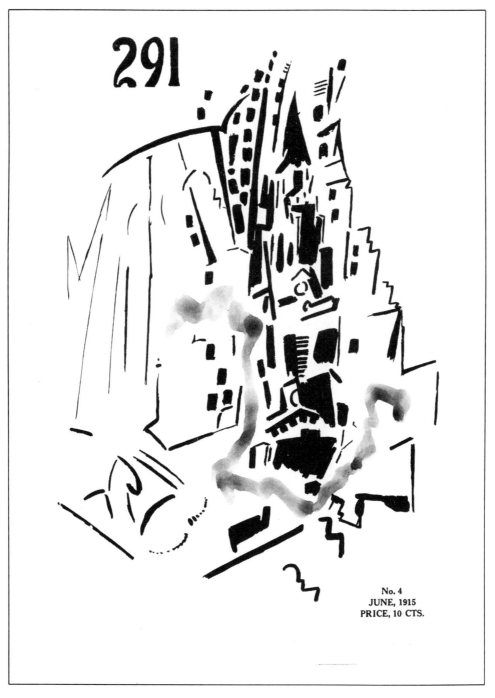

291

No. 4
JUNE, 1915
PRICE, 10 CTS.

COVER OF THE JUNE 1915 ISSUE OF *291*,
FEATURING A DRAWING BY JOHN MARIN

a college instructor who was teaching government at the university summer school. His name was Arthur Macmahon.

**Georgia to Anita, Charlottesville, Va., July 1915**

. . . I quite agree with you about the pictures. So far no one but you and I like the flower study but I think it one of my best. The poppies are not good I know—but I hope to make something better from them.

. . . So far the events of the summer have been weekend camping trips and long walks and a very good friend—an interesting person is always a great event to me. You mustn't tell Dorothy [True] because she always imagines things and there is nothing to imagine. The good friend is professor of political science here and at Columbia—and he is even very interested in new art. A great friend really. A great find really—I've told him lots about you. Send me what you have been doing.

**Anita to Georgia, Hendersonville, N.C., August 7, 1915**

Dear Pat:

Mayn't I snitch Dorothy's name for you—it's the only thing that fits, & I do love it so. Has she a patent on it, or may I use it? Answer please! . . . I'm awfully glad you & I agree about your little flower study. Show it in N.Y. next winter—I'm not joking—It's simple & good.

The most exciting thing was about your friend, the Professional one—He sounds very interesting. Of course I won't tell Dorothy for she may imagine things. But don't you know I'm glad to hear a little speck of private news like that about you.

. . . [D]id you get the #4 "291" with the Marin cover. Tell me—because I wrote to Mr. Stieglitz & asked him to send it to you. . . .

. . . I've been a perfect lady this summer—dressed up—&

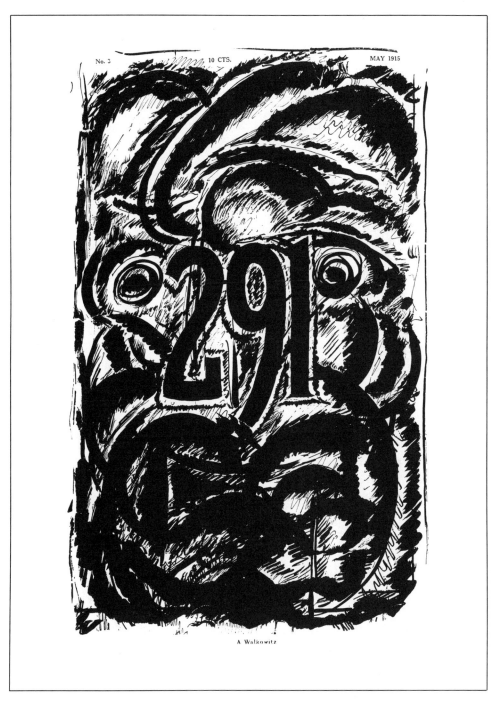

No. 3          10 CTS.                    MAY 1915

A Walkowitz

AN ALBERT WALKOWITZ COVER FOR
THE MAY 1915 ISSUE OF *291*

auto & company over & over & over again—It's great for a
little while but I'm ready to work again. All the little boys up
here own little automobiles—It's perfectly killing—so we ride
around all the time. . . . This afternoon one of the boys
phoned me & I suggested a real good long walk for a change.
It *was* good & it was long—We walked up a twisty little path
& had a gorgeous valley—birds—wild flowers. Mountains big
& grand—much scenery—no people.

**Georgia to Anita, Charlottesville, Va., August 25, 1915**

Thank you for calling me Pat. I like it—It always seemed
funny that we called one another Miss.

Your letters are certainly like drinks of fine cold spring
water on a hot day—They have a spark of the kind of fire in
them that makes life worthwhile—That nervous energy that
makes people like you and I want and go after everything in
the world—bump our heads on all the hard walls and scratch
our hands on all the briars—but it makes living great—doesn't
it?—I'm glad I want everything in the world—good and bad—
bitter and sweet—I want it all and a lot of it too—Your letter
makes me think that life is almost as good to you as it is to
me. . . .

. . . Then the 291 came and I was so crazy about it that I
sent for Number 2 and 3—and I think they are great—They
just take my breath away—it is almost as good as going to
291.

. . . I got Floyd Dell's "Women as World Builders" a few
days ago and got quite excited over it. The professor was very
much interested in Feminism—that's why I read it—and I've
been slaving on war books trying to catch up with some of the
things he started me on. I've been reading yarns too—some
that he liked that I hadn't read—am on Thomas Hardy's "Jude
the Obscure" now and it is very interesting. . . .

. . . Anita—talking of 291—and New York—I'm afraid I'll not
be there. Maybe you can help me decide. I have a position in

Columbia College—South Carolina—I don't want it—I want to go back to N.Y. I have a notion I want to go back to college but I'm not sure—what do you think? I want to show Mr. Martin what I've been doing and see what he says about it. I think I would have time down there by myself but nobody will be interested. . . .

**Anita to Georgia, Hendersonville, N.C., August 1915**

Pat! such a letter—It was perfectly great and so good to get it—you write letters exactly like yourself, and I love them. . . .

. . . Please remember this for ever—every thing you say to me is absolutely ours, and no one else will get one word of it—so please write what you want to always—and feel safe about it!

. . . Now about you—I've been thinking loads about it—I really can't make up my mind—It seems to me that you're the only one who could possibly know—New York won't be New York for me without you, but of course that has nothing to do with it.

. . . Of course a College Position is not to be gotten so easily, but I hate to think of your teaching those people how to draw red apples that aren't "absolutely round"—Of course you might have extra time to do work for yourself—and you might make piles of money and come up north the year after. It's awful that we have to think of so many things before we ever do anything! If you don't come up—but you will—send me everything you own and I'll get criticisms from Mr. Martin for you and write them to you in detail

. . . Your "Women as World Builders" sounds very interesting. I've been doing Suffrage work on the side this summer—Just private conversions of course—I worked hard for it the week I was in Charleston—was one of a deputation to visit our Congressman—gave out Suffrage Literature and Lemonade at a booth and such things. I've a trunk full of Art and Suffrage things here. . . .

THE LIBRARY OF THE UNIVERSITY OF
VIRGINIA, CHARLOTTESVILLE, CIRCA
1915, WHERE O'KEEFFE PARTICIPATED
IN THE SUMMER ART SCHOOL FROM
1912 THROUGH 1916

Georgia to Anita, Charlottesville, Va., September 9, 1915

> Your letter actually made me shed about three tears this
> morning—and I thank you for it—it made it possible for me to
> go to work. I had one from Dorothy [True] at the same time. I
> certainly wish you both luck. Your program doesnt look spe-
> cially appetizing—but I guess you will survive with Mr. Mar-
> tin's blushes and red hair to warm you twice a week. I have
> written Dorothy a young volume and asked her to show it to
> you because I am sending my work to her and it is mostly
> about that. It was nice of you both to offer to take it to Mr.
> Martin—it isn't much—because I weeded on it till there wasnt
> much left—
>      . . . Anita I am sleepy—and can't write any more tonight—
>      It feels like squeezing blood out of a turnip—and I like only
> to write you when its an overflow. . . .

Georgia to Anita, Charlottesville, Va., September 1915

> . . . I must say I am putting the dollar for Mr. Martin's book
> in this letter. I have intended to every other time and always
> forgot. I am ashamed of myself after you did all the work. . . .
>      . . . I think I will go to South Carolina—for time to do some-
> thing I want to as much as anything—It will be nearer free-
> dom to me than New York you see—I have to make a living—
> I don't know that I will ever be able to do it just expressing
> myself as I want to—so it seems to me that the best course is
> the one that leaves my mind freest—(is there such a word—I
> should probably have said most free) to work as I please and
> at the same time make me some money. If I went to New York
> I would be lucky if I could make a living and at the same time
> it would take all my time and energy—there would be noth-
> ing left that would be just myself for fun—it would be all my-
> self for money—and I loathe money. . . . If I can't work by my-
> self for a year with no stimulus other than what I can get from
> books—distant friends—and from my own fun in living—I'm
> not worth much. . . .

**Anita to Georgia, Hendersonville, N.C., September 15, 1915**

> . . . You don't owe me a whole dollar—I'll send you the change some day—Please tell me as soon as you know what you'll do—I do care so much Pat. . . .

**Georgia to Anita, Charlottesville, Va., September 19, 1915**

> . . . I have made up my mind. I am going to Columbia. I made it up yesterday—Made it all up in a package—tied it with a rope and plomped on it with my heels.
>
> . . . I will arrive at the confounded place Wednesday morning—September 22 and will write to you as soon as I get there.

# COLUMBIA, SOUTH CAROLINA: 1915

*T*HE summer's vacation over, I was back in New York, studying at Columbia University and at the Art Students League, sad that Georgia was missing so much that I was still getting from lectures, study and exhibitions.

As planned, Georgia arrived at College Station, Columbia, South Carolina, September 22, 1915. Her teaching schedule left her free for her own art all of Mondays and in the afternoons after three. She began working on her own "ideas," drawing things that she felt she must express.

Her letters to me during this period provide such an illuminating portrait of the woman herself that I have included extracts from them. When we exchanged these letters, neither of us was thinking of what they might mean at a future time. I kept them because they were good to read:

**Georgia to Anita, Columbia, S.C., fall 1915**

> Anita—it is going to take such a tremendous effort to keep from stagnating here that I don't know whether I am going to be equal to it or not. I have been painting a lot of canvases and boards white—getting ready for work—I think I am going to have lots of time to work but bless you—Anita—one can't work with nothing to express. I never felt such vacancy in my life—Everything is so mediocre—I don't dislike it—I don't like it—It is existing—not living—and absolutely—I just wish some

one would take hold of me and shake me out of my wits—I
feel that insanity might be a luxury.

All the people Ive met are all right to exist with—and it is
awful when you are in the habit of living.

Ill be better for having told you and tomorrow can get out
and take a long walk—that will probably help—I can always
live in the woods. And Anita—maybe I'll have something to
say then.

Write me quick—

**Anita to Georgia, New York City, October 3, 1915**

Dear Pat you needn't think I don't know how you feel—It was
bound to come—Thank your stars you're a lucky enough devil
to want to go-go-go—inside & out—You can do both right
where you are in Columbia if you buckle down—& grit your
teeth & bear it Pat—Everything I tell you is going to make you
homesick for a while—but tho' it's cruel I think you'll like to
know it all—Your letter came as I was going down to dinner
tonight—And I've been thinking loads about you since it . . .
I don't think it will hurt you to be like hundreds of other people
for a year—I've a very positive notion that you've never been
like anyone else—you're tremendously strong Pat—though
you could be weak if you let yourself down one inch—so don't
slacken—It won't hurt you to know tame people for a little
while—they'll be a rest for you—Pat—such a rest that you'll
die for lack of stimulus—but you're not jailed in Columbia for
life, remember—you're only serving a one year sentence!

—Don't think from this that you're not to tell me when you
feel like yelling—you are!! and you're to write to me when
you feel worst—We've all got to tell a little of it to someone—
it's worse all pent up—and Pat I know you a darn sight better
than you think I do—and I think you're a great sport & will
pull thru this Columbia game all right—Now don't disappoint
me—I really feel like there's a hole in the floor where you
used to sit in Mr. Martin's back room. . . .

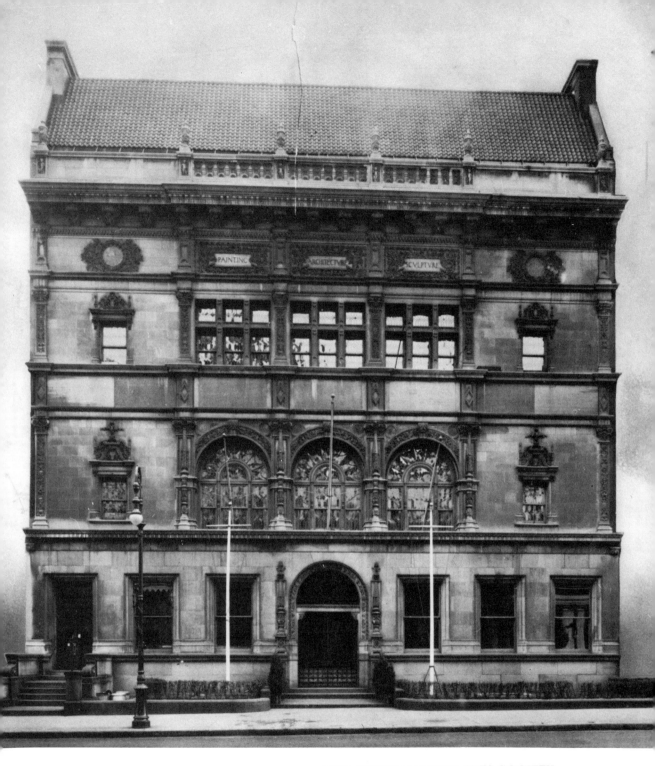

THE AMERICAN FINE ARTS SOCIETY
BUILDING ON WEST 57TH STREET, NEW
YORK, CIRCA 1915. AT THAT TIME, THE
ART STUDENTS LEAGUE OF NEW YORK
OCCUPIED ONLY THE UPPER FLOORS

. . . Mr. Martin's hair is redder than ever & he blushes more & is even nicer. He asked me where you were & if you sent pictures to me & what they were like—send me more pastels & I'll get you a criticism from him.

. . . I'm sending you my program—I expect Mechanical Drawing will be slow death. . . .

. . . Pat do you remember the big design you did one day—surface pattern—in Miss Cornell's class—you had two up one day for criticism & this one—well it's in the case in Miss Cornell's studio where the textiles were last year—along with two others—& it knocked me flat on my back, the moment I opened the door . . .

. . . Have you ever met such a bunch of sweet self-sufficient—unknowing-fools in your life as you're meeting now—No?—Well then that's an experience—grab it & rejoice!—

Oh Pat lets swear—It helps so much—Write me your bad feelings if you like & your good ones when you get them. It may make me & you nearer. . . .

**Anita to Georgia, New York City, October 8, 1915**

Hello Patsy—old girl—

Your letter tonight sounded a little more like you—don't force it tho'. Today was glorious for me. A morning—till 11:30—of hard work at the League on the model's ankle and leg curves—but it showed the work—Then I hurried down to 291 & saw our friend Stieglitz. He's a great man Pat, & it does me good to breathe his air for a little while. Nothing was on the walls—everything was on the floors—he was in the back room sneezing like a tornado when I entered—He came out when he got good & ready, & we talked like old times. Then he & I went in the back room & he gave me my "291" numbers—Isn't the Picasso violin one a beauty. Walkowitz was there too. I told Mr. Stieglitz I was going to the League & to my surprise—he said—"Do it"—Walkowitz then spoke up in his funny quiet little way & said—"You know what I think—

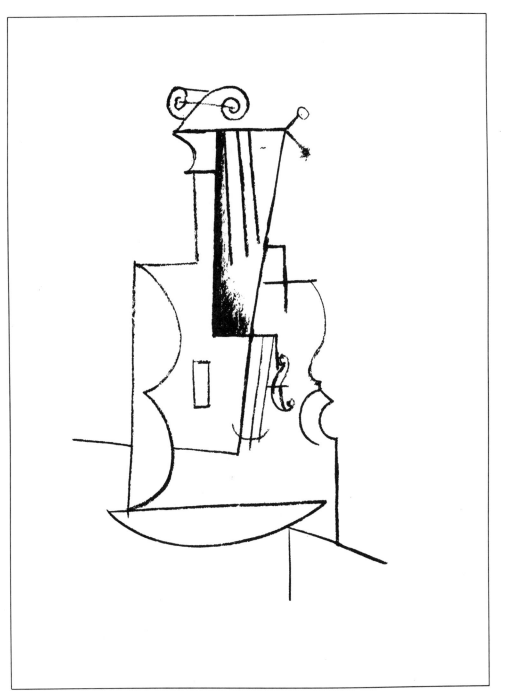

THE PICASSO VIOLIN DRAWING,
REPRODUCED IN *291*, THAT O'KEEFFE
AND POLLITZER SO ADMIRED

that you should go to the League & learn all they've got to
teach you—then work by yourself & forget *all you can* of what
they've told you, & what's left will be the part that's good for
you"—Mr. Stieglitz said [George R.] Bridgeman was the draw-
ing man—& then he said he wished I'd get Kenneth Hayes
Miller—you remember the interesting skeleton composition
done in Miller's class. Pat I told him where you were and that
I hated you to be there & he said "Say—don't tell me—I
know" in that way of his & then he said—"When she gets her
money—she'll do Art with it—& if she'll get anywhere—it's
worth going to Hell to get there"—Perhaps that'll help you
teach for a week! He has the right stuff & I tell you when I left
I'd forgotten the League & you & life drawing & teachers & I
felt like I counted, & could do something, & if I didn't I had
only myself to blame. . . .

   . . . Pat you know I think those League People are as near-
sighted as an old nurse I once had, who only saw 2 inches in
front of her nose. They're working for tomorrow—always—
Perhaps I'm a silly idealist—At least thank heavens I try to see
a little farther—Lots of love Pat—goodnight—sleep well—Anita.

Sometimes, after a walk of miles by herself or with a friend, Georgia
would sit on the bank of a stream, her bare feet in the water, wholly
unconscious of herself, in a day when women teachers in good Southern
colleges were usually most conventional.

**Georgia to Anita, Columbia, S.C., October 11, 1915**

Anita—aren't you funny to wonder if I like your letters. I was
walking up from the little bandbox post office with the mail
under my arm—reading your letter this afternoon—and when
I came to the part telling what Stieglitz said about "its worth
going to Hell to get there"—I laughed aloud—and dropped all
the things under my arm. . . .

   . . . —I read your letter twice then went for a walk with
about eight of the girls—it was supposed to be a run—and

ALFRED STIEGLITZ'S 1917 PHOTOGRAPH OF
291 FIFTH AVENUE (CENTER BUILDING)

they were all very much astonished that none of them could keep up with me—I can run at a jog trot almost as easily as I can walk—and most girls cant you know.

We explored much woods and country and found the quaintest little deserted house imaginable with wonderful big pink and white and yellow roses climbing on it—and funny little garden effects—all surrounded by great tall pines.

It would have been too cold to go without a coat if we hadn't run most of the way—whenever they had breath—so you know how great it felt

I came back and read your letter again.

Anita—do you know—I believe I would rather have Stieglitz like something—anything I had done—than anyone else I know of—I have always thought that—If I ever make anything that satisfies me even ever so little—I am going to show it to him to find out if its any good—Don't you often wish you could make something he might like?

Still Anita—I dont see why we ever think of what others think of what we do—no matter who they are—isn't it enough just to express yourself—If it were to a particular person as music often is—of course we would like them to understand— at least a little—but why should we care about the rest of the crowd—If I make a picture to you why should I care if anyone else likes it or is interested in it or not. I am getting a lot of fun out of slaving by myself—The disgusting part is that I so often find myself saying—what would you—or Dorothy—or Mr. Martin or Mr. Dow—or Mr. Bement—or somebody—most any- body—say if they saw it—It is curious—how one works for flattery—

Rather it is curious how hard it seems to be for me right now not to cater to someone when I work—rather than just ex- press myself.

During the summer—I didn't work for anyone—I just sort of went mad usually—I wanted to say "Let them all be damned—I'll do as I please"—It was vacation after the win- ter—but—now—remember Ive only been working a week—I

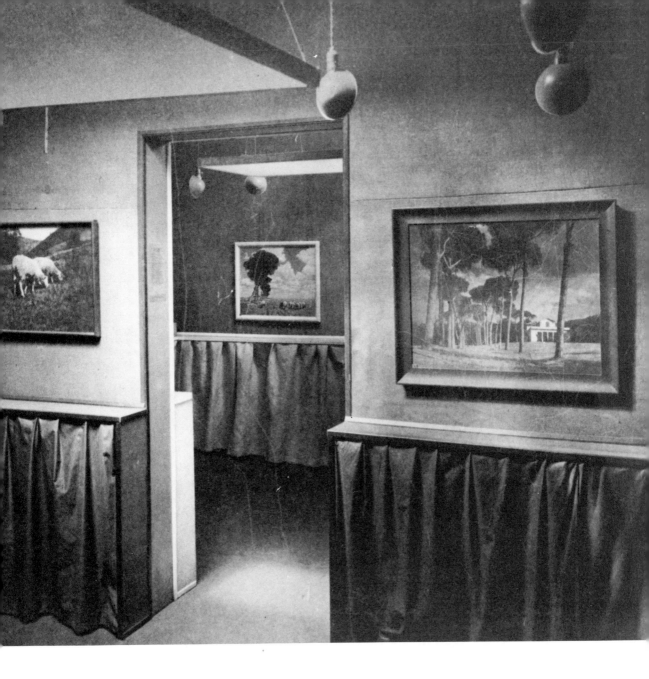

ALFRED STIEGLITZ'S 1906 PHOTOGRAPH
OF TWO OF THE SHOWROOMS OF THE
PHOTO SECESSION GALLERY AT 291
FIFTH AVENUE

find myself catering to opinion again—and I think I'll just stop it.

Anita—I just want to tell you lots of things—we all stood still and listened to the wind way up in the top of the pines this afternoon—and I wished you could hear it—I just imagined how your eyes would shine and how you would love it—I haven't found anyone who likes to live like we do. . . .

Georgia to Anita, Columbia, S.C., October, 1915

. . . What has happened to 291? I never got anything after that June Number and I subscribed to it for a year. Did you get yours?

I wish you could see the things I made today—I am afraid I will get distorted with only seeing my own things that I will be more queer than ever.

I don't mind—I would show it to you only it doesnt satisfy me even a little bit so I must work longer—Fancy me working a whole week—all my spare time doing the same thing over and over again—I am beginning to think that by the time Whistler had worked for 62 sittings on that portrait they tell about—he would have been a pretty unlucky devil if he hadn't hit something fairly good in all that slaving on the same thing. . . .

Anita to Georgia, New York City, October 12, 1915

. . . Have you seen this month's Suffrage Masses or would you like to see mine?

. . . When you get thru slaving over the thing you painted on—and having been working on for apparently some time—send it to me if you like. When I go up to Photo Secession I'll ask Mr. Stieglitz if he has your address. That's probably why you haven't received the 291s. . . .

**Anita to Georgia, New York City, October 14, 1915**

Your letter came this morning Pat—I read it at breakfast and it made me quite hungry! I knew you'd explode over what I wrote you about Mr. Stieglitz. I wish I was bumming this year. I'd manage to get in time for him there—as it is I haven't been there since—for time of course and I want to—so!

Your walk sounded pretty much like fun. Perhaps I would have liked to try to jog-trot with you & fall behind like the rest—I feel as tho' *I am* falling behind Pat—If I only had time for Mr. Martin's stuff—but if I don't flunk anything I get my degree this year—then I can work for love and not for points. I've had things my own way in college anyway—pretty much.

Now Pat—Here's why I'm writing.

I saw [the work you sent Dorothy True] yesterday—and they made me feel—I swear they did—They have emotions that sing out or holler as the case may be. I'm talking about your pastels—of course. . . . They've all got *feeling* Pat—written in red right over them—no one could possibly get your definite meanings Pat—that is unless they knew you better than I believe anyone does know you—but the Mood is there everytime. I'll tell you the ones that I sat longest in front of:—The crazy one—all lines & colors & angles—There is none other like it so you'll know the one I mean—it is so consistently full & confused & crazy that it pleases me tremendously. It struck me as a perfect expression of a mood!—That was why I liked it—not because it was pleasing or pretty for it's far from that— It screams like a maniac & runs around like a dog chasing his tail. Then the flower study which I liked *so* much this summer gives me infinite joy—It is just a beautiful little thing and I do like beautiful things sometimes—Your color in that orange and red ball . . . is very strong & powerful—It doesn't mean just as much to me as that first—I guess its more yours Pat and less anybody else's. The blue-purple mountain is exquisitely fine & rare. It expresses perfect strength—but a kind not a brutal strength.

Your trees—green and purple are *very* simple and stand

well and firmly. I like that as it is—but Dorothy wrote you what Mr. Martin said I guess last night. Then the smaller one of the yellow and redish orange pictures struck me as awfully good but *I didn't like it*—It meant something *awfully different* to me and I couldn't get that out of my head. Your monotype that you did of me is a masterpiece! I think anyone could have done those Hollyhocks but Mr. Martin seemed to think they should be sent to Philadelphia and the Monotype too of course. Pat I wrote for entry cards for the Philadelphia Water Club tonight and we're going to fill two out for you for the Hollyhocks and Monotype—I sent them an envelope addressed to you and told them to send you 2 entry cards—(in case you spoil one)—If you've decided to fix your big simple trees—frame it and send it—then make out an entry card for it as soon as you get it.

Georgia's love of flowers and of color was in letter after letter:

**Georgia to Anita, Columbia, S.C., October, 1915**

Anita—do you feel like flowers sometimes?

Tonight I have an enormous bunch of dark red and pink cosmos—mostly dark red—over against the wall—on the floor where I can only know they are there with my left eye—but with my right eye and part of my left eye—I can see a bunch of petunias—pink—lavender—and red lavender—one white—on my bureau—it is dark mission wood—They give me a curious feeling of satisfaction—I put them there so I could see them—just because I like them tonight—and put a wonderful bunch of zinnias in the closet. Anita—I feel bothered about that stuff I sent Dorothy. I wish I hadn't sent it—I always have a curious sort of feeling about some of my things—I hate to show them—I am perfectly inconsistent about it—I am afraid people wont understand—and I hope they wont—and am afraid they will.

Then too they will probably be all messed up—

But it can't be helped—they are at your mercy—do as you please with them—

I am starting all over new—

Have put everything I have ever done away and don't expect to get any of it out ever again—or for a long time anyway. I feel disgusted with it all and am glad I'm disgusted.

Yes—I'm feeling happier—Anita—maybe it would be better to say that I feel more as if I have my balance—

Now Anita—I will tell you something else—Living is so funny to me—It made me feel so dismal to think of you up there that I just didn't know what to do about it—for a little while—I wasn't very busy either—you know how it always is when school begins—and I wasn't settled enough to get to work— With an abundance of time on my hands—and little inclination to work when everything felt so mixed up—and some very nice letters from Arthur [Macmahon]—I got rather out of gear. He is the sort of person who seems to say nice things in the very nicest way they could be said—and Anita—I found I was going on like a fool—and—was nearer being in love with him than I wanted to be—It was disgusting—simply because I hadn't anything else to work off my energy on—To think that I would be liking anyone more than usual—simply because I had nothing else that demanded my attention—I felt that I was insulting him.

I know it was only a notion—but it made me furious with myself—I know I like him very much—and he likes me as much—I think—or I'd not like him I'm sure—but there is no earthly reason why I should let him trail around in my mind like he was trailing.

So—I thank you and Dorothy for giving me a jolt that started me at work—Maybe you can understand me better now— how *much* I thank you. . . .

Anita—I am sending it [a letter from Arthur Macmahon] to you because it is an interesting sort of document from—a man that I don't know what to do with. If he were less fine—I

would drop him like a hot cake—but he is too fine to drop—
and too fine to keep—and he doesn't know how fine he is. I
have known him for a long time—he trailed up to Charlottes-
ville to see me this summer just before I came down here—He
teaches school because—he likes to work with children—he
says his own childhood was so cramped and twisted that he
wants to do what he can for some others before he starts his
own life work. . . .

　. . . Well—Anita—I felt as if my soul had been peeled and
sand-papered by the time I had finished this letter.

　You may read it if you want to—It simply will lay bare to
you a personality—and as you will never meet I am giving
you the privilege of choosing yourself if you havent scruples—
Some people have I know—but it is an unusual letter—his let-
ters are always unusual—So—with this as the pictures I sent
Dorothy—do as you choose—It is only a human document—
that wild blue picture with the yellow and red ball in the cor-
ner—I made during the summer when one of his letters al-
most drove me crazy—I just exploded it into the picture—it
was what I wanted to tell him only I didn't dare in words—
Words seem to me such a poor medium of expression—for
some things—That little blue mountain with the green streak
across it is what he expresses to me. . . .

　I have one interesting pupil—a little girl—eleven—Mary
Adelaide—English—daughter of the musical director [Profes-
sor Harry Horsfall]—yellow hair like Dorothy's. . . .

**Georgia to Anita, Columbia, S.C., October, 1915**

　. . . [D]on't you think we need to conserve our energies—emo-
tions and feelings for what we are going to make the big
things in our lives instead of letting so much run away on the
little things every day.

　Self control is a wonderful thing—I think we must even keep
ourselves from feeling too much—often—if we are going to
keep sane and see with a clear—unprejudiced vision—

I do not want to preach to you—I like you the way you are—but I would like to think you had a string on yourself and that you were not wearing yourself all out feeling and living now—save a little so you can *live* always—

It always seems to me that so few people live—they just seem to exist—and I don't see any reason why we shouldn't *live always*—till we die physically—why do we do it all in our teens and twenties . . .

. . . You shouldn't have been so excited on my behalf over the letter I sent you—I sent it because people don't often express so much of themselves in words and it was honest and interesting—

I don't love him—I don't pretend to—sometimes when I'm very tired I used to want him because he is restful—I probably will again—though I doubt it. . . .

. . . I almost want to say—don't mention loving anyone to me—It is a curious thing—don't let it get you Anita if you value your peace of mind—it will eat you up and swallow you whole. . . .

. . . Another thing—Dorothy knows me in a different way than you do—different people always call out different things in us—I could not possibly seem the same to you both—you call for such different responses—but Anita—you mustn't expect too much of me for your bubble is bound to burst if you do—

**Anita to Georgia, New York City, October 16, 1915**

I'm not at all sorry for what I wrote you that night—I meant it and felt it—and it wouldn't have been *me* if I hadn't said it. Why should I use self control (as you suggest) when I'm just writing to you? Heavens knows it's a treat to be oneself to somebody once in a while! . . .

. . . Perhaps your little sermons about not letting my emotions run riot are true, but it is more of a physical strain Pat to keep them quiet when they want to come out—I'd lots rather

live hard than long! P'raps I'm a fool—it would be lots of fun
to be one and be different from the rest of people. Pat—other
People don't excite—or even make me feel much—I only
know three people who do. To everyone else I'm a terribly
prosaic (p'haps nice and pleasing occasionally) person. Don't
fool yourself Pat—you say I mustn't expect too much from
you—I don't—I know what you are—I really don't expect any-
thing else—

New York's quite a strain. The poor babies on the streets
nearly make me sick—I hurry—inside—too much. That I do
know. I am getting so much out of the League—in actual con-
struction—[Mr. Martin] tells me why & where my drawings
are atrocious & shows me *how* to fix them. . . .

. . . Pat don't think I mind being told things—I've always
longed to be ripped up the back & left unsewed—nobody's
done it—Won't you write me some day about my worst self—I
mean the things which I'll have to change before I can ever
do anything. . . .
Goodnight—sleepwell—Anita

**Anita to Georgia, New York City, October 23, 1915**

I can't stand not hearing from you or not writing to you anoth-
er night. It's like stopping drinking all of a sudden I imagine.

Today Dorothy [True] & I went from the League to the Pal-
ette Art & then she walked to the Photo Secession with me but
wouldn't come up—Why I don't know—Mr. Stieglitz wasn't in
& nothing was around so I went out & raced after Dorothy,
who was walking slowly & we went together to 500 Fifth Ave-
nue which is a daughter of 291—[Marius] de Zayas & [Francis]
Picabia & some others have charge—its called The Modern
Gallery. Things are bought there—sold rather—& of course at
291 no one ever mentioned money. 291 will still live for the
same reason as it always has lived, & this 500 will be an out-
let for goods which is good! We walked up together Dorothy &
I & what was my surprise—but to find Mr. Stieglitz there. He

is just himself, that's why he does me good. Guess what was on the wall—That Picasso violin which was the 1st thing I ever saw the 1st day I ever entered 291. Braques & Marins and Picabias were on the walls which are hung in a soft love-ly tan-yellow. Dorothy left—I stayed afterwards—just looking & feeling that Picasso thing. It's the greatest thing in Art I know—It's music on paper. . . .

. . . Tomorrow is the suffrage parade—a huge affair—The question is up to N.Y.'s voters on the 2nd you know & tomor-row 25,000 women & 10,000 men will march—simply to defeat the argument of the Antis that only a few want it—maybe more will march but these have registered. As I am neither halt nor lame & have "The courage of my convictions" I walk also. . . .

**Georgia to Anita, Columbia, S.C., October 26, 1915**

. . . Anita? What is Art anyway?

When I think of how hopelessly unable I am to answer that question I cannot help feeling like a farce—pretending to teach anybody anything about it—I won't be able to keep at it long Anita—or I'll lose what little self respect I have—unless I can in some way solve the problem a little—give myself some little answer to it.

What are we trying to do—what is the excuse for it all . . .

The things I've done that satisfy me most are charcoal land-scapes—and—things—the colors I seem to want to use abso-lutely nauseate me—

I don't mean to complain—I am really quite enjoying the muddle—and am wondering if I'll get anything out of it and if I do what it will be—I decided I wasn't going to cater to what anyone else might like—why should I?

**Anita to Georgia, New York City, October 26, 1915**

. . . Pat—you're screamingly funny—I shook absolutely when

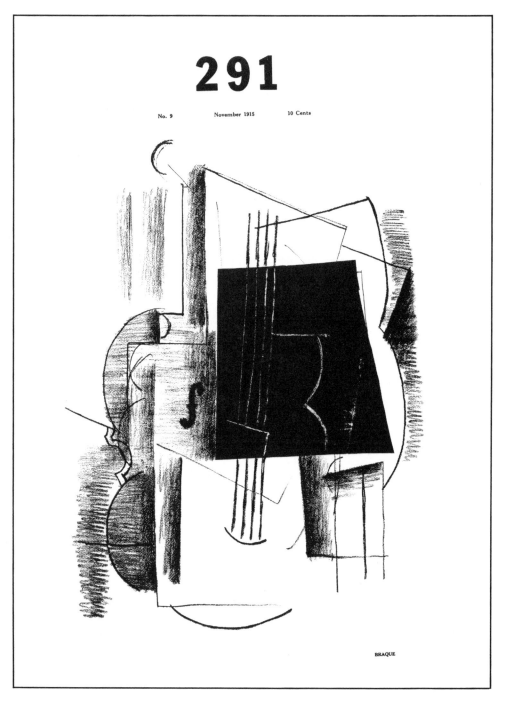

GEORGES BRAQUE'S COVER FOR THE
NOVEMBER 1915 ISSUE OF *291*

I came to the serious part of your letter asking me what Art is—

Do you think I know?

Do you think I'd think anybody knew, even if they said they did?

Do you think I'd *care what* anybody thought?

Now if you ask me what we're trying to do that's a different thing—We're trying to live (& perhaps help other people to live) by saying or feeling—things or people—on canvas or paper—in lines, spaces & color—

. . . To live on paper what we're living in our hearts & heads, & all the exquisite lines & good spaces & ripplingly good colors are only a way of getting rid of these feelings & making them tangible—

What a lot of rot I write you Pat—you know from the moment I write "Dear Pat" & begin a letter to you I don't think my pen just goes exactly where it pleases—I let it—You know all that stuff I've written you. . . .

**Georgia to Anita, Columbia, S.C., October 1915**

. . . When I came in [from a walk with Adelaide] your letter was slipped under my door with the Stieglitz clipping in it— You can laugh all you want to about my wondering what Art is—Yes—Laugh. I believe some wise fool says its good for the soul so maybe it will help—

. . . It is all very well to laugh—I laugh too—

But you get mightily twisted with yourself at the tail end of the earth with no one to talk to—Then thinking gets more serious when you wonder and fight and think alone—Of course I have thought what you say about it—but sometimes hearing some one say it again—just the phrasing—gives you a starting point for a new idea—I dont know that my heart or head or anything in me is worth living on paper. . . .

**Anita to Georgia, New York City, November 4, 1915**

> Are you calling for your mail as expectantly as I go to that
> darned P.O. window. I bothered the woman twice today.

**Anita to Georgia, New York City, November 8, 1915**

> What's the matter Pat?
>      Nothing I like to think. . . .
>      . . . Oh Pat—the other day I went into the Modern Gallery
> "500" to rest—Stieglitz was there. He gave me some old Cam-
> era Works to look at & I stayed awfully long—Just as tho' I
> were at home—He was hopping around on the tables &
> chairs taking pictures of 5th Ave looking down—You see "500"
> is on the 8th floor of the corner opp. the Library—"42 & 5th"—
> a great corner! He certainly waited for compositions—He is a
> rare one. . . . [Stieglitz] told me to read 2 new good books—so
> I'm telling them to you—Make your college library get them—
> they are "Jerusalem" by Selma Laegerlof & "Research Magnif-
> icent" by "Wells"!
>      . . . Did you change your mind about sending me those
> things of Adelaide's—I want them to see. . . .

Georgia was reading widely—Thomas Hardy, Herman Melville and Sid-
ney Lanier were among those whose work she would especially mention
in letters.

**Georgia to Anita, Columbia, S.C., November 1915**

> Your letter this morning was good to get.
>      I am sorry you didn't get anything from me at the little win-
> dow but I just haven't felt like writing so didn't write. Haven't
> worked either—since Monday and here it is Saturday after-
> noon—I've just been living. It seems rediculous that anyone
> should get as much fun out of just living—as I—poor fool—
> do. . . .

. . . This black and white thing has been in this envelope addressed to you for several days. In one of your letters you asked about Adelaide and I made this of her when she was working across the table from me that day to tell you.

**Anita to Georgia, New York City, November 13, 1915**

. . . Now that I know how Adelaide looks I'm glad. She's an awfully self-sufficient looking youngster from your brush drawing. You'll get her to do something yet. . . .

. . . An exhibition of Oscar Bluemner is on [at 291]—It was the brightest thing in color I ever expect to see. I think he does it by placing his opposites together & he's experimenting with new paints.

Stieglitz was great! He talked a blue streak & his hair was extra bushy.

**Georgia to Anita, Columbia, S.C., November 1915**

. . . It is so easy to loaf here—I'm not doing anything—I'm just experimenting. I have such a mania for walking that I start out at four every afternoon and walk till six—It is great. I'm feeling fine—like turning the world over—Anita—I just want to kick a hole in it. . . .

. . . Yes—I am going to send you Adelaide's things—and a couple of mine—just for fun. . . .

**Anita to Georgia, New York City, November 16, 1915**

. . . They came today—I took them in an empty classroom—got thumb tacks and stuck them over the wall. First of all come your two moods—They are pretty fine I think but you know I'm crazy when it comes to things like that. I like the one in black & gray on the very white charcoal paper. . . . The other is quite dramatic—I like it, but it's so sensational—so explosive that it's bound to carry me—I don't know what to say

about it—I'd love to ask Mr. Stieglitz Pat. Of course I never should till you said the word & I don't feel the time's come yet—but keep on working this way like the devil. Hear Victrola Records, Read Poetry, Think of people & put your reactions on paper. I like the first one I mentioned—little black on lots of white—

. . . I guess all the others are Adelaide's—I like the still life & the doll and Pat the flower basket is rather interesting but it isn't good—to me. I think we can fool ourselves easily on that type of thing. . . .

**Georgia to Anita, Columbia, S.C., November 1915**

If I told you that I am so glad about something that I am almost afraid I'm going to die—I wonder if you could imagine how glad I am. I just can't imagine any one being more pleased and still able to live.

Arthur is coming down to spend Thanksgiving with me—His letter this afternoon was like a thunderbolt out of a clear sky.

**Anita to Georgia, New York City, November 21, 1915**

I'm so glad for you! It's perfectly wonderful—even I with little understanding—and much distance away can see that.

. . . In the morning I heard George Bellows! He was lots of fun & worth hearing. I should like to take a few lessons from him sometime in my life—Not yet though. He was so truthful, and frank and boylike—almost crude—that it was refreshing—not foolish—just open sincerity. . . .

**Georgia to Anita, Columbia, S.C, November 1915**

. . . [Arthur] has been here and has gone. What can I say about it—I don't seem to have anything to say . . .

**Georgia to Anita, Columbia, S.C., November 1915**

. . . He has the nicest way of saying things and making you feel that he loves you—all the way round—not just in spots. . . .

**Georgia to Anita, Columbia, S.C., December 1915**

Its a wonderful night—

I've been hanging out the window wanting to tell someone about it—wondering how I could—I've labored on the violin till all my fingers are sore—You never in your wildest dreams imagined anything worse than the noises I get out of it—That was before supper—Now I imagine I could tell about the sky tonight if I could only get the noises I want to out of it—Isn't it funny!

So I thought for a long time—and wished you were here—but Im going to try to tell you—about tonight—another way—Im going to try to tell you about the music of it—with charcoal—a miserable medium—for things that seem alive—and sing—only I wanted to tell you first that I was going to try to do it because I want to have you right by me and say it to you. . . .

**Georgia to Anita, Columbia, S.C., December 13, 1915**

Dear Anita—Did you ever have something to say and feel as if the whole side of the wall wouldn't be big enough to say it on and then sit down on the floor and try to get it on to a sheet of charcoal paper—and when you had put it down look at it and try to put into words what you have been trying to say with just marks—and then—wonder what it all is anyway—Ive been crawling around on the floor till I have cramps in my feet—one creation looks too much like [Teachers College] the other too much like soft soap—Maybe the fault is with what Im trying to say—I dont seem to be able to find words for it—

I always have a hard time finding words for anything—
Anita—I wonder if I am a raving lunatic for trying to make
these things—You know—I don't care if I am—but I do won-
der sometimes.

I wish I could see you—I cant tell you how much I wish it.
Im going to try some more—I turned them to the wall while I
wrote this—One I made this afternoon—the other tonight—
they always seem different when you have been away a little
while. I hope you love me a little tonight—I seem to want
everybody in the world to—Anita. . . .

**Anita to Georgia, New York City, December 17, 1915**

Go ahead saying "those idiotic things"—Use two sides of the
wall if necessary—Your letter was great, Pat, I could feel the
cramps in your feet from crawling all over the floor & trying to
make the darn marks look like the things in your heart &
head. Keep at it. Cezanne & Van Gogh and Gauguin were all
raving lunatics—but they didn't mind a little thing like
that. . . .

Georgia had begun to paint and draw what today would be called ab-
stractions, expressing in lines and forms, and sometimes in vivid color,
feelings that she would not and could not have put into words.

Those were the days when we were reading Michael Sadler's translation
of Kandinsky's *The Art of Spiritual Harmony* with his emphasis on inner
harmony and the language of color. It was a book that completely changed
one's way of looking at pictures.

In South Carolina, away from art influences and previous teachers,
Georgia wrote to me with dissatisfaction that she felt she was "still working
like other people." During this time she had a showing of her work—"just
for myself." She wrote me how she had put up her drawings on the wall
of her room at the college and when she looked at them she found that
she could say, "This one is affected by Mr. Dow's teaching, this by Mr.
Martin's, this by Mr. Bement's."

Later she stated: "I thought to myself, well, if that's been done, I don't

have to do it, I guess if I'm going to do something that is my own, I'd better start, and I'll start in black and white." She decided to pack up her watercolors and oils and, with her paper and charcoal, make something to please herself.

The things she felt keenly at this time were expressed in these "first charcoal drawings," which she was soon to send to me. She started working, with great abandon, and entirely in the way she wished. With her work, away from art teachers and exhibitions, it was as Taine, great philosopher and critic of the nineteenth century, expressed it:

> All original art is self regulated; and no
> original art can be regulated from without. It
> carries its own counterpoise and does not receive
> it from elsewhere—lives on its own blood.

# A WOMAN ON PAPER: 1915

ƎN the spirit in which we had been sharing in our letters what we were discovering in art and literature, one day after Christmas in 1915, Georgia sent me a roll of drawings, with the express injunction that I was to show them to no one.

They arrived unregistered, care of the college post office. I took them up to the fourth floor studio, locked the door so that no one would see them, as she had asked, and spread them out on the studio floor.

I was struck by their livingness. Here were sensitive charcoals, on the same kind of paper that all art students were using, and through no trick, no superiority of tools, they were expressing what I felt had not been said in any art I had seen; and what they were expressing seemed important and beautiful.

In the intervening time, I too had been making discoveries, the greatest of which was what Alfred Stieglitz was giving to America: its first realization of contemporary art as a living force. I had discovered his gallery at 291 Fifth Avenue after Georgia had left New York for her teaching. Again and again that year, I had gone there to see the early Marins, Picassos, Braques, and Hartleys that hung on the walls.

After the many galleries where one could see only what was then accepted in art, this gallery called simply 291 was a moving experience. Here, people and paintings were amazingly drawn together. The formality of the great galleries was lacking. There were no attendants, no gold frames. The paintings were beautifully hung on immaculate walls. And

Jan. 1- 1916

Astounded and awfully happy were my
feelings today when I opened this
batch of drawings. I tell you I feel
them! + when I say that I mean that
They're gotten past the personal stage
into the big sort of emotions that
are common to big people - but it's
your version of it. I mean if they'd
been stuck on a wall + I'd been
told X Z did them I'd
have liked them as much as if
I'd been told Picasso did them, or
someone I'd never heard of. That——
Well they're gotten there as far as
I'm concerned + you ought to
cry because you're so happy.
You've said something! I took
them up in the 4th floor +
stayed alone with them in

always, an extraordinary man was in the gallery, communicating in a crisp, lively fashion—sometimes through his questions—an awareness of the pictures and an awakening of one's self. The gallery was a dedicated place because of the spirit with which Stieglitz invested it.

At certain moments in our lives we know what we must do, and when I saw Georgia's drawings, it was such a moment. Although we had been writing back and forth, nothing had conveyed to me what these drawings did. There was one of two black lines of unequal height, with the promise and sensitiveness of the now famous *Blue Lines* (1916). There were rich round forms, in blacks, whites and grays, beautiful in texture and proportion. Although I had turned the key in the door of the college studio, so that no one would see the drawings as she had asked, I knew after looking at them, in spite of her bidding, that there was one person who must see them. So with the roll of drawings under my arm, I went downtown to 291 and Alfred Stieglitz.

I have asked myself over and over why I was so sure of the importance of the drawings. I think it was that within the year that I had first seen 291 its exhibitions had made a profound impression upon me. I had gone downtown between my college classes day after day, feeling that at this gallery there was something rare, something I could not afford to miss. Here now were drawings, most of which would now be called abstract, entirely different from anything I had seen there, but with just as complete expression. Stieglitz, at the gallery, had shown the other amazing pictures that had moved me so deeply. These drawings, I knew, should also be seen by him.

It was after five on a rainy afternoon when I arrived at 291. The elevator was out of order. I hurried up the stairs and found Stieglitz in the front room, alone. He looked particularly discouraged but turned and smiled a welcome.

"Would you like to see some drawings I have brought to show you?" I asked. He nodded affirmatively. Stieglitz was always ready for the unexpected and for the person who came in expectantly.

Leading the way to the little rear room where there were two straight chairs, he sat down. I spread the drawings on the floor in front of him and said nothing about them or the artist. He looked at them earnestly and then with assurance, exclaimed:

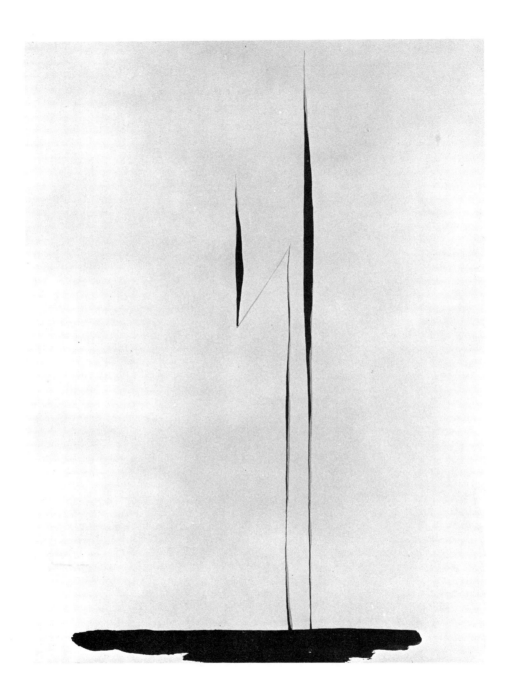

*BLUE LINES X* (1916),
WATERCOLOR ON PAPER, 25 X 19 IN.
METROPOLITAN MUSEUM OF ART,
ALFRED STIEGLITZ COLLECTION

"Finally a woman on paper!"

To the only other person then in the gallery, he called out: "Walkowitz, come here."

Abraham Walkowitz, an artist of the early 291 group, then the little elf-like person of the fine line drawings, came from the other room and bent over the drawings: "Very fine," he kept saying.

Stieglitz picked up the drawings, examined them one by one, and after a pause he asked me, "What woman did these?" but he did not seem to care about the answer.

"Are you writing to this girl?" he continued. "Will you tell her for me that this is the purest, most sincere work that has entered 291 in a long while."

And then he said, as if to himself: "I think I will give these drawings a show."

The drawings "belonged," as he later expressed it, although Georgia O'Keeffe, as a person, did not yet exist for Alfred Stieglitz. His idea, as always, was that individual and alive work should be "given a chance." I left the drawings with him.

Walkowitz afterward gave this account of what occurred that day, before and after Stieglitz saw the drawings:

"Stieglitz, Hartley, Marin, de Zayas, Haviland, Kerfoot, Hutchins Hapgood and I had eaten lunch at the Holland House opposite 291, as we so often did, and had discussed many things. Something had occurred that day that worried Stieglitz greatly, and he was also depressed because the world was thinking war. While he was in that black mood, in which nothing seemed worthwhile, you appeared with O'Keeffe's drawings. They were a revelation to him. He had long hoped that someday drawings with such feeling and candor would be put on paper by a woman. In O'Keeffe's work he saw a new expression of things felt, a new beauty.

"When we left 291 that evening, Stieglitz wanted to walk. He talked the whole way home about the drawings, that might be called abstract drawings, but that designation was not used then, nor did Stieglitz separate art that way. He was curious about who she was; he was never interested in names. It was the work that he talked about. He thought that there had never been anything that expressed what they expressed. 'Finally, a woman's feeling, on paper,' was what he kept saying. He felt that these

drawings were a contribution to creative art; that at last a woman was sensitively seeing and expressing in visual form her own relation to the universe. From that first moment, the drawings became an important factor in the great experiment being conducted at 291."

# SUN PRAIRIE: 1887–1900

*a*S the character of each of us is so largely determined by the circumstances of early life, when I began to write the story of Georgia O'Keeffe I went to the Wisconsin farm of her childhood, spoke with members of her family and friends of her youth, and then to Williamsburg, Virginia, to speak with some who knew her when her family moved there during her girlhood.

A satisfaction ran through much of Georgia O'Keeffe's childhood. If there was something she wanted, aside from what the family supplied, she found it on the farm or tried to make it. The outdoors and her own initiative gave her happiness. She knew the trees in the orchard where the sweet apples grew and, when she preferred them, the sour ones. She could, when she wished, take the cows down to pasture "where the willows met overhead, because it was so beautiful there."

But it was not just the beautiful that appealed to her. Everything about the outdoors was of interest: the hissing geese that chased her up the path; the clammy frogs that she would pick up from their water hole in early spring, so many of them that she had to take off both cotton stockings to carry them in, up to the pan of water on the back step; and there was always her repeated surprise in the morning that they had all jumped away to freedom. She remembers the early mornings in winter before school opened, when she was sent across the frozen cornfield with messages for her father, and how icy her feet felt. She remembers that with

O'KEEFFE'S BIRTHPLACE IN SUN PRAIRIE, WISCONSIN, AS
PHOTOGRAPHED IN THE 1940S. THE HOUSE WAS
DESTROYED BY FIRE IN THE 1970's

her sisters and brother she would race down to the cow pasture and then, as the cows came to the gate to greet them, they would reach in and feel their rough tongues and watch the funny roll of their eyes.

There was a richness and independence about life that encouraged creativeness in a child of her nature. It was a fine world to this little girl, but she was not conscious of its special fineness, for until her thirteenth year it was the only world she knew.

She was a solitary child, but it is clear that she was always busy doing what interested her most. The self-reliance and closeness to nature of those impressionable years left their mark on her entire life and are in everything she ever painted.

Her Sun Prairie years were years of abundance, independence and security. Her memories are of hay loads at dusk, wagons winding slowly down the road, apple trees she loved to climb, the crunch of the snow at night, fields of many-colored wild flowers, an enormous round moon coming up over the woods, the little low place in the meadow where she played alone—and always an emphasis on the blue sky overhead.

Sunlight and soil and sky, so extremely alive in the clear air of Sun Prairie, Wisconsin, appear again and again in the earliest memories of Georgia O'Keeffe as they do in her paintings.

The land where she was born and where she spent hours of her childhood out of doors was undoubtedly the influence of her whole life, the source of her happiness then, and of her life-long independence and achievement.

In that country, in one of the most fertile valleys of the Middle West, on November 15, 1887, Georgia was born to Francis and Ida (Totto) O'Keeffe, the second child and the oldest girl in a family of seven children—two boys and five girls. Her grandparents on both sides had settled in Wisconsin in its pioneer days.

The town, still young, stretched out to three-and-a-half miles from her father's well-tended farm of six hundred acres. His section, then known as "the O'Keeffe neighborhood," belonged, when I was there a few years ago, to four different farmers. The home was a generously proportioned frame house with big rooms. On the living room wall were dents left in the wood when their first wall telephone was moved. There were substantial barns, an apple orchard, old oaks, a maple with the hooks from

which the hammock of the O'Keeffe children swung.

This was a part of the country where in her childhood, as now, there were luxurious fields of bountiful crops and cattle and horses—all that made for a prosperous, confident people. The characteristics of Sun Prairie were those of a young American community: independence, happiness in the outdoors, pride in good work done with one's hands—all related to the qualities we find in O'Keeffe, the woman and artist.

In Georgia's childhood, parts of Wisconsin were still blanketed by virgin forest. Where the dense tracts of land had been cleared by the settlers, many small communities had come into being but there were still woods through which she walked daily, from her home to the schoolhouses. Indians still passed close by from time to time, walking on the high road.

The beauty of this primitive country, to which families from the Eastern cities or from the Old World had come, was noted by Carl Schurz in a letter written from there to his wife in 1851. He expressed it this way: "Wisconsin is a beautiful land . . . one finds the borders of civilization so near at hand that in hunting one often encounters Indians, yet the Southern half of the State is developing into a great blooming densely populated agricultural district."

Georgia's roots were in this farm country—so much so, that many years later when I asked her to tell me of her childhood, her first words were: "Papa had a prize farm; there was no better one in Sun Prairie. Although he had plenty of farm help, he worked from dawn to dark."

As to her father, she had been impressed as a child with his laughter at the things that others took so gravely, of his making light of any little mishaps. He carried many picturesque images in his mind and would change their moments of distress with his fun and lightheartedness. When he would say to one of the children, "Speeney, Spawney, Go to the Moon," even a splinter in a finger would immediately vanish. He was a man of great simplicity, a handsome person with curly hair, which none of his children inherited. As a little girl, Georgia was exceedingly proud of him.

His children admired all their father did, particularly his hard work. He always took time to be kind to them. When he went driving, he would bring back little surprises such as horehound candy and candy kernels. If they were with him, he would stop his horse at the ice cream store and treat them all. It was he who, with indefatigable work, brought the

telephone line into Sun Prairie. Georgia went with him in the buggy and waited while he called at the farmers' houses to tell them that if they would each dig a certain number of holes for poles they would get a telephone wire past their door, and soon after each could have a telephone. The O'Keeffes' telephone, mounted on the parlor wall, was the first out their way, a big box with a hand ring. To his children he had invented the telephone.

The O'Keeffes were a prosperous family—and an intellectual one. In the early summer evenings Georgia's mother would sit in her square garden with the lovely sweetbriar roses that she had planted. When it grew dark, she would take the children in and read to them—travel stories and history— *The Life of Hannibal, Stanley's Adventures in Africa,* all *The Leatherstocking Tales,* the Bible, *Pilgrim's Progress, Arabian Nights,* and *The Life of Kit Carson.* It was Wild West stories of the cattlemen, buffalos and Indians that Georgia loved the best.

The books were picked by their mother, especially for their elder brother, Francis, but when she read, all the children gathered around her, fascinated. There was never a time when they were growing up that their mother did not read aloud to all of them at night.

Because of this nightly reading, Georgia did not feel the need to read anything for herself but school assignments. Oddly enough, the first story of any length that she remembers reading by herself was a newspaper account in the pink section of some big city newspaper of the Fitzsimmons-Corbett heavyweight championship fight, which occurred at Carson City, Nevada, in March 1897.

Often, evenings, their mother accompanied their father as he played the tunes he loved on his violin—standard American favorites and familiar Irish airs such as "The Black Bird" and "Galway Bay." At times, neighbors would drive over and join them. Ida O'Keeffe had a great gift for gathering the world around her and Georgia was contentedly silent—always her preference—when her sociable mother was present.

Friends gathered at the big white wooden house on the rise of a large, sloping lawn, surrounded by lilacs and roses and evergreen hedges, winter and summer, and for holiday parties. Each Christmas, a well-chosen tree almost touched the ceiling; it was looped with chains of bright-colored paper, shiny ornaments and ablaze with the lights of real candles.

MAIN STREET, SUN PRAIRIE,
WISCONSIN, AT THE TURN OF THE
CENTURY, AFTER TELEPHONES HAD
BECOME COMMON

The only playmates the O'Keeffe children were allowed to have were those who came over to their house. It never occurred to Georgia to wonder about other people's houses, but she remembers how much she liked her own.

Independence in thinking was encouraged in the O'Keeffe home. The women in the family were the forceful ones and the girls, long before this was a generally accepted idea, were encouraged to be successful at whatever they did.

When the older brother would insist that girls could not do this or that, Georgia would quietly refute this by climbing the highest tree or winning the race around the barn. At times she would point out that their mother was a woman and could do everything. But because her mother's nature was so different from her own, Georgia did not try to copy her and grew more and more satisfied to live within herself. She did not try to win the smallest point by arguing with her elders nor would that have been permitted. She remembers figuring out that the grown-ups had their world and she could have hers too, and do in it what she wished without argument. So, early in life, something firm and self-reliant, bent on its own way, crystallized within her.

"As a little girl," Georgia said, "I think I craved a certain kind of affection that Mama did not give. I do not remember that she ever praised us. She counted on us and we were to do our best as a matter of course because we were her children."

Georgia's father was adventurous. In his early twenties, he had left Sun Prairie, alone, to explore the almost virgin Dakotas. Georgia later said, "Although I received my Mother's strict kind of bringing up, I think that deep down I am like my Father. When he wanted to see the country, he just got up and went. That is how it has to be at times with me."

Mrs. O'Keeffe was an extraordinarily able mother. Georgia later reflected that had her mother lived today, she would have been what is called a really great career woman.

The paternal and maternal grandmothers, Mrs. O'Keeffe and Mrs. Totto, were an intimate part of Georgia's early life. She remembers that "Grandmother Totto, a tall dignified woman, beautiful in bearing, with masses of white hair and most particular ways, kept in her parlor 'whatnots' with fine ornaments. I would play with them and when she would say firmly,

'You must not do that a—gain,' I was so fascinated by her precise way of speaking that I would do it again just to hear her say it."

Grandmother O'Keeffe lived down the road in the farmhouse where Georgia's father was born. She was very kindly, her voice gentle, and she loved beautiful sewing. She wore her hair in a wide brown braid, coiled around her head, and she gave the children all they wanted of her homemade cookies and homemade raspberry jam.

Georgia thought everything about this grandmother, including her name, Mary Catherine O'Keeffe, was very fine, and wished that she had been named for her instead of being named Georgia Totto O'Keeffe, which seemed to her almost a man's name.

And there was "Auntie," the great aunt, Eliza Jane Wykoff Varney, who lived with Georgia's family. Born and bred in a conservative New York set, she had married a Mr. Varney when she was eighteen, and they had left for California in a covered wagon on their wedding trip, in the days when this was a hazardous journey. Often along the route, they saw signs of earlier caravans that had been destroyed by Indians.

Soon after their arrival on the West Coast, Auntie's husband was killed, and she returned East, taking the long sea voyage around South America, and then on to Wisconsin, to make her home with her niece and help bring up her family. Auntie never forgot this primary objective.

The children were never permitted to refer to Auntie's adventures or to her husband's death, but on days when she seemed particularly strict they would speculate secretly on whether her husband had been eaten by the wolves or killed by the Indians. They never found out and it intensified for them the mystery of the Far West.

It was Auntie who supervised the younger children. "I can see her now, standing there with her hands clasped, inspecting her charges. Auntie was the headache of my life," Georgia said, with her usual directness.

In addition to her father, the person to whom her little girl affections went out most was Annie, the blond, buxom, young German servant who lived in. Annie represented the warmth that Georgia did not find in the women of her own family. It was Annie whom Georgia liked and the hired man, August, because he liked Annie.

Early mornings, Georgia would run downstairs to watch Annie lay the wood and light the kitchen fire. Together they would enjoy the colors of

the flames and the sparks as they leapt up. Once Annie started getting the breakfast, Georgia would run upstairs and stay there until the day grew lighter, then dress and come down with the others to breakfast at the long table.

"Annie was important to me," Georgia said. "I longed to go wherever she was working in the house, for no matter how busy she was she would find moments to retell me the fairy tales of Hans Christian Andersen—'The Nightingale,' 'The Fir Tree,' 'The Ugly Duckling,' and 'The Red Shoes'—the first fairy tales I had ever heard."

Georgia enjoyed hours alone on the farm with the velvet moss, the brook, the grass, the glistening dew—all playing roles in her imaginative life. These fairy tales were proof that nothing could bound a world of make-believe.

But taking much of Annie's time was taboo, and so it was really outdoors and alone that Georgia carried on her childhood world. During the years when most children would be playing with brothers and sisters, she was outdoors, alone, sewing, carpentering, constructing a house for the dolls she loved. They were little china dolls, brought to her on every occasion by her aunts; fine little dolls with arms and legs that moved and long golden hair. Georgia made them outfits like the real dresses she saw or like magazine illustrations.

Then she decided to make the dollhouse and to set it down in the pasture away from any interference. Making this house and the things that went into it became her principal interest. She made the house by herself, of two thin boards, about eighteen by twenty-four inches. She sawed over half way up each board, and putting one into the other, she created a house of four rooms with partitions. Then she papered the rooms and made all the furniture. What many families bought or had made for their children, at this period Georgia made for herself.

The house was made so that she could fold it up and carry it wherever she went. In spring and summer she set it in a beautiful shady place among the apple trees. She arranged a park to go with the house, cut the grass, left the tall ragweed for trees, made walks with sand and stones, and with a little pan of water made a wooden boat to put on the lake. For her dolls she made bathing suits. Certain little round seed pods were cheese for the dolls like the cheese that the grown-ups got from the Wis-

consin market. A space with rocks became a national park in which were the castle and everything Georgia ever dreamed of.

The work on the dollhouse was the great creative venture of Georgia O'Keeffe's early life. Even in her most imaginative moments here, she was accurate. One doesn't cut boards or put up wallpaper vaguely.

It is, of course, unusual that the eldest girl in a family of seven children on a farm could have succeeded in being so alone: but Auntie, who had come to Wisconsin to assume full charge of the younger ones, wanted no interference from her, and the more Georgia entertained herself, the more time her mother had for her cherished reading. Sometimes Georgia played with her sisters and brothers, but not in her important moments. She often remembers Auntie's repeated "You naughty child," when she teased her sister Anita, whose "wide open eyes and enormous tears" Georgia thought funny. She felt apart from both the grown-ups and from the younger children, for whom she never had particular responsibility.

But for three meals a day, everyone gathered at a long table: the parents, Auntie, the seven children, the farm help and the Sun Prairie teacher who often lived with them in winter. Theirs was the home nearest to the schoolhouse and Mr. O'Keeffe was on the school board. Here at table the children heard discussion of crops and soil and livestock.

They were brought up firmly. Duty and excellence of work were expected from each. The only punishments—being sent to bed at four o'clock and given bread and milk with no sugar for supper—were not punishments for Georgia, who liked bread and milk with no sugar and being alone in her room. She got no pleasure from disobeying, for home was a good place to her and she liked peace too much to shatter it. She was the only one, except her older brother, to have a room of her own. It gave her a chance to work out many things that she couldn't have done had she shared a room with one of the younger children. Hers was a nice room with gray-painted furniture, trimmed in blue with roses and pansies. She remembers that there was no rose on the bureau where she could have seen it, only pansies; but there was the rose on the top of the bed, where she could not see it. It troubled her, she says, and she would think and think about it as she lay in bed at night. She always wondered if that was the start of what she later called her "flower life."

Nellie, the carriage horse, was hitched to the two-seated carriage every

Sunday and the three older girls, who accompanied Auntie, were driven
to the Congregational Sunday School. They always wore crisp white or-
gandy dresses—Georgia's with a blue sash, Ida's with a red sash, and
Anita's with a pink sash. These, each child would roll up smoothly on
returning home, to be unrolled and worn the following Sunday. Georgia
with characteristic austerity and simplicity thought the sashes unnecessary
since the white dresses were pretty enough without them.

When she was five years old, she started to go to school, walking there
with her six-year-old brother through fields of lady's slipper, fringed gen-
tian and many-colored phlox, and in the winter through ice and snow.
She went to a little one-teacher school which had about thirty children.
Her mother, always particular about keeping the children near home,
had Georgia attend the last grade there twice; she would not allow her
to ride in the crowded school bus to the town school where more advanced
grades were taught. Georgia went to this one school until she was thirteen.

Mrs. Zed Edison, who taught Georgia at this Sun Prairie school, later
said that she was an eager child, full of curiosity. She did not mingle
much with the other children but in class would suddenly speak up with
the most precise, unexpected questions. Among them, Mrs. Edison re-
membered: "If the lake near us rose up, way up, and spilled all over,
how many people would be drowned?" When the questions were not sat-
isfactorily answered, Georgia would say very politely: "Don't bother, I'll
just ask my aunt Lola, she knows everything." Aunt Lola Totto was a school
teacher in Madison.

Georgia was average in her school studies but at recess she excelled
as a good runner and catcher, both of which were necessary in the popular
game "Andy, Andy, over the school house," in which a child threw a ball
over the school house and the child on the other side would catch it, run
around the building and tag someone else. The neighbors said that Geor-
gia could beat most of the boys in running and in climbing trees.

She also had fun making May baskets. In early spring, the children
would make fancy baskets of paper and on the eve of May Day, each
child would go into the fields, pick buttercups, violets and apple blossoms,
fill her basket, and steal after dark to a friend's doorstep, to avoid being
caught leaving the surprise present.

Georgia's earliest memory is "of an afternoon in the late fall in the

brightness of outdoor life" when she was a little over one year old. She was on their Sun Prairie lawn with her mother and a friend of her mother's with a big twist of golden hair, and her brother Francis, not yet three. She remembers how much this blond woman, such a contrast to her own family, impressed her. In her own words: "I was looking all around, at the brightness of the light. I remember the light, our unusually big pillows, the quilt I was on and the ground beyond. It all seemed so new and I started to go toward it. I clearly remember my mother snatching me up and sticking me down in the pillows so that I couldn't get out. I remember my annoyance at not being able to get to the brightness of the light beyond, and my struggle to get there. Years later when I described this, my first memory, to my mother and told her of the blond friend, the quilt, the afternoon and the incident, she was surprised and she said it happened that way."

Another interesting memory was of the time just before she was two years old. The entrance drive was to the left of the large lawn around their house. Georgia was always told most positively to stay inside the hedge, but on this day she disobeyed and toddled to the road alone with great pleasure. She remembers that the color of the dust in the road was very bright with the sun on it and that the road was full of ridges made by their buggy wheels.She was having a fine time when her mother came swiftly around the hedge, picked her up and carried her away from the road where she might have been run over by any vehicle coming around the corner of the barn. What stayed with her was the way her mother took her up, and the fact that she was made to leave the place with the fine sun on it. She had worked to get there by herself, and loved the brightness of the road. She resented the interference and of course was oblivious to the dangers on the high road.

The first drawing in her life that Georgia remembers making, was a little picture of a man lying on his back with his feet up in the air. She used a tan paper bag and made the drawing on it carefully with a black lead pencil. She wanted the man to be very dark so she wet her pencil and pressed as hard as she could. First she tried to draw him bending over but he wouldn't bend right so she turned the paper bag around and to her surprise, there was a man lying on his back with his feet in the air. Although she thought it a funny position for a man to be in, he looked all

right and she remembers her relief. She says that she kept that drawing for a long time, as it represented something she had really worked on, and she looked at it again and again.

When Georgia was eleven, she and her two younger sisters were sent to take private drawing lessons from the teacher who taught regular subjects at the little country school. Their mother was eager that all three older girls should know how to draw and to play piano.

The teacher had each of them get a Prang Drawing Book from which they learned about the perspective of a cube, the shading of a sphere and the drawing of a spray of oats. On winter nights and Saturdays, at the end of the long family dining room table, the three little girls worked for hours at their drawing lessons.

The next year their mother had the three girls taken into the town of Sun Prairie every Saturday afternoon for private painting lessons with Mrs. Mann who taught art. She showed them pictures to choose from and they copied them, painting them in watercolors. Georgia especially remembers two of her copies— "Pharoah's Horses" in sepia, and "Pansies" in color. Most of Mrs. Mann's pupils worked at china painting, but the three O'Keeffe girls were allowed to work at "free hand painting." They looked forward greatly to their lessons, and between times would draw and paint diligently at home.

Georgia remembers most vividly a lighthouse that she copied from her geography book at home. "I had never seen a real lighthouse. I drew it on a long point of land extending into the sea. I had never seen the sea. My paper seemed empty, so I drew a horizon line and put in some palm trees. I had never seen palm trees. Then the sky seemed empty so I drew in a sun. I painted the sun yellow, the sky and water blue, and left the lighthouse white. I could not make my sun as bright and shining as I knew it was. It seemed dull against the fine sky. The more yellow and pink I put on the sun, the less bright it looked. This disturbed me so I began all over and made another lighthouse painting, but this time with a cloudy sky, and in contrast the sun seemed a little brighter. As I remember it now, it finally became a moon. This painting I kept. It has followed me all through life. I still have it."

Another picture important to her was done from the window of an upstairs room. The teacher who stayed with the O'Keeffes during the winter

was in the room, writing and paying no attention to Georgia, who was busy drawing what she saw out the window—a tall, pointed spruce tree in the yard and, beyond the road, a buroak, black against the snow.

Across the field was the outline of another big oak tree and the soft line of the woods. It was Georgia's first concentration on thick snow on a bright moonlight night. After she had drawn it, she wanted to paint the tree, which seemed so black against the snow in the moonlight. Because the whiteness proved too great a problem, she left the white of the paper to signify the snow, and as the picture looked empty, she put in a road passing the house. She remembers working very hard on that picture and feeling that it was a great improvement to add the imaginary road. As early as this, reality was consciously changed by her own imagining.

The copies that she made with Mrs. Mann and the other pictures that she made later when she went off to school were framed by her mother and hung on the wall. But to Georgia they were not satisfactory. Those pictures are now lost, but she kept the two early pictures—the lighthouse and the snow landscape—that she did alone and worked on so hard.

Here an experience occurred to which Georgia attributed a great part of her lifetime of painting. Her mother and a neighbor, Mrs. Crippen, who lived several miles down the road, were in the habit of lending each other books, particularly those they had received from a distance. That day Mrs. Crippen had driven over in her buggy with a set of books she had just received. The visit over, Mrs. O'Keeffe sat down to read and Georgia picked up a volume. On one of its pages she saw a pen and ink drawing of a girl with beads around her neck. It was just about two inches high, and under it was the inscription: "The Maid of Athens." It was romantic and yet it was real, and it struck her as had no drawing before. For as long as the book was in the house, she looked at it again and again. In her own words, "I believe that picture started something moving in me that has had to do with the everlasting urge that makes me keep on painting."

Before Georgia was twelve, the year that she was finishing the eighth grade, she was looking out of a high side window of the country school house at recess with Lena, their washerwoman's daughter, a little older than herself. She remembers that it was a dull day, the grass was dry and brown, and all the other children were outside playing a game. Georgia asked Lena what she was going to do when she grew up. Lena

said she did not know, and Georgia remembers saying with finality, as if she had long thought it out, "I am going to be an artist."

It was the first time she had said these words and she remembers that she did not have a clear idea of what being an artist meant. She only knows that by the time she had said it, the fact was definitely settled in her mind.

Up to that time, aside from the "Maid of Athens" drawing, she does not remember any pictures that had particularly interested her except a Mother Goose book printed on cloth, her school tablet cover with a picture of a little girl with pink roses, and a painting of fierce Arabs on horseback, that hung in her grandmother's parlor.

From this time on, whenever she was asked, she would say, "I am going to be an artist." And it became an important idea to her for the remainder of her Sun Prairie years.

# MADISON: 1900-1901

*T*HE autumn she turned thirteen, Georgia was sent away from Sun Prairie for her first year of high school. Her family had selected the academically excellent Sacred Heart Academy, a Dominican convent school, located twelve miles from Madison, where her mother's sisters lived. Georgia left behind her precious dollhouse, the preoccupation of many years; years later her younger sisters discovered it together with the handmade doll clothes she had kept in a red tin tea box.

Excited by the prospect of new things, Georgia was glad to go away. During the course of this year she was to learn more than at any other time in her school days.

As was the case with several other Protestant girls, she was to attend this school for the diversified education their mothers felt they would receive. Although being with strangers was a new experience, she accepted it quite naturally. She was most attentive to the sisters' teaching even though it was understood that she was not taking part in the school's doctrinal life. They allowed her to walk in the woods and along the lake at chapel time, so long as she got to class when the bell rang.

In addition to her other lessons, she was scheduled to take drawing and on her first day she was sent to the studio on the top floor. An incident that day made a lasting impression on Georgia. The sister in charge of the studio placed a plaster cast of a baby's hand on the table near her. She was given some charcoal and told to draw it. There was one other

girl in the big studio, and she, too, was to draw the cast. The sister left them alone in the room. Georgia worked steadily and long, trying very hard to draw the baby's hand with a clear black outline—and small as she felt it should be. When the sister came back, she came over to Georgia and told her that the hand was much too small and the lines too heavy. Georgia remembers blushing and keeping back her tears with difficulty.

The sister drew a few large, light lines, blocking them in, the way she felt the drawing should be. It looked very strange to Georgia who was not at all convinced that a baby's hand should not be small as she had drawn it. At that moment she said to herself that never again would she draw anything too small.

She was told to draw the hand over again, and this time she drew it a little larger than the sister's sketch. That whole year she worked with a hard pencil to avoid making heavy black lines and drew everything larger than she thought it should be. "It always seemed to be stretching me," she says. However, when the June exhibition of the students' best art work was put up, to her surprise there was a whole wall of her very pale drawings of casts. She had not signed any of them, but she found that the sister had written G. O'Keeffe on each of them in a big free hand, writing with a lead pencil much darker than the tone of the drawings.

When she returned home that year, she told her mother that she had been awarded the medal in drawing. When there was no reply, Georgia continued: "Most of the girls didn't get medals in drawing." Her mother answered: "Why shouldn't you get a medal? I would be surprised if you didn't."

The following year, at fourteen, Georgia changed schools again. She and her brother Francis were sent to live in Madison with her mother's unmarried sisters, Miss Lola Totto, a school teacher, and Miss Ollie Totto, a librarian, who had their own home on Madison's Lake Mendota. During the winter, Georgia loved walking the mile through the deep snow to and from the public high school she attended; and she loved ice boating on the lake after school. She worked hard at her studies and the aunts, who had high standards of what young people should accomplish, were very pleased.

In this, her second year of high school, she had private lessons in drawing as well as in music and worked at both seriously. Her school schedule

did not include art lessons but sometimes she would visit the art class and on one such visit the art teacher was standing in front of the class, holding up a jack-in-the-pulpit that the students were to draw. The teacher pointed out the flower's strange shapes and its variations in color—from the deep almost earthy violet color through the heavy green of the leaves. She held back its purplish hood or flap, and showed the students the jack inside. Georgia had seen jack-in-the-pulpits all her life, but this was the first time she remembers examining a flower so closely and having her attention called to the outlines or color of a growing thing with the expectation of her drawing or painting it.

Maybe it was this lesson, she feels, that started her looking at details so carefully. Maybe she would have done so anyway. Strangely enough, she does not remember drawing or painting the jack-in-the-pulpit that day, but she does remember the flower in the teacher's hands and how impressed she was with what the teacher said about that particular flower's form. That flower lesson seems to have stayed with her always and to have influenced her detailed seeing.

While Georgia was living with her aunts, visitors who came to call would ask her the standard question, "What are you going to be when you grow up?" Georgia never deviated from her original answer: "I am going to be an artist." To the next question, "What kind of artist?" she had difficulty in replying. When she was asked: "An illustrator?" or "a designer?", having no clear idea of what various types of artists were supposed to do, she would answer, "A portrait painter." For in her home in Sun Prairie there were two large handsome portraits in oils of her great-grandparents, Charles Wyckoff and Aletta Field Wyckoff, as well as a crayon portrait of her grandmother, and another of her mother. Thus, portrait painting occurred to her as an answer, but not, she says, as a way of working; and she just continued with the general idea of being an artist.

In her early teens, when her matter-of-fact Aunt Lola would say, "If you're a portrait painter, you'll have to paint anyone who wishes to be painted," Georgia would reply that she intended to paint only what she liked to paint. Her aunt would continue, "You can't make a living that way." But Georgia did not lose confidence that she could.

An old gentleman friend of the family, hearing that Georgia wanted "to be an artist," framed and brought her a meticulous little painting that

her Grandmother O'Keeffe had done—a little watercolor, shaded with hairlines, of a plum with a stem and two leaves. She also remembered another little painting of her grandmother's—a thorny moss rose rendered in the same detailed manner. As an artist, whatever she did, she would not paint in this style.

When the time came to leave Madison, Georgia had not only firmly resolved to be an artist, but also knew the kind of artist that she did not wish to be.

# WILLIAMSBURG: 1901–1905

EORGIA was fourteen years old when her parents left Sun Prairie in 1901 and made the great move to Williamsburg, Virginia. Leaving Sun Prairie and his prosperous farm was not easy for Mr. O'Keeffe. But he had overworked and was not well, and he had been advised to seek a warmer climate—Wisconsin winters were cruelly severe.

Those who have known Williamsburg only since its restoration will find it hard to imagine the peace of the sleepy little community in the early 1900s with its population of about 2,500, the complete absence of tourists, its mud roads, its principal buildings little changed since the end of the Revolutionary War. Its manners and customs were very much as they had been in the Old South before the Civil War.

For the O'Keeffe family, Williamsburg again meant the land, a farm, and a spacious house in a community also choice in its standards but so different in customs and tempo. Because of its beauty and historic interest, Mrs. O'Keeffe was attracted the moment she saw it. Also, the College of William and Mary would be at their door for Francis, who would soon be of college age. When the family moved there, the large gardens surrounding the residences were outlined by great boxwood hedges and fragrant flowering syringa or lilac bushes. They found a large piece of land to their liking on Scotland Street, Peacock Hill, near the College and Duke of Gloucester Street, Williamsburg's principal thoroughfare. On it was a white frame residence, known as the Wheatland House, which was almost a duplicate of their Sun Prairie home, but larger, with two great

WHEATLAND HOUSE, ON DUKE OF GLOUCESTER STREET,
THE FIRST HOME OF THE O'KEEFFE FAMILY IN
WILLIAMSBURG, VIRGINIA

porches, steps to the side, and impressive, wide stone steps in front. The big circular driveway cut through a huge rising lawn where, soon after they moved in, a pet sheep would picturesquely graze. There were big oak and hackberry trees and mock orange bushes with white blossoms. Mrs. O'Keeffe gloried in the roses that seemed to bloom everywhere, especially a climbing white rose that covered the front of the house. Roses bloom in Williamsburg as late as Christmas.

Williamsburg was a place where almost no outsiders came to settle and where almost none of the natives ever left. Evenings, the whole O'Keeffe family would take the town's customary stroll, the length of the Duke of Gloucester Street from the college gate to the Capitol grounds. In the daytime there was buggy riding. The older girls were allowed to drive the surrey—its seats back to back, piled full of children—to picnics on the edge of town or the seven miles to the James River. The family horse named Penelope, but called Pen-a-lope by the neighboring children, and Rigor, the liver-colored pointer, who followed after, were long remembered by the playmates of the younger children.

While the O'Keeffe girls differed from each other in tastes, they shared strong family characteristics. The older ones were popular with the college set, Georgia was the quiet one, and Anita, strikingly handsome, with her dark hair and cameo-like features, was often chosen to lead the college dances which were important social events. Georgia once said to me that no girls ever had a pleasanter time than they did when they were growing up.

And certainly no boys ever had a more pleasant time than some of the young gentlemen whose families had chosen to send them to the College of William and Mary. Georgia's brother Francis, by nature an aristocrat like his mother, often brought his college friends home for weekends. Students lived on campus, or in good homes, for very little money.

Earl Baldwin Thomas, who graduated in 1913 and was a friend of the O'Keeffe girls during his college years, recalls that room and board in town then cost about twelve to fifteen dollars a month, a whole sweet-potato pie could be bought for a nickel and the delicious and plentiful oysters from the James River were brought around in an ox cart and sold before the sun was high by an old man who had a special street cry.

With Francis settled in the College of William and Mary, Georgia, then

fifteen, was sent to the Chatham Episcopal Institute in Chatham, Virginia; Ida and Anita, just old enough to be sent away to school, were to go to another boarding school, and the three younger children were of course kept at home.

Books had become important to Georgia, and the high point of her first summer in Williamsburg was reading Washington Irving's *The Alhambra* in her mother's library. She loved its romance and its soft purple leather binding—so lovely to touch. This book carried her beyond reality, as had the Sun Prairie dollhouse of her early life, and it brought Spain close to her, where it always remained.

Chatham, now a fashionable, expensive girls school, was then modest in its fees. There, in an atmosphere so different from that of her earlier schooling, Georgia had the equivalent of her last two years of high school.

Christine McRae, later Mrs. R. Preston Cocke of Williamsburg, who was in Georgia's Chatham class, recalled the first night that Georgia walked into the study hall where the girls had assembled. "We noticed at once," she said, "her absolutely plain suit coat of exceptionally good material, which fitted her loosely, was a contrast to the tiny waists and tight-fitting dresses with ruffles that the rest of us wore. Pompadours and elaborate bows were then the fashion, but Georgia's hair was drawn smoothly back from her broad forehead, and one small bow was tied at the bottom of a long braid to keep it from unplaiting."

Georgia began—at least mentally—to specialize in art, but she was so interested in music that in addition to her full schedule of schoolwork she practiced the piano for three, sometimes four, hours a day. She used to go over and over her pieces "to get them with a certain speed and strength," she said. She was said to have played extremely well.

The principal at Chatham, Mrs. L. May Willis, also the art teacher, recognized Georgia's abilities at once. Georgia felt that she might have been a difficult pupil for the average person, but that Mrs. Willis understood her, and was not only her art teacher but her friend.

The big studio at Chatham, with its well-worn board floor and white cracked plaster walls, became Georgia's home. The girls who did china painting, the usual accomplishment of the day, used the long table down the center of the room, while Georgia and a few others who "drew and painted free-hand" had individual tables.

Georgia remembers two of her paintings from that time: one, a large bunch of purple lilacs, the other, some red and yellow corn, both on Whatman paper, painted by the wet paper method. She had begun to work with great freedom on whole sheets of paper with a large brush. The red and yellow corn was her best painting and when she graduated from Chatham, the school asked to keep it.

The girls admired her for the many things she could do well, but it was in the studio that she was queen. Mrs. Willis said frankly that she had never seen such talent and Mrs. Cocke said that the girls at Chatham expected her to be the greatest artist in the world, and that their eyes would widen with admiration when Georgia would draw a pencil sketch of one of her schoolmates. It "would be as like her as a photograph," and after completing it, Georgia would crumple it up and toss it into the stove, saying, "I don't want any of those pictures floating around to haunt me in my later years."

Mrs. Cocke remembered that Georgia once declared very earnestly, "I am going to live a different kind of life from the rest of you girls. After we are through school, I am going to give up everything for my art." And Mrs. Cocke added, "I realized then that nothing was going to stop Georgia—that she meant it when she said this."

Georgia, however, was full of mischief in her high-school days; had she received one more demerit in her graduating year, she would have been expelled. In one semester, she was so interested in English that she almost failed the other subjects. Another term, she did so badly in spelling that Mrs. Willis told her that in order to pass she would have to spell seventy-five words out of one hundred on the first try. She studied hard and spelled seventy-six words correctly.

Outwardly demure, but a rebel by nature, Georgia had a way of ignoring the fact that rules existed. For example, she taught some of the girls to play poker, unsuspected by the authorities. Afternoons, everybody in the school walked with a teacher, but often on their return, with or without permission, Georgia and her friend, Susan Young, would start out again.

Rarely did a day go by at Chatham when someone did not think it strange because Georgia O'Keeffe was doing something her own way. She was the only Northern girl at the school, and when her classmates

would laugh at her rolled "r" in "carnation," or her midwestern twang when she said "house," it did not worry her at all, for she spoke as other members of her family spoke, and that was sufficient for her. Her mother's tremendous confidence in her children resulted in their having no desire to be like anyone but themselves and members of the O'Keeffe family.

School to Georgia at this time meant art, music and her walks. "The best things during my fifteenth and sixteenth years were my walks in the Virginia hills, with the line of the Blue Ridge Mountains on the horizon calling me, as distances have always called me," she said.

Because of her love of nature and Mrs. Willis's appreciation of her unusual talent, she did not lose her sense of freedom or wonder or her desire to explore, as so many do during their high school years. In her final year at Chatham, Georgia, then sixteen, was chosen to write the class prophecy. Six years after graduation, Mrs. Willis telegraphed to Georgia in Williamsburg to ask her to come to Chatham to teach art in her place for three months, which she did. In later years, Mrs. Willis, then an elderly woman, traveled to New York again and again to see the annual O'Keeffe exhibitions.

When vacation time arrived, and the older O'Keeffe girls returned to their Williamsburg home after their second year in Virginia, they realized that their father was intensely worried. Moving a whole family and its possessions from Wisconsin had used much of their capital and his new farm ventures in Virginia had not gone well.

Of her father, Georgia once said that in Wisconsin in the early days, "He was like a ship, floating on the water, that takes the waves." Never a businessman, it was to growing things that he had always given his allegiance, but now in such a different situation, he seemed beaten. He tried many ways of succeeding. When the land he farmed on the road to Jamestown did not prosper, he bought a molding machine to utilize shell deposits from the river to make construction blocks —a similar idea brought large returns to industry after his death. But here, too, there was greater outlay and greater loss. His days of farming were over; in spite of his perseverance, nothing seemed to succeed.

In 1907, six years after the family arrived in Williamsburg, and when Georgia was twenty, the O'Keeffes sold their first Williamsburg home, keeping a strip of land to the front and side. They moved to the Travis

House, built in 1765, situated on Francis Street near the college. It was a large house with six dormer windows, a narrow gambrel roof and a long porch encircling the ground floor. The Travis House was one of the houses restored as part of Colonial Williamsburg.

With her characteristic stamina and without any discussion, Mrs. O'-Keeffe began to take in boarders. Some of Francis's college friends who had stayed with them often, now came to board for pay, helping do the chores. To Georgia, it was like having more brothers.

Mrs. George F. Coleman, a rare woman, whose husband was road commissioner for the Commonwealth of Virginia, and who lived in their ancestral St. George Tucker house facing the Court House Green, knew Georgia O'Keeffe in her late teens. Mrs. Coleman was then a young married woman and Georgia was a friend of both Mrs. Coleman and her young daughter. One day Mrs. Coleman was having a terrible time with a savage laying hen that she was trying to get off her nest. No one dared touch the hen, but Georgia, who had stopped in to pay a visit, offered to help. With quiet and strength, Georgia lifted the hen off her nest in spite of her fighting. When they came into the house, they were still laughing over it, Georgia bubbling with gaiety. "After she left," Mrs. Coleman said, "my observant mother, who was Scotch and not given to compliments, said quite simply: 'If I were a man, I'd fall in love with that young woman at first sight! She is beautiful to look at and so full of spirit.'"

In her youth, however, marriage never seems to have been discussed by her parents as the goal for Georgia. Mrs. O'Keeffe and Georgia greatly admired those who succeeded in their chosen fields and in the early 1900s, to combine a career and marriage was unusual—particularly in Williamsburg. Georgia nevertheless had a good time socially with the young people of the college set.

By this time, Georgia was considered the community's rising young artist. She drew skillful pencil portrait sketches of her friends with great ease—excellent likenesses of beautiful delicacy. Mrs. Coleman said that Georgia, when about nineteen, sitting on the porch of one of the college buildings, sketched the young woman who was addressing a group of students. Knowing that this young woman was soon to marry Mrs. Coleman's brother, Georgia presented the drawing to Mrs. Coleman. This portrait of his wife hung in the home of Mrs. Coleman's brother, Professor Robert

TRAVIS HOUSE, BUILT IN 1765, ON FRANCIS STREET NEAR
THE COLLEGE OF WILLIAM AND MARY, WHERE THE
O'KEEFFE FAMILY MOVED IN 1907—NOW PART OF
COLONIAL WILLIAMSBURG

Burns Haldane Begg of Blacksburg, Virginia, all his life; it was a remarkable likeness and one of his most cherished possessions.

In 1938, decades after the O'Keeffe family had lived in Virginia, the College of William and Mary notified Georgia that it was to confer the degree of Doctor of Fine Arts upon her, "for the Revealing Insight, Strict Integrity and Supreme Artistry of her work." The citation also declared: "Williamsburg may well find a grateful bond in recalling that in its quiet atmosphere her talents for vision and craftsmanship were first given an opportunity to mature."

To receive this degree, Georgia and her sister, Anita Young, returned to Williamsburg where they received a heartwarming welcome. Eight of Georgia's paintings, lent for this event, were on exhibition in the college's Phi Beta Kappa Hall. At the opening, one of the ladies of the city looked at a large flower painting and commented, "I've never seen flowers like that." The elderly Mrs. Coleman, Georgia's champion from her younger days, entranced with the painting's rich colors and imaginative shapes, retorted, "It's a pity that you haven't."

# CHICAGO AND THE ART INSTITUTE: 1905–1906

UPON her graduation from Chatham at seventeen, Georgia was eager to continue her studies. Her parents decided to send her from Williamsburg to the Art Institute of Chicago, for if she was going to be an artist, they wanted her to have the best training they could find. Her aunts, Lola and Ollie, and Uncle Charles Totto had moved from Madison to Chicago, which meant she could live with them and be cared for. Their home was near enough to the Art Institute for her to walk to classes each morning. She took the great adventure of traveling from Williamsburg to Chicago calmly. There was excitement in the Chicago family about the visit of their young niece. Uncle Charles went everywhere, and took Georgia with him. Twice each week he bought tickets to plays, and sometimes ballets and musical comedies, in seats that were never back of the fourth row in the orchestra. Georgia says that going to the theater with him was a hard thing to do, feeling that if she wanted to be a good painter, she should work at it day and night. That was why she had left Williamsburg and had come so many miles.

On her first day at the Art Institute she was sent to one of the huge, dark galleries to draw in charcoal a headless, armless plaster torso of a man. The place and the study seemed frightening to her—not at all what she had thought studying at a real art school would be like. A boy in her class came out of the recesses of the cold spaces, looked at her pale drawing, and invited her to come and see his lively drawing done in heavy black lines with shadows. She had tried to make hers neat and faint, the

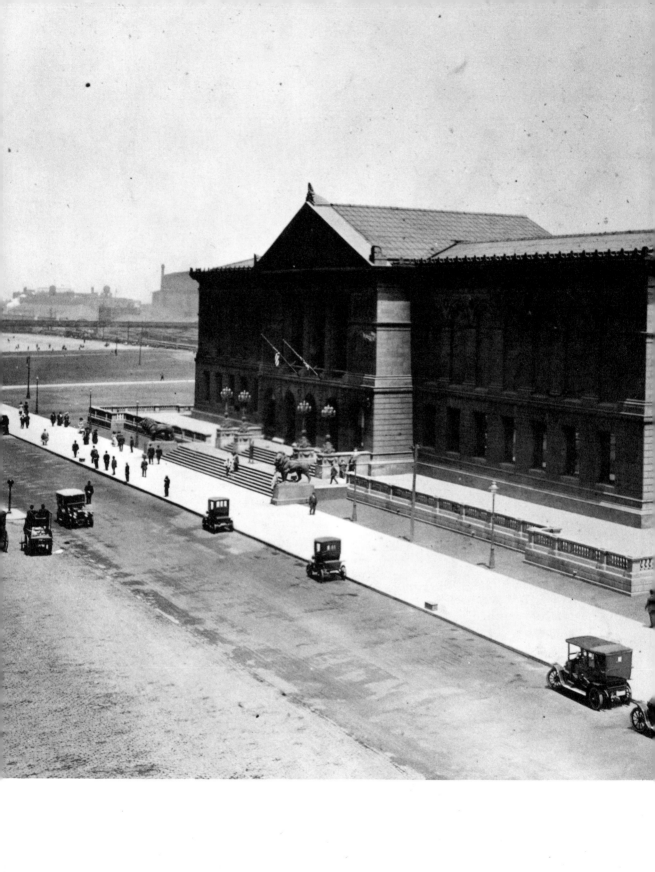

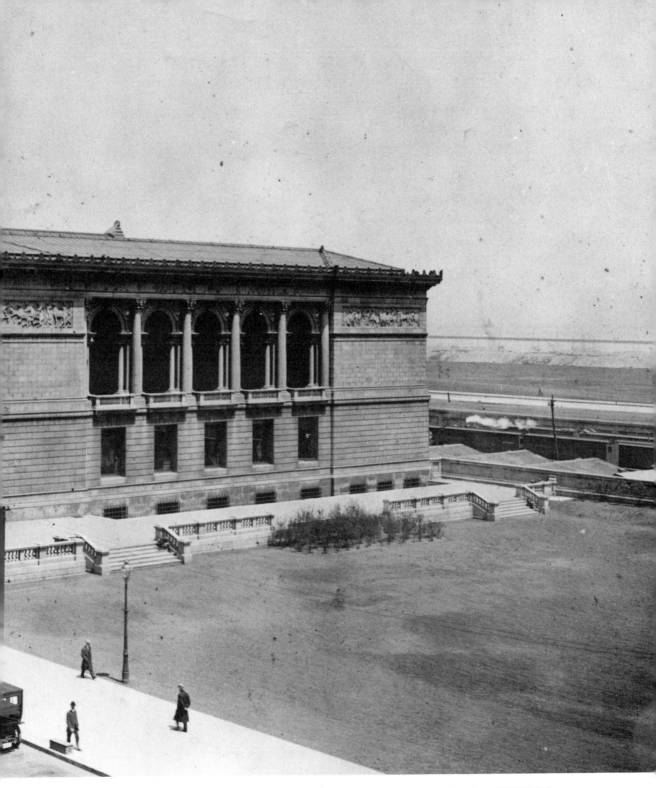

THE ART INSTITUTE OF CHICAGO,
CIRCA 1908, ABOUT TWO YEARS AFTER
O'KEEFFE ATTENDED CLASSES THERE

way she had been taught. He managed to convince her that he knew far more than she did; therefore she was very puzzled, when the institute's first monthly competitive exhibition took place, to find that her drawings got much better marks than his.

Then came her first lesson in anatomy. This class was held in one of the half-lighted rooms then considered good enough for art students. The room was overcrowded with many standees. Suddenly, the teacher stopped lecturing and said: "Come out now." From behind a curtain there walked a lean man who was—as in every professional life class—naked except for a loincloth. Georgia, one of the youngest pupils at the Institute, had not anticipated this. She remembers her sense of sadness that an unhappy-looking man was paid to stand in front of them. She says that she turned away from the teacher and from the model. At home the girls and boys went swimming in the river together and all was so joyous and sunny and friendly. Here, all was dark and dismal, the model sad, and the class forbidding.

Suddenly she felt she had very little in common with the other students. When the lesson was over, she left the room with a sense of suffering. The weight of her resolution to be an artist now overwhelmed her; home and all that she had always believed in seemed too good to have left.

Until the second lesson the following week, she thought of little else except whether to return to the class or to leave. She spoke of it to no one. She still wanted to be an artist and that meant studying anatomy. For the time being she could work on casts, but in time she would be promoted to a life class. So, utterly miserable, she reasoned to herself about what she·would have to face to be an artist. It was the first big decision she had to make in art.

By the time the following Wednesday had arrived, she had decided to continue. She went stoically to class and to every succeeding lesson to draw the nude model.

The lectures by John Vanderpoel on the human figure became significant events in Georgia's Chicago life, as he was one of the country's most eminent draftsmen and one of the greatest teachers of his day. She bought his book, *The Human Figure*, and studied it thoroughly. She remembers him as being "very kind." As he lectured the class in the large auditorium on the structure of the human figure, he made large drawings with white

and black crayons on huge sheets of tan paper.

In the first month of her work with Vanderpoel, one of her drawings of the human figure was given number four in the monthly concours, or competition of work from all the life classes of the Institute. She remembers her astonishment that her drawing was thought good.

Her year at the Chicago Art Institute over, she returned to Williamsburg. One of the college boys who was boarding with the O'Keeffe family had sailed a fruit boat between Venezuela and British Honduras and his talk of sailing had filled them all with a desire to live near the water, so the family rented an old house and a sailboat on the York River for the summer. It was a wonderful vacation.

When the O'Keeffes had money they had always lived well, and now, although times were hard, the parties and dances and gaiety continued. In spite of financial difficulties, Mrs. O'Keeffe's optimism never flagged.

The holidays at home seemed a healthy and amusing vacation for Georgia whose career was yet to start in earnest. "I remember," she said, "that after my bleak winter in Chicago, my walks in the Virginia country seemed the most important things that could happen. In Williamsburg, in spring, the countryside had a gentle kind of liveliness, the grass was full of pink and blue hyacinths, stars of Bethlehem, jonquils and crocuses, and on the way to Yorktown, we picked the yellow flowering Scotch broom which grew abundantly along the roadside."

Georgia continued to draw and paint and was regarded as a young person of promise by those who knew her in Williamsburg.

# NEW YORK AND THE ART STUDENTS LEAGUE:
## 1906–1908

*a* FTER the year in Chicago and back in Williamsburg with the family, Georgia became gravely ill with a difficult case of typhoid. A large part of the following year was spent in recuperation. She learned what it was to have a whole family tip-toe in and out, greatly concerned about her. As she recuperated, on good days she could be carried downstairs to lie in the hammock under the big trees. Her long straight hair had been cut very short during the fever and afterward it grew out in a thick crop of chestnut brown curls.

When she was well enough to continue her studies and restless to begin them again, it was decided that she should enroll at the Art Students League in New York City, which was nearer to Williamsburg than Chicago. Her brother Francis, who was studying architecture in New York, could look after her.

Georgia was now twenty. Sun Prairie and Williamsburg were the only places she had cared for. Nothing in Chicago had given her the pleasure that life in those small places had given; but as she was more and more determined to be a good artist, she wished to go to a good art school.

In a rented room near the league on West Fifty-seventh Street, Georgia lived with Florence Cooney, a friend. Her studies in New York meant a sacrifice for her family and so she tried to make each moment there count. She studied with two of the best teachers of the day: William Merritt Chase and F. Luis Mora, working with Mora mornings. She remembered Mora later as a handsome, slim young man who drew hands and heads and

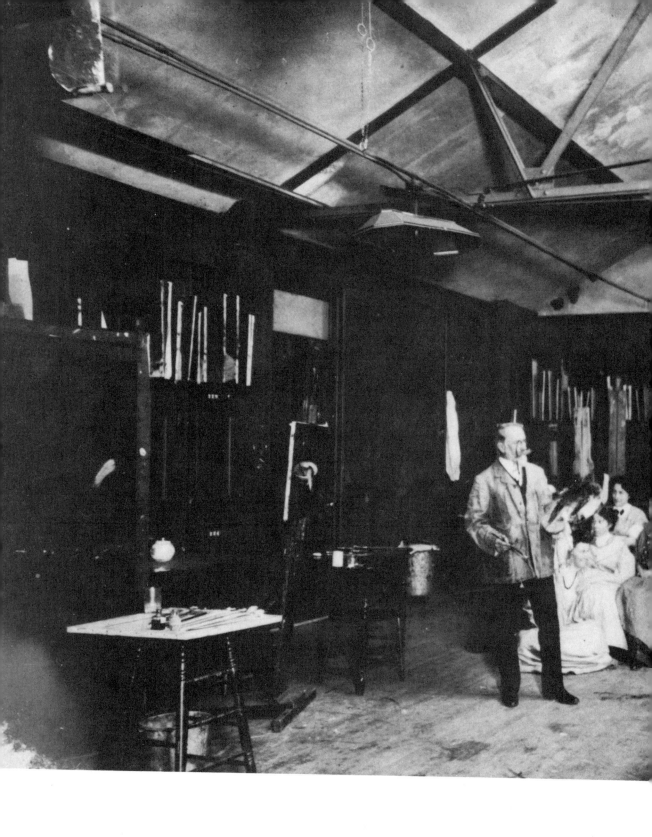

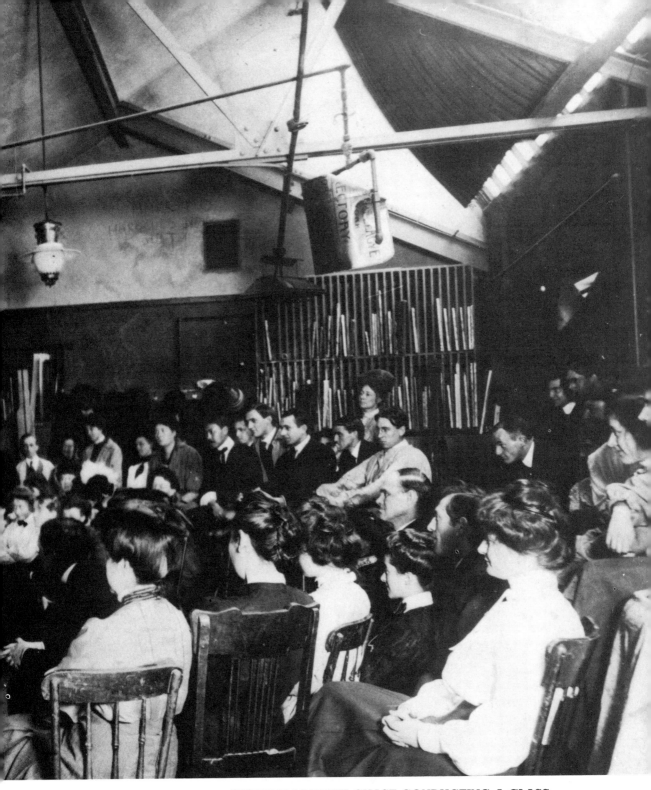

WILLIAM MERRITT CHASE CONDUCTING A CLASS
AT THE ART STUDENTS LEAGUE OF NEW YORK IN
1907. GEORGIA O'KEEFFE IS PROBABLY ONE OF
THE STUDENTS IN THIS PHOTOGRAPH

feet along the margins of the pupils' work. She said she found out later that he always drew sketches that seemed to be pictures of his wife, no matter what kind of model the class had.

She had drawn from life, but this was her first year of life painting. Two canvases that she made in Mora's class continued to stand out in her mind. One was of a man seated on a stool, bending forward. She remembers her desperation at the dual problem of getting the man to sit and bend at the same time. The second was of a man standing with his back turned to the class. Georgia had prepared her canvas with a white preparation brought by a fellow student. It was the first time she had used such a preparation, and it made her color exceptionally bright; she took the painting home and put it in her window to dry. That evening, while visiting a student across the street, she happened to look over at her own window and was astonished to see her painting. It was in startling contrast to the dark things done at that period. She remembers the pleasant impression that this new freshness made upon her.

Afternoons she attended the classes of William Chase. This aggressive realist with a tremendous ability in painting was a romantic figure to his entire generation. Georgia later said to me, "There was something fierce and exacting about Mr. Chase that made painting with him gay and exciting. Every day he had each of us paint an entirely new still life. Once a week, he came in to criticize our paintings. He always arrived at the League wearing a high silk hat, a fine brown suit and light-colored spats. His love of style, of color and of paint itself was great. We would all listen with great attention and respect while he criticized each student's work. He had a kind of dash and go that kept his students keyed up and looking for the exciting in paint. I loved the color in the brass and copper pots and pans, the peppers and onions, and other things that we painted for him on the slick canvases with sometimes eight or ten layers painted one over another. Chase was always stressing the use of pigment and the beauty of oil paint. To interest him, our canvases had to be alive with paint."

Chase's love of paint for paint's sake combined with his respect for style undoubtedly made a deep and lasting impression upon Georgia. Although she was one of the two youngest students in his class, she won the coveted first prize for still life.

PORTRAIT OF O'KEEFFE BY EUGENE
SPEICHER, PAINTED IN 1905 WHEN BOTH
ATTENDED CLASS AT THE ART
STUDENTS LEAGUE OF NEW YORK.
COLLECTION: ART STUDENTS LEAGUE
OF NEW YORK

One day, someone took her into the composition class. She was struck when she discovered that she did not think much of the compositions that were put up for criticism. This made her think that she would try to make a painting that she herself would really like, regardless of what anyone else thought—a most unusual position for a student in those days.

It was at this time, on a beautiful clear night in spring, that a group of the league students, Georgia among them, walked up Riverside Drive. Near the Soldiers' and Sailors' Monument, they sat down on the grass at the foot of two tall poplar trees. The foliage was thick and dark. The grass was bright in the moonlight. The river was below them—lights twinkled from the Jersey side. Georgia knew she must remember it until the next morning and see if she could paint it. She studied the outline of the trees carefully and the uneven openings where the sky came through. The next morning she painted the trees against the sky, the grass and the water. It was the first painting that really meant something to her.

She showed it to one of the boys in the group whose paintings she thought very good. He said her trees did not have enough color, that she should have painted them with spots of red and blue and green, like the Impressionists. He explained to her about Impressionist painting, of which she had not heard before. She tried to tell him that she had not seen any spots of red and blue and green. While he talked, he painted on her canvas on the very tree that she had liked so much and had painted rich and dark as she had seen it. Georgia felt that he had spoiled her painting. When she got back to her room, she worked on it again but she remembers her disappointment at being unable to recapture the feeling of the night or the tree she had painted. She kept this canvas for years because it represented an effort toward something that had personal meaning for her, much more meaning than the subjects selected for her by the school. It represented feeling that had to be expressed in her own way. She realized, too, that the feeling of the night was very different for different people.

Georgia was a great favorite at the league. A sculptor, Alice Morgan Wright, also a student at the league at that time, said: "Patsy O'Keeffe, as she was called, a pretty, dark, curly-headed young girl, was the pet of the League whom everyone wanted to paint."

There was hardly a week when someone did not want to paint her

portrait. One tale of this 1907-1908 period is amusing because of the later eminence of the two painters concerned. On a Monday morning, as usual, she had climbed the stairs of the league for the life-painting class. There, on the top step of the highest floor, under the bright daylight from the skylight above, sat Eugene Speicher, a fellow student who was later to become a well-known portrait painter.

He laughed good-naturedly and said he wanted her to pose. She had refused him many times before when he had asked her, not seeing why she should sit still and lose time while he worked. It never occurred to her to feel flattered. She tried to go to class but Speicher, who badly wanted to paint her portrait, said she could never be much of a painter anyway for women could not paint; that she would, at best, only teach art in some girls' school, while he would become a painter. Georgia thought it strange that he was so sure about her but she agreed that after going to class, if she didn't like the model, she would return to be painted by him. Speicher, a few years older than O'Keeffe, consented.

The class model was middle-aged and he seemed so uninteresting to Georgia that she went back to pose for Speicher. What he wanted to paint was so clear that he put it down in that one sitting—a pale young girl with finely etched eyebrows and dark curls. Speicher won a prize for this painting.

During this time at the League, Hilda Belcher was making a portrait to send to the New York Watercolor Society. It was completed except for the face and hands. She asked Georgia to pose, and the portrait, known as *The Checkered Dress*, won a prize. It is a classic study from that period.

At the close of the league year, Georgia was awarded the coveted Chase scholarship for her still life painting, *Rabbit and Copper Pot*, which was reproduced in the league catalog. As a scholarship student, she was chosen to go to the League Outdoor Summer School at Lake George, New York, with its mountains and lake, where the Spencer Trasks had given the use of their estate. Less than thirty students were selected.

Georgia, known for her dependability, became a leader of the group. She was interested in painting and loved the outdoors. Up to now, she had been taught by strict and excellent teachers to paint copper bowls, human beings and still life, but she had never painted trees, mountains or a field of daisies, and they seemed more wonderful to her than anything

ABOVE: *RABBIT AND COPPER POT* (1907),
FOR WHICH O'KEEFFE WON THE CHASE
SCHOLARSHIP AT THE ART STUDENTS
LEAGUE. COLLECTION: ART STUDENTS
LEAGUE OF NEW YORK

RIGHT: *THE CHECKERED DRESS* (1907)
A WATERCOLOR PORTRAIT OF
O'KEEFFE BY HILDA BELCHER. 22 X 16 IN.
COLLECTION VASSAR ART GALLERY,
POUGHKEEPSIE, N.Y., BEQUEST OF
MARY S. BEDELL.

she had ever painted before.

She enjoyed that summer. The work was stimulating and there were two young league students who were very fond of her and when the work was over, they would go out rowing on the lake. One of them didn't care who came along, but the other was furious if anyone did. One night as he rowed across to the village, he was so angry that he sulked all the way, thinking of the boy who had not even come along. After shopping for provisions, Georgia and he went back to the dock only to find that someone had stolen their boat. This meant a walk of at least two miles to the foot of the lake. The young man was still furious. Georgia stumbled along in the dark beside him carrying a large package of supplies. She was so upset that she stopped suddenly. Looking across the marshes, with tall cattails, she saw a patch of water, more marsh, then the woods with birch trees, shining white at the edge beyond. She realized for the first time that a landscape could look just as a person felt—gloomy and dark or cheerful. It came to her then that when the thing painted was painted well, expressing the painter's feeling, it had a double strength. Up to then, her teachers had only stressed how things looked. Now she would seek to reflect her own feelings in the things she chose to paint.

The next morning she painted what she had seen as she had felt it. When the young man saw the picture, he said: "Patsy, give that to me." And she did. This was the second painting of the year that meant something to her.

She became very much interested in this student from the West. Not only did they share a love of painting and dancing but also of the outdoors. There were several young men at the league who thought an evening should not go by unless they had danced with Georgia, but it was with this young man that sketching, as well as dancing, was the most fun.

"If he had later come to Williamsburg and taken me away, instead of writing about it, I think I would have married him," she said years later. But the direction that her life was already taking was of such interest to her, and her responsibility for being able soon to support herself through her art was so real, that until something moving in the same direction carried her off her feet, romance was not for her.

## NEXT DECISIONS: 1908–1912

THE summer months over, Georgia returned to Williamsburg at the time when the family was to make a move from the old Travis House to another house in Williamsburg.

As money was now a real consideration, Mr. O'Keeffe, never afraid of work, personally built a house for his family on Scotland Street, where they owned a lot. The house was constructed of the large blocks that he molded with his own machinery from James River shells. With backbreaking labor, he brought these blocks to the site, rolling them there in a wheelbarrow. The house was spacious, with a room for each child. It was a supreme effort on his part to make things easier for the family, accomplished while there seemed no profitable work to do. He may have realized profit from the sale of the Travis House.

Georgia often wrote from Williamsburg to Florence Cooney in New York about how she did not miss the Art Students League, but believed that by October she would be ready to "get into a paint apron and up on a high stool." In Williamsburg her sister, Anita, the second after her, became her companion, as Georgia found her attractive, interesting and fun to be with. This relationship together with the time she spent painting helped her to pass the summer months at home.

When the fall season of the league opened, Georgia was not able to return as there was no money for her to go to art school. It was a time when few girls in conservative Williamsburg were going into paid work, however, Georgia saw the need to begin to support herself and decided to look for a position.

THE STONE-BLOCK HOUSE ON
SCOTLAND STREET, WILLIAMBURG,
BUILT IN 1908 BY FRANCIS O'KEEFFE

PORTRAIT OF ANITA O'KEEFFE
(1907) BY GEORGIA O'KEEFFE

Letters from her beau at the league continued to arrive from New York, where he was studying, from his home in the West and later from Paris where he went to paint. Georgia had this boy in mind for a very long time. Through his letters, we can construct a view of Georgia O'Keeffe in her early twenties. On February 8, 1910, he wrote from New York: "My dear Pats: It always makes me feel good to get a few of your quaint little lines. Honest Patsy, I feel like writing what I can't because you won't let me. I'm interested head-over-heels in painting now. . . . I hope you are

painting. . . . Don't wait a month before writing."

On the margin of one of his letters, she penciled these words to him, which probably she never sent: "Is it wrong for me to think I would like to put a hand on either side of your head and kiss you, not a kiss that would hurt anyone—just like I might kiss little Oran next door—because I love you for your goodness and your badness—and a kiss helps lots sometimes."

On September 7, 1910, he wrote from the Far West: "It will be only about a month now before I can finish up what work I have on hand and shake these parts for the East. I hope I may see you before I sail. Wish I could take you with me. It is not so very impossible so don't laugh. . . . "

Georgia was still hoping to get back to her painting, but this seemed increasingly impossible financially.

The letters from Europe continued. Georgia had written that she was not back at the league and he replied from Paris on February 19, 1911: "My dear Patsy: The old concierge who brought me your letter last night was really alarmed. They always frighten me, your letters, and the old woman who guards my gate is my most sympathetic friend. That fact that you have abandoned paint does not mean that you have given up art. You are and always will be an artist. . . . I sat on the bench on the Battery all night (before sailing) trying to decide whether I should come to see you or not. That morning I sailed for Holland. Am I crazy or stupid? Both I believe, because if there is anything in the world I want, it is Patsy."

Restless and worried about the money situation at home and believing that she could now earn money by her art, Georgia asked the Chicago aunts if she could again come to live with them. They were delighted. Soon after her return to Chicago, she met a family friend in the advertising business who sent her to a fashion house where at once she got a position drawing lace and embroidery. It was a job that demanded tremendous accuracy.

It was here, she says, that she learned about working hard and not wasting a moment of time. The employees drew fast and worked at desks for long hours. In order to get more work assigned, they had to finish each assignment quickly. Georgia did well in this, her first job of highly competitive commercial work. Her drawings were of value to the firm and she was kept busy. This soon led to a new and better position in another fashion

house; there she was also successful. She says she had about six ideas a morning and there was a market for ideas.

Suddenly, she came down with a bad case of measles. When she recovered, she was told not to use her eyes for some time. Then, from home came the sudden news that in addition to the mounting financial difficulties, her mother had been told that, because of her own persistent bronchial trouble, she must move to a more mountainous climate. Georgia therefore returned to Williamsburg at once to keep house for her father and the younger ones.

In Mrs. O'Keeffe's intensely courageous way, she decided that the new climate she would find for herself must be one to which she could eventually bring the family. Her choice for the new home was Charlottesville, where the University of Virginia is located. She rented a house near the university grounds, and to make ends meet, again started renting rooms to university students.

Letters to Georgia from the affluent, gifted young man from the Art Students League continued; but now they seemed to come from another world. From Paris in February 1912, he wrote: "Dear Girl: Today is the fete of Mardi Gras. Already the streets are filled with music and dancing, and by evening there will be a riot of color all over Paris. In a few days I am going south on the Riviera and later, in the early summer, to America and I hope to Virginia. . . . I have plans ahead that cannot help but materialize, they are so clear. The Georgia O'Keeffe that I appreciate exists only for me. You will realize it when you are forty. The frank, simple little shell of doubt and uncertainty that you love to crawl in and out of. Sometime, I shall prove to you what I mean."

Once Mrs. O'Keeffe had established the new home in Charlottesville, she sent for her family to join her. Georgia superintended the packing and moving at the Williamsburg end.

At twenty-five, soon after her league days, she decided that she was "through with art as a career." All those years of training in good art schools had been devoted to copying old masters. Suddenly, it had come to her: "Why all this emphasis on striving for effect? Why have as an aim the copying of paintings so great they can never be copied?" Great paintings, she realized, were expressions of the lives of the artists who made them. She wished her work to be wholly an expression of her life.

With her characteristic way of listening to her own voices, she decided that she would give up painting rather than try to imitate the subject and the technique of others as was expected in painting classes.

That summer her sisters, Ida and Anita, enrolled for art courses at the University of Virginia. Although Georgia had made the decision to discard art forever, she accompanied one of them as a visitor to a class being taught by Alon Bement. In his classes, Bement, who served on the staff of Arthur Wesley Dow at Columbia University, New York, emphasized the art structure that Dow had brought into American art teaching.

Dow believed a student's power must be developed through exercises in rhythm, subordination, balance and by finer arrangements of line, black and white and color. To Georgia who had been taught to paint realistically by the best American academic teachers and who was proficient in drawing casts and the human figure, this was an entirely new approach—a chance to make her own pictures, to create. She became so interested in this way of working that she followed Bement from class to class that day, to listen to his teaching. After she had audited two of his classes, she enrolled. There she created her own designs to express original ideas.

After two weeks of working together, Bement asked her if she wanted to teach in the Art Department of the University of Virginia the following summer. The university required its teachers to have had practical experience in art teaching in the public schools, and as Georgia had had none, Bement secured her a position in Roanoke for the following year, so she could fulfill the university's requirement.

Shortly thereafter, Alice Beretta, who had been a fellow student during Georgia's high-school days at the Chatham Episcopal Institute and who remembered her ability, sent a telegram from Amarillo, Texas to ask if Georgia would like to come to Amarillo to accept a position there as art supervisor in the schools.

At once the appeal that the West always had for her and the memory of the Western stories read by her mother in the Sun Prairie days pulled her to Amarillo. She wired Roanoke that she would not come to teach. At last she could see the West for herself.

As in her grandmother's orderly patchwork quilts, everything began to hitch together. She now had a reason for being. Early September 1912, she left for the Texas Panhandle.

# AMARILLO: 1912–1914

*W*HEN Georgia went to Texas to teach, Amarillo was the main city of the Panhandle and the largest cattle-shipping point in the Southwest. Still a frontier town, it had been known a few decades before chiefly to Indians, hunters and cattlemen. In 1912 it had no paved or gravel roads or fences; the superhighway that leads to Amarillo today was a single track dirt road. There were only a dozen automobiles in the town.

This was the West—with the roughness and adventure Georgia had dreamed of. Soon after she arrived, there was a sensational murder on the next block and she saw the murderer, black-bearded, gun on his arm, walk past the hotel with careless indifference.

Since Georgia was paid more as an art supervisor than she would have been as a teacher, she could afford the independence few women had of living at the hotel rather than in a boarding house. The hotel was the center of Amarillo life and there she heard the stirring tales of cattlemen as they came and went on their journeys through the country.

Everything about the freedom and the wildness of the place provided great excitement for the high-spirited, twenty-five-year-old Georgia. "To see and hear such wind was good. I can remember a buggy being blown a block, a house being turned over. When the creeks overflowed, they washed benches down stream," she said.

She often ate an early breakfast at the hotel with Mr. McGregor who had helped to load the first gold that came from Alaska in the Gold Rush.

POLK STREET, AMARILLO, TEXAS, IN 1912

He would tell tales of his adventures until time came for her to leave for her school classes. During her first months in Amarillo in the autumn of 1912 Mr. McGregor drove her to see the dramatic Palo Duro Canyon, now preserved as an important state park. The scene, like a small Grand Canyon, made a big impression. How wonderful it would be to paint the rugged terrain and the plains where the Comanches had pitched their camp in winter.

Sometimes in the evening, she stopped at the home of friends, a block from the hotel, to play chess with the young man of the house. She liked to play and she liked to win. He was what the town might have called a beau, but he was actually not. She was still thinking of the boy from the league whose letters to her from Europe continued. During her first days of teaching, she received a letter from Paris, dated September 23, saying: "Dear Pats: You ought to be in Paris—It's your turn—the Quarter is filled with real clever people and wonderful times. The exhibition I had here in Paris was quite a success. Going over to England next week to see if I can fix things for a show.

" . . . Don't get married to a successful young man and settle down, Pats."

A previous card, which she had answered quite tartly, brought this answer: "Dear Georgia: Sorry my postal was so newsless. . . . Are you really so 'out on the prairie,' so 'naive'?"

Georgia was attracted to certain places with the intensity most human beings reserve for certain people. Her life had now changed profoundly— she was tremendously busy, greatly drawn to Amarillo and its wildness.

Her work required a hardiness and inventiveness that few could have met. Amarillo was so dry that there were no flowers for the classes to paint—only ragweed and a few locust trees to draw. Supervising art kept her days too full to try to do any painting of her own. She supervised every grade through the eighth, and sometimes taught the art lessons in addition.In some rooms there were seventy-five children. She encouraged them to paint what they loved best. One day a little boy rode his long-haired pony to school and Georgia, who never thought of convention or precedent, with the help of the class hoisted the pony up onto the teacher's big flat desk, so that the children could see it and draw it. She got to know many of the youngsters who were considered difficult; they deeply needed

to have personal interest taken in them and she came to know their families. This was her first school position and she was pleased with the country and her classes.

There was only one thing she objected to in her school duties, and it resulted in her first, and worst, confrontation with authority. It was then the custom of public schools to require the use of printed books with serial art lessons; the teachers were expected to give these lessons in the sequence indicated, but Georgia considered such teaching rigid and dead. She explained to those in authority that she did not intend to use these books the following season, that she felt the children could create their art from the material in nature around them, thereby increasing enjoyment of art and life. The authorities finally concurred, although it seemed a momentous change.

That summer she was offered a position in another state at several hundred dollars more for the next year—a lot of money to her then. But she did not wish to leave Amarillo. During the summer vacation, she taught, as planned, at the University of Virginia, in the art department, and in the fall, returned to Amarillo. Ready to begin the school session and looking forward to helping the children explore the beauty of their own leaves and grasses, she was shocked to learn from the school authorities that the books she had objected to were to be used after all. Georgia considered this a breach of faith. She explained to the teachers that she wanted the material for the lessons chosen from the region so that the children could capture the rhythm and lines of familiar growing things and would thus express themselves rather than copy stereotyped patterns. She entered single-handedly upon a battle for individual expression— against regimentation.

The store, which had reordered the books for the classes, complained to the authorities that the books were not selling; the teachers were following Miss O'Keeffe's plan of work. Again she went to the authorities, talked to them earnestly, and this time won her point that art should not spring from dictation nor should authority be imposed from without. This was something she felt most strongly at a time before "self-expression" in art was current in public school systems.

She had won her fight but had not enjoyed the fighting. "I could not let those children, some of them so poor that their toes were sticking out of

their shoes, be forced to pay seventy-five cents or a dollar for a drawing book, when fine things that were part of their lives were growing at their very doors in Amarillo," she said.

Georgia's sister, Catherine, has said that she thought Georgia with her excellent skill had drawn "like any other good artist" until she returned from the Texas country where the open spaces and stars had captured her completely. From then on, in Catherine's words, "Georgia seemed to be drawing just for herself, and her work was like that of no one else."

# ALFRED STIEGLITZ: 1864–1916

*F*ROM the moment he saw Georgia O'Keeffe's work, Alfred Stieglitz's story was to be so interwoven with hers that his background becomes a vital part of this book.

This man, such a powerful force in photography and art in America for over a half century, was born in 1864, in what was then fashionable Hoboken, New Jersey, just across the river from New York. His was a cultivated, prosperous family. When he was nine, they moved to New York City and Alfred, the eldest son, attended the Charlier Institute, an outstanding French-speaking private school, where great stress was laid on perfection of work and on fine penmanship. Stieglitz often spoke of the meticulous grounding he had received.

In winter the family lived in a brownstone house his father, Edward Stieglitz, had built on East Sixtieth Street. From spring to late fall each year, the family spent time in their summer home at Lake George in northern New York State. There Alfred Stieglitz fell under the spell of the lake, the trees, the light and shades of nature.

At thirteen, he entered public school, and later, for two years, the College of the City of New York. In 1881, when he was seventeen, his father took the whole family to Europe to give his children the advantages of education on the Continent. Alfred specialized in engineering at the Berlin Polytechnic Institute, where he enrolled in a course in photochemistry, which was then a new subject; he used the institute's laboratory for his own experiments. For three years he studied at the University of Berlin.

Photography became his passion.

He traveled with his camera throughout Europe, photographing constantly and entering prints in international competitions and winning many prizes. It was the time when art in the European centers was in an exciting ferment. In 1889, while Stieglitz was still in Europe, Manet's controversial painting *Olympia* was bought by the Louvre. Names symbolizing revolt in the arts were feverishly discussed. The young Stieglitz was fired with the excitement of it all and with the infinite possibilities ahead in the new field of photography.

At the age of twenty-six, already a recognized photographer, he returned to New York. He was no dilettante but an adventurous young man who did many things extremely well. During his student years he had been Germany's amateur billiard champion; he had climbed the Alps; he loved horses and horse racing, theater, music and literature. With the best of training, he was in the forefront of every photographic experiment and, through his own work and the leadership he gave to other serious photographers, he soon brought camera art to eminence in America. His work, sent to exhibitions at home and abroad, received one hundred and fifty medals in a short time.

In 1902, when he was thirty-eight years old, he formed the Photo Secession group and became its active leader. The same year he began to edit and publish *Camera Work*. The first volume issued was dated 1903. He continued to publish it until 1917. This important document in the field of photography also included commentary and photographs of significant modern art. It was one of the most beautiful magazines ever produced.

In 1905 Stieglitz opened a gallery at 291 Fifth Avenue, which became known in the United States and abroad simply as 291. In the early days, through his gallery and *Camera Work*, Stieglitz brought together and presented the work of noted photographers, including Gertrude Kasëbier, Alvin Langdon Coburn, Edward Steichen and Clarence White.

From the beginning Stieglitz sought to dignify the profession of photography as an art form. He often said that had Whistler photographed, with his influence and ability, he could have put photography at once in its proper place as one of the major forms of art alongside painting, drawing, etching and engraving.

Edward Steichen took an important place in Stieglitz's life and in the

PHOTOGRAPH OF ALFRED STIEGLITZ (1910) BY ANNE BRIGMAN.
SHE CALLED IT "THE OLD WAR HORSE"

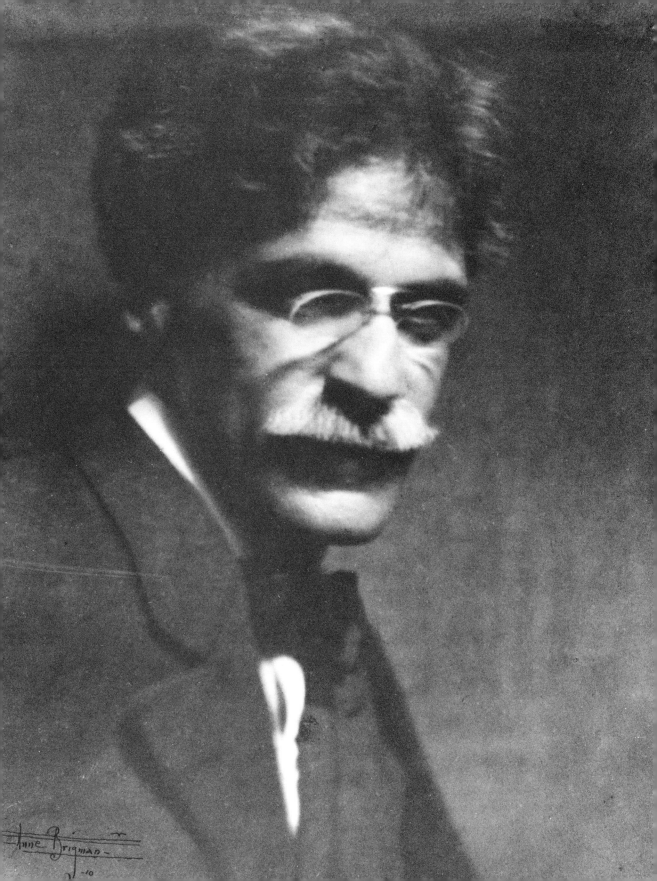

history and direction of art in America. Fifteen years younger than Stieglitz, he was both a photographer of the first rank and a painter. He had a keen appreciation of the modern art movement and of what Stieglitz, with his drive and crusading spirit, was trying to accomplish.

Most fortunately Steichen had gone to France where great events in creative art were happening. In Paris he had photographed Rodin, and with full understanding of 291 as a force in America, he had sent Stieglitz some of Rodin's drawings. Those epoch-making drawings and color sketches, exhibited by Stieglitz in January 1908, created a furor. They were followed by a Matisse exhibition, also sent over by Steichen, presented in April of the same year. The work of these artists had not been seen in America before and they presented a startling challenge to the established art of the day.

For five years before the 1913 Armory Show, 291 was the only American gallery that consistently showed modern work. The academicians were firmly in control of American art, and nothing was known by the American public of the great changes that had come in European art. The only liberal group protesting the official attitude in their painting were known as "The Eight." The Eight were Robert Henri, George B. Luks, William J. Glackens, John Sloan, Everett Shinn, Arthur B. Davies, Ernest Lawson and Maurice B. Prendergast. They had one exhibit in 1908 and their voices, later augmented by a few individuals who were also determined to free American art from dogma, resulted in the organization of the famous Armory Show. This exhibition established the modern movement in art in America.

Leon Dabo, a pupil of Whistler, who was one of the organizing board of the show, gave an illuminating account of the deciding voice in that exhibition:

> Stieglitz was the electric spark that made the Armory Show the history making event that it turned out to be. The first few meetings to discuss such an exhibition had been held on 23rd Street with a few of us determined and enthusiastic. Then someone suggested that before we went any further Alfred Stieglitz be brought into the picture. With his entrance, the whole plan took on the kind of life that Stieglitz always created around him. He spoke with authority, gave us names of significance, and with an uncanny perception and psychic

flair for what has ever since been modern tendency in art, he kept the whole exhibition to its purpose but on the vast scale which resulted.

The frankness of the Rodin drawings Stieglitz had exhibited startled New Yorkers and earned him the fury of both the dealers and the conservative custodians of art. With the Rodin exhibition at the Photo Secession gallery, photography and art were for the first time under one roof, a shocking departure for the art world and an important step for Stieglitz.

It was the storm precipitated by the Rodin exhibition that made Stieglitz decide upon the next memorable phase of his life. He resolved to fight for artists in media other than photography. It is hard to understand the difficulties then facing artists in America who were working in a new way. No dealer would show their work. Every avenue of making a living through art was closed to them.

With his determination and discrimination, Stieglitz was able to galvanize opinion to support the artists in whom he believed. He held open the doors that might otherwise have remained closed to them, and it was he who first convinced many in this country that the contribution of the artist was of utmost importance to society. In the work that Stieglitz showed at 291, America first saw modern art.

A partial list of the exhibitions held at 291 in its early years is a roll call of many of the leading artists of the century. After the Rodins came the Matisse exhibit in 1908, also sent by Steichen from Paris. New York critics almost unanimously called the Matisses "ugly" and "hideous." Then came exhibitions of the paintings of Alfred Maurer, John Marin and Marsden Hartley and the lithographs of Toulouse-Lautrec in 1909; the memorial exhibition of paintings and drawings by Henri Rousseau in 1910; Picasso drawings, Cezanne watercolors and Max Weber paintings in 1911; Walkowitz drawings and paintings and de Zayas drawings in 1913; and Brancusi, Picasso, Braque and Nadelman in 1914. For the Americans, it was their first exhibition anywhere; for the Europeans, the introduction of their art to America.

Stieglitz often told me that when he showed the first Cezanne drawings ever seen in the United States, no one was willing to buy a single one of them for forty dollars. The worship of Cezanne, which came within a few

PLATES FROM *CAMERA WORK* (CLOCKWISE FROM LEFT): *THE BRIDGE, VENICE* (1908), ALVIN LANGDON COBURN; *PHOTOGRAPH* (1917), PAUL STRAND; *THE RED MAN* (1903), GERTRUDE KÄSEBIER

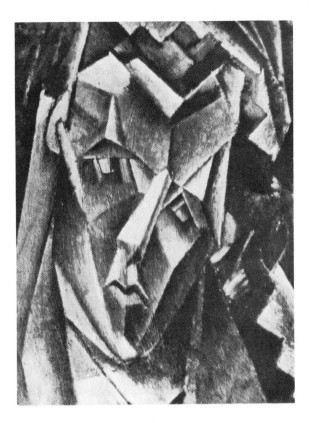

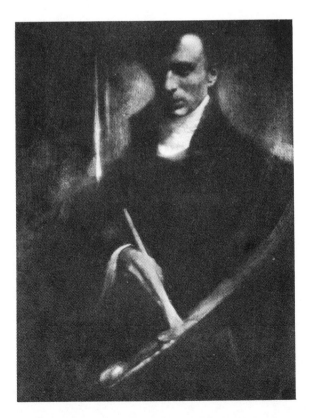

*PLATES FROM CAMERA WORK
(CLOCKWISE FROM LEFT): SELF
PORTRAIT (1903), EDUARD J.
STEICHEN; UNTITLED (1912), PABLO
PICASSO; PHOTOGRAVURE OF
DRAWING (1910), HENRI MATISSE*

years, and the attempt to copy this great artist whom the public and the dealers had earlier ignored, were revolting to Stieglitz and was unquestionably one of the reasons why he decided to champion those American artists who had set out along new paths and whose work he felt had "something of importance to say." Marin, Hartley, Walkowitz, Max Weber and Dove came under his special care.

No one will ever know all that Stieglitz did in their early days to make it possible for these artists to keep on working. He assumed their responsibilities and gave them advice; they met, talked and shared ideas as they previously could have done only in Paris. They showed their pictures under his auspices, and he spared them worry by dealing and taking blows for them. When there were sales, he set the prices.

Stieglitz was a constant inspiration to the young—those far as well as near—who had high aspirations. One of them was Kay Boyle, then the youngest American in the Paris avant- garde group of writers. Her drawings and paintings, made when she was nine, were among those shown by Stieglitz at 291 in an exhibition of children's drawings, watercolors and pastels—the first exhibition of its kind anywhere.

**Kay Boyle to Stieglitz, Paris, 1927**

> Alfred Stieglitz: . . . [D]o you realize that you are the most important man in America? Can you, who are there, see that as we see it here? You who are tired perhaps, who can see the ugliness, who know the flagging interest, the mean, the small. . . . [Y]ou are the courage of America. . . . I see you as clear as a skyscraper.
>
> . . . Here is my love . . . for you and O'Keeffe. I saw her only once, a lovely Nefertiti.

The group around Stieglitz lunched often at the old Holland House, with Stieglitz paying the checks for those who could not. Stieglitz always dressed the same. In his black pancake felt hat and his flowing English-style black cape, he caused many a passing New Yorker to look as he led the way from the gallery to the restaurant and back, the shepherd of his strange-looking flock.

Those who entered the modest gallery, even if unprepared for the art they would see, were immediately impressed by the atmosphere of the place and the superb placing of the pictures or sculpture. There was an air of reverence toward the art that set this place distinctly apart from other galleries.

Often John Marin, of monosyllabic words and roguish humor, stood before a picture for hours; Walkowitz was there, silent, seconding Stieglitz's pronouncements with affirmative nods; Hartley discoursed on some view of his own or the beauty of the Maine rocks; but it was Stieglitz who by his words or dramatic silences would galvanize the scene. To him the drawings, paintings and sculpture shown were a means of challenging America to a more creative life.

All day long, every day, fall, winter, spring, Stieglitz with his phenomenal energy and comprehension was at the gallery, talking to whoever came in about the pictures on the wall or about themselves, hurling ideas at them on every phase of art. He insisted that the pictures were for sale only to those who were worthy of them. To those who responded sympathetically to the art shown or who were frank about their doubts, he was stimulating. To those who were flippant or would take advantage of the artists, he was devastating. He was a great slayer of pretense, and with his knowledge, amazing memory and joy in debate, he could cap any argument. His flashing eyes and meaningful gestures supported his mood, whether of wrath or tenderness or of an almost theatrical melancholy. Whatever he was, he was wholeheartedly that; and for the truth as he saw it and the loyalties he lived by, he would engage in combat.

At such times, the atmosphere was electric. It is hard to give any idea of the violence of the scenes that went on—the conversations for and against everything touching on life or art. He stood, hours at a time, holding forth on some idea that had not yet gained acceptance. In 1936, when Stieglitz hung the Marin retrospective exhibit at the Museum of Modern Art, the New York *Herald Tribune* reported that as he talked about the pictures, "the explanations cascaded out in torrents of words, and carpenters and electricians putting the finishing touches on the exhibition stopped their work to listen to him."

Stieglitz was either loved or cordially disliked. He was caustic to buyers because of his concern for the pictures and the artists. His unwillingness

to compromise was hard for many to understand.

At 291 pictures were sold because the artists had to live, but persons of means had to satisfy Stieglitz that they were worthy of the trust before buying a picture. The artists repeatedly saw him refuse to sell because he felt the picture represented a milestone and should be possessed by the artist or museum or patron who understood it.

But he was kindness itself to those he admired. The artists believed in him. They knew that he made no money for himself, that he raised the money through which numerous artists lived, and that of his own small income, he gave liberally. Georgia, in later days, said: "Nobody ever did so much with so little as Alfred."

And now that the artists of this century whom he sponsored are established in the first ranks of painting, it is hard to visualize the brilliant, persistent effort that he contributed over the years to bring this to pass.

Marsden Hartley, whose own gifts in painting were first recognized by Stieglitz, in speaking of 291, said, "I think never had a body of individuals—large or small—kept its head more clear, or its hands and feet freer of the fetter of personal gain or group malice than has this 291 body."

In *Seven Arts* in November 1916, Paul Rosenfeld, gave this picture:

> Only to those who seek the gallery at a moment when the individual staying power is near collapse, when energy subsides and faith crumbles and vanishes, does it reveal itself.
>
> . . . You have been in the gallery but ten minutes. But for those ten minutes, the gallery exists. Not for the sake of Picasso and Marin and Nadelman. For your sake that you may live your life.
>
> . . . Stieglitz's ideas are not what make Stieglitz. It is rather more his spirit, that splendid desire to give himself to whomsoever needs him—to America.

# AFTER THE FIRST DRAWINGS: 1916

STIEGLITZ with his striking demonstration of art at 291 was certainly the voice of modern art at a turning point in American public opinion. His vision and accomplishment awakened an entire generation from its timidity. He was the man to whom I had felt impelled to take the O'Keeffe drawings; it was the only thing to do—they belonged with him at 291.

Georgia, of course, knew of Alfred Stieglitz's greatness. She had seen him years before when studying at the Art Students League. She had gone with a group of students to see the Rodin exhibition which the league instructors had insisted they see. They were asked to decide whether Rodin was putting something over on America or whether it was Stieglitz who was playing a joke on the public. The latter was implied by the teachers.

On the way down, the boys from the league planned to get into "an argument with Stieglitz." On arrival, they began at once and the visit became so stormy and Stieglitz's discourse so fiery that Georgia, one of the two girls in the group, went out of the room. The boys followed shortly, quite beaten. Georgia had taken no part in the conversation and as she had vanished as soon as she could, she was sure Stieglitz had not remembered her presence. In the intervening years, she had examined issues of *Camera Work* and seen copies of *291* and had come to value deeply Stieglitz's accomplishment.

On New Year's Day 1916, I wrote to tell Georgia what I had done.

**Anita to Georgia, New York City, January 1, 1916**

Astounded and awfully happy were my feelings today when I
opened the batch of drawings. I tell you I felt them! & when I
say that I mean that. They've gotten past the personal stage
into the big sort of emotions that are common to big people—
but it's your version of it. I mean if they'd been stuck on a wall
& I'd been told XZ did them I'd have liked them as much as if
I'd been told Picasso did them, or someone I'd never heard of.
Pat—Well, they've gotten there as far as I'm concerned & you
ought to cry because you're so happy. You've said something!
. . . [T]hey spoke to me—I swear they did.

    . . . It's 11 at night and I'm dead tired in bed and they're
with me—next to my bed—I left them alone. [Stieglitz and
Walkowitz] lived thru them—Then Stieglitz said "Are you writ-
ing to this girl soon?" I said "Yes"—"Well tell her," he said
"They're the purest, fairest, sincerest things that have entered
291 in a long while"—and he said—"I wouldn't mind showing
them in one of these rooms one bit—perhaps I shall—For
what they're worth"—"You keep them"—and he turned to me
and said this "For later I may want to see them, and I thank
you," he said—"for letting me see them now."

    Pat I hold your hand. I think you wrote to me once—"I
would rather have Stieglitz like something I'd done than any-
one else."—It's come true. . . .

    . . . You're living Pat in spite of your work at Columbia!!!

Georgia was most astonished that, in spite of her injunction that I show
them to no one, I had done so. Her reply reflects her lifelong way of never
protesting once a thing is over, but going on from there.

**Georgia to Anita, Columbia, S.C., January 4, 1916**

There seems to be nothing for me to say except Thank you—
very calmly and quietly. I could hardly believe my eyes when
I read your letter this afternoon—I haven't been working—ex-
cept one night—all during the holidays—that night I worked
till nearly morning—The thing seems to express in a way

what I want it to but—it also seems rather effeminate—it is essentially a womans feeling—satisfies me in a way—I dont know whether the fault is with the execution or with what I tried to say—Ive doubted over it—and wondered over it till I had just about decided it wasnt any use to keep on amusing myself ruining perfectly good paper trying to express myself—I wasn't even sure that I had anything worth expressing—There are things we want to say—but saying them is pretty nervy—What reason have I for getting the notion that I want to say something and must say it—Of course marks on paper are free—free speech—press—pictures—all go together I suppose—but I was just feeling rather downcast about it—and it is so nice to feel that I said something to you—and to Stieglitz

I wonder what I said—I wonder if any of you got what I tried to say—Isn't it damnable that I cant talk to you. If Stieglitz says any more about them—ask him why he liked them—

Anyway, Anita—it makes me want to keep on—and I had almost decided that it was a fool's game—Of course I would rather have something hang in 291 than anyplace in New York—but wanting things hung is simply wanting your vanity satisfied —of course it sounds good but what sounds best to me is that he liked them—I don't care so much about the rest of it—only I would be interested in knowing what people get out of them—if they get anything—Wouldn't it be a great experiment—I'll just not even imagine such luck—but I'll keep working—anyway—

You say I am *living* in Columbia—Anita—how could I help it—balancing on the edge of loving like I imagine we never love but once—. Columbia is a nightmare to me—everything out here is deliciously stupid—and Anita—I—am simply walking along through it while—something—that I dont want to hurry seems to be growing in my brain—heart—all of me—whatever it is that makes me—I don't know Anita—I can't explain it even to myself but Im terribly afraid the bubble will break— and all the time I feel so ridiculously secure that it makes me laugh

Anita, I cant begin to tell you how much I have enjoyed
that Camera Work—It surprised me so much—and you know
how much I love what is inside of it—That Picasso Drawing is
wonderful music isn't it—Anita—I like it so much that I am al-
most jealous of other people even looking at it—and I love the
Gertrude Stein portrait—the stuff simply fascinates me—I like
it all—you know how much without my trying to tell you—
The word—food—seems to express what it gives me more
than anything else.

We have been having wonderful warm weather—I have
thrown the whole holiday away and am not sorry—Spent
most of it outdoors—I don't regret the laziness of it either—

Im feeling fine—never felt better in my life and am weigh-
ing the most I ever do—It's disgusting to be feeling so fine—so
much like reaching to all creation—and to be sitting around
spending so much time on nothing—

Im disgusted with myself—

I was made to work hard—and Im not working half hard
enough—Nobody else here has energy like I have—no one
else can keep up

I hate it

Still—its wonderful and I like it too

At any rate—as you said in the fall—it is an experience.

I am glad you showed the things to Stieglitz—but how on
earth am I ever going to thank you or get even with you—I
love these Nadelman things too Anita—I just have too many
things to thank you for tonight—I'll just have to stop and not
try

Goodnight.

Georgia

Anita to Georgia, New York City, January 8, 1916

Well Pat—I'm glad.

I got your letter this morning. I thought you'd feel pretty new
after all I had to tell you. I felt like a sneaking cat today be-

cause Dorothy & I were talking about you & I of course said
nothing [about the drawings]—but I'm sure it's better so. Her-
mie my cousin was around the other night & I was just putting
away your feelings when she came—she begged to see
them—but I told her no. They're not for everybody. I haven't
been to 291 since.

That is a wonderful number of Camera Work. I knew Picas-
so would thrill you. He does me, you know, more than all put
together. The Nadelman sculptures are good.

. . . I've been so gay during vacation that I'm really alto-
gether tired. That's why I've had my bath & am in bed,
though its only ten o'clock. Do you talk to people at night, or
read or what?

. . . I looked at your things again last night. Pat I should
like to hold a little button on your waist, or your short waist
string, or something close to you, while I tell you I feel you-
you-you thru charcoal and paper. It's Art Pat and I'd yell it to
the moon. You've found it, altho' you didn't know the
dictionary definition.

. . . Goodnight Patrick—you're a strong, healthy old fellow.
It's good to drink with you. . . .

So I sip my *water* and fall asleep—
Anita

About a week after her letter to me, Georgia wrote, with characteristic
directness, a letter straight to Stieglitz. This first letter from her to him gives
an important clue to her early work.

### Georgia to Stieglitz, Columbia, S.C., January 1916

If you remember for a week why you liked my charcoals that
Anita Pollitzer showed you—and what they said to you—I
would like to know if you want to tell me.

I don't mind asking—you can do as you please about an-
swering. Of course I know you will do as you please.

I make them just to express myself—Things I feel and want

to say—haven't words for. You probably know without my
saying it that I ask because I wonder if I got over to anyone
what I wanted to say.

Georgia O'Keeffe

Then came Stieglitz' first letter to Georgia.

**Stieglitz to Georgia, New York City, mid-January 1916**

My dear Miss O'Keeffe:

What am I to say? It is impossible for me to put into words
what I saw and felt in your drawings. As a matter of fact I
would not make any attempt to do so. I might give you what I
received from them if you and I were to meet and talk about
life. Possibly then through such a conversation I might make
you feel what your drawings gave me.

I do not want to tell you that they gave me much joy. They
were a real surprise and above all I felt that they were a gen-
uine expression of yourself. I do not know what you had in
mind while doing them. If at all possible I would like to show
them, but we will see about that. I do not quite know where I
am just at present. The future is rather hazy, but the present is
very positive and very delightful.

With greetings,
Cordially,
Alfred Stieglitz

Georgia told me in a letter that she had written to Stieglitz, and soon
after she wrote again to me: "You probably were pretty much surprised
at my popping up and writing him—I just wanted to—so I did. . . . I didn't
know whether he would be interested enough to answer me or not—No
risk—no gain."

In South Carolina, she went on teaching and experimenting in her
drawing and painting, but she had become restless. Both Texas and New
York were constantly in her mind. A replacement for her at the College

would be easy, she felt, as she was the only one in the art department.

**Anita to Georgia, New York City, January 12, 1916**

. . . I wonder what you're doing now! Pat I wonder if you have an inkling of an idea how much of Pat O'Keeffe you get into every line you write me. I swear its my tonic. For heavens sake tell me should I tell Dorothy about the charcoals I showed Stieglitz or not. I'd say not yet, but still I'd like you to tell me. When she talks about wondering what you're doing away from N.Y. & Mr. Martin & Exhibitions I wonder too. I think we better wait till Stieglitz takes them (if he does, or till you send me more if you do). You see I don't tell anything Pat—& I don't know that you have & I rather think those drawings without you or your feelings to explain them wouldn't quite explain themselves to practical Dorothy. But please dont write her about them without telling me first so I can tell her I rec'd them. It would seem mean—You see what I mean. For we tell each other so much about ourselves & Dorothy would think it selfish for me to have had these so long naturally. Pat they still thrill me! I suppose you would rather have me write about exhibitions & tell you what I'm learning— rather than this nothingful junk—but I didn't want to.

Goodnight Pat & please love Anita, or else hate her, but don't like her what ever you do.

**Georgia to Anita, Columbia, S.C., January 14, 1916**

. . . Everything I do looks like dough—or the devil—I dont know which—and I dont seem to be able to collect my wits enough to get anything done—so I started to sew—have almost made a waist—just have to stitch the cuffs on to finish it and I dont seem to care if they never get stitched—My brain feels like an old scrap bag—all sorts of pieces of all sorts of things—Yes—tell Dorothy about the drawings if you want to— when you want to—Do just as you please—I dont care a bit—

about anything now—I just seem to be asleep and cant wake up—Ill not tell her—you see I couldnt very well—you have all the facts—so do as you please—I know they look like nonsense to her—but opinions are always interesting—Im not sure that it isnt all a fool game—Id like to get it either knocked in harder or knocked out. Ive always tried to knock it out—Nobody ever tried to knock it in but you—I had almost decided never to try any more when you showed them to 291—Yesterday just by accident I found those music things I did with Bement last year and they are certainly different———

Anita—Id pack my trunk for half a cent—I never was so disgusted with such a lot of people and their ways of doing—I half way have a new job out in Texas—hope I get it—Ill have a cat and a dog and a horse to ride if I want it—and the wind blows like mad—and there is nothing after the last house of town as far as you can see—there is something wonderful about the bigness and the lonelyness and the windyness of it all— mirages people it with all sorts of things at times—sometimes Ive seen the most wonderful sunsets over what seemed to be the ocean.—It is great—I would like to go today—Next to New York its the finest thing I know—here I feel like Im in a shoe that doesnt fit.—So far Ive forgotten it by dreaming I guess—and I'm disgusted with dreams now—I want real things —live people to take hold of—to see—and to talk to— Music that makes holes in the sky—and Anita–I want to love as hard as I can and I cant let myself—When he is far away I can't feel *sure* that he wants me to—even though I know it— so Im only feeling lukewarm when I want to be hot and can't let myself—It's damnable—but it doesn't matter—so long as its just me—

Pat.

Anita to Georgia, New York City, January 22, 1916

Pat,

You do keep people going—thats part of why you're you. I

move in leaps after your letters. So you may really go—to Texas. Pat I don't know what to think. Distance doesn't matter Pat—you know that—but just a minute—to be disappointingly sane & practical. How can you leave Columbia?— I don't quite understand. I guess you know what you're talking about.

Pat Mr. Stieglitz has spoken to me twice since—once he said he heard from you—the next time he said he had let you hear from him—but he said—"She probably can't get what I mean. I *have* to talk to people—letters don't do it." The first of these two times was last Sat night at about 10.10—at 86th St & Central Park West. I was coming from a lecture by William Chase at the Metropolitan. There was a bit of charcoal burning at the little motorsman shed there—so warm & lovely looking that I walked up—& I swear I was surprised to see Mr. Stieglitz standing there looking too. He said—"Oh Miss Pollitzer the Marins go up on Monday and I heard from Miss O'-Keeffe today! She asked me what I got out of those things— I got something very definite but I shan't be able to tell her" — But he did didn't he for yest I saw the Marins & he came in the room & said—"I wrote Miss O'Keeffe." Then he said that stuff about not being able to tell you accurately & not seeing you. The Marins are lovely Pat—so fine you know & sincere & not a bit clever—If you know what I mean. That's the differences I feel between your music compositions that you did with Mr. Bement & these new things. These plainly show that you were telling a truth you knew, & telling it because you had something to express & were doing it perfectly naturally—those compared with these—look like talking to show off, more or less, before a class! . . .

Georgia to Anita, Columbia, S.C., January 22, 1916

. . . Wouldn't it be great if you were here watching the sunset by me. Its almost gone—wonderful blue grey—pink and orange —Ive been thinking lots about colors—I think Im going

to use different ones—but—Im not wanting to try as much as I
ought to because maybe I cant do what Ive been think-
ing. . . .

Anita to Georgia, New York City, January 28, 1916

. . . Pat I told Dorothy about your pictures and she was so
glad—she does think so much of you Pat. I like to hear her
talk about you. She hasn't seen them yet & probably won't till
next week. Then she'll write you. As to Alon [Bement] I shall
dodge him for a week to give him a chance to forget [that he
asked to see the drawings] . . .

Georgia to Anita, Columbia, S.C., February 9, 1916

For the lord's sake—tie a rope around my neck and then get
everybody you know—and everyone you dont know to swing
onto the other end of it—because Im going crazy if you dont
hold me down and keep me from it. I seem to want to tell you
all the world again tonight.

I've been working like mad all day—had a great time—An-
ita it seems I never had such a good time—I was just trying to
say what I wanted to say—and it is so much fun to say what
you want to—I worked till my head all felt tight in the top—
then I stopped and looked Anita—and do you know—I really
doubted the soundness of the mentality of a person who can
work so hard and laugh like I did and get such genuine fun
out of that sort of thing—who can make anything like that as
seriously as I did

Anita—do you suppose Im crazy? Send me that number of
*291* you said you got for me—if you have a roll for it—and I'll
send you some drawings in the roll—If I can think to get a roll
myself I'll send them before—because I want you to tell me if
I'm completely mad—I look at the stuff and want to feel my
own skull—Anita—I get such a lot of fun out of it—I just went
down the hall and asked Professor Ariel [Ariail] if he had a

paper roll and he said "For goodness sake— whats up now— what have you got in your head—I never saw such excitement in anyones eyes"—just to see what he would say —I took the drawing down and showed it to him—He liked it— and he laughed—"Why it's mad as a March hare"—he said— I've been trying to educate him to Modern Art—but had never showed him anything of mine before He didn't have a paper roll—Maybe I can get one tomorrow from someone. I have a notion its the best one I ever made—but Anita—I believe I'll have to stop—or risk going crazy. . . .

**Anita to Georgia, New York City, February 12, 1916**

Pat: Your letter made me downright glad today. Why I'm crazy to see your new production. Let me tell you something right away—I haven't time for much.—Listen: I took those things of yours which have become part of me to school today & when Mr. Bement met me in the corridor & said "Well are you coming up this aft to show me those things of Miss O'Keeffe." I said "No but I have them here & am going to show them to you in a spare room"—I thumb-tacked them up—He came in—Damn him—He looked for a second & then said "Well aren't they great!"—I didn't—couldn't say anything—I said "Well" after a long time & he said again—"Well aren't they great?" I said "I think so" Again the room was quiet—In a little while he said "You said Stieglitz liked them & said he wouldn't mind showing them"—I said "Yes"—He said "Well I'll go down & have a talk with Stieglitz about her"—I said "Oh no Mr. Bement you promised you wouldn't say anything to anyone"—He said "Yes but Stieglitz won't show them unless she's got some backing up"—I said "Well you're very much mistaken, but the point to her & to me was that he even thought them worth showing—that's all"—Then he said (Pat I'm really afraid I dislike him enormously. I can't stand a man you know who has no principle.)—"Do you know what Stieglitz is waiting for, he's waiting for a good round $100 check."

Well I was downright disgusted. I've *known* since the beginning of this year how money talked to him but how could he say that about anyone—Well I did say a few things about the sort of men he was living for—Walkowitz, Marin, Nadelman & the other poor fellows—He said "Well I'm going to take these things to Mr. Dow—for they're just like the music compositions —(he didn't say just like that but said something about "same style") etc—I said that you yourself had written how different they are from those music things—He said "Well they're mysterious, weird etc"—Pat he isn't capable of feeling deeply! Then he said "And if she's going to exhibit I can get her in a better place than 291"—I said "Mr. Bement she had no idea of exhibiting—Stieglitz got what was in them & to my mind if they are ever shown it could only be there—they're related to 291, a part of its spirit." He said "Artists you know don't think much of 291"—I said "No the aims are pretty different."— Finally in a very sweet voice he said—"Well I like this one the best—I like it very much in fact. May I show it to Mr. Dow." I was so sick of his eternal whimpering I said "Yes"—He said "And to my class" I said "Yes"—So he took the very dark one—the most sensational of the crowd & he has it—He said finally "Well I admire your being so loyal to Miss O'Keeffe but I think I'd better back her up to Stieglitz"—Then he said "I'll write to her & ask her if I can't"—I said that's a good idea—do it?"—So you may hear from this practical commercial soul!!

. . . When he writes tell him what you please—

It's none of my business—I beg you Pat don't tell anyone ever of this letter—I'm ashamed of it because it seems little:— but I've given it to you as simply as I could.

**Georgia to Anita, Columbia, S.C., February 25, 1916**

Dear Anita:

Kick up your heels in the air! I'm elected to go to Texas and will probably be up next week. I am two hundred dollars short of what I need to finance me through the time I want to

spend in N.Y. but if I can't scratch around and chase it up from somewhere I'll go without it—because I'm going. I'm chasing it—hunting for it at a great rate. . . .

Georgia to Anita, Columbia, S.C., February 28, 1916

. . . [I]t makes me laugh that I should have come to this half dead place—to get such luck with my drawings—and at the same time—to run down the position I would rather have than most any I know of. I am crazy about living out there in Texas you know.

Yes—I wrote Alon—I simply couldnt stand it—to think of his prancing about [Teachers College] with those drawings— showing them—so—I asked him not to—because I could almost see their smiles through space—in the Fine Arts office— and I just couldnt stand it. . . .

The position that Georgia had been offered at the West Texas State Normal College (teachers' colleges at that time were generally called "normal colleges") in Canyon, Texas, at one hundred and fifty dollars a month for nine months' work, was to begin in September 1917 on condition that in the interim she would return for the spring term to Columbia University in New York, to take a course in methods of teaching art with Professor Dow.

# THE FIRST EXHIBITIONS: 1916–1917

**S**OON after her arrival in New York, Georgia began her studies. She had not gone down to 291 as anyone who knows her habit of concentration on the work at hand would understand. Maybe also she was reluctant to see Stieglitz.

In May 1916, Stieglitz hung the O'Keeffe drawings at 291. It was her first exhibit anywhere and a history-making one.

Stieglitz did not know that Georgia was in New York City at the time, nor did she know about the exhibition. She was eating lunch in the Columbia University cafeteria when a student asked, "Are you Virginia O'Keeffe?"

"No, I am Georgia O'Keeffe. Why?" she replied.

"It says on the bulletin board that Virginia O'Keeffe is having an exhibition at a gallery called 291. That's why I asked you."

Georgia sat there dumbfounded. I had written her, when I showed Stieglitz the drawings, what he had said to me about the possibility of showing them, but she had heard no more.

She went to the bulletin board and looked at the notice. Her state—Virginia—was probably the cause of the error. She hurried downtown determined to tell Mr. Stieglitz to take her drawings off the wall.

Before coming to New York, she had referred to these drawings in letters to me as "so personal." Once she wrote: "Those things meant so much when I tried to say them. They were the first things I had put down that I felt were my own."

When Georgia arrived at 291, she found an open door and an empty gallery. She walked in. Hodge, the elevator man, who through the years was devoted to Stieglitz, followed her. "Where is Mr. Stieglitz?" Georgia asked imperiously.

"He's on jury duty and won't be here this week," Hodge answered. He stayed in the room. Georgia slowly examined her drawings and then walked out.

A week later, when she thought Stieglitz would be finished with jury duty, she went down again. This time Stieglitz was there, alone in the gallery. She entered, announcing to him, "I am Georgia O'Keeffe."

He looked up to see a young woman of simplicity, poise and dignity. "I want you to take my drawings off the wall," she said firmly, in a tone that no one used to him. "You didn't tell me before you put them up."

Stieglitz, stunned by the surprise of the visit and also by the implied reproach, replied: "You don't know what you have done in those pictures." Georgia, not liking the challenge, flashed back: "Certainly I know what I've done. Do you think I'm an idiot?"

There was sincerity in Georgia's objection. Up to this time, there had been complete reserve about herself and her work. She had rarely shared important feelings or ideas, and to see herself revealed to others through those drawings—which though "abstract" seemed so personal to her—had been a shock. She was extremely annoyed.

Stieglitz, disregarding her words and attitude, talked on, which was never hard for him, about the worth of the drawings, and then she went away.

The pictures stayed on the wall and Georgia, without going back to visit the galley, soon left New York to teach at the University of Virginia for the summer session. It was a pleasant summer for her and when she was not busy teaching or preparing classes or enjoying the out-of-doors, she was at work on her own drawings.

Stieglitz, catalog foreword for Forum Exhibition of Modern
American Painters, March 1916

> There has never been more art-talk and seeming art interest
> in this country than today. In my mind there is the constant

question: Is the American really interested in painting as a life expression? Is he really interested in any form of art? Twenty-five years of concentrated study has resulted in my knowing that he is not. There may be a few rare exceptions.

Two months after he wrote this, he hung the first O'Keeffe drawings. He had decided that Georgia O'Keeffe was one of those "rare exceptions" and that work of such consequence should, in his words, "be given a chance." He felt that "the Place," as his gallery was affectionately called, would be a "protection" to her way of working. He also believed that her work, with its ability to convey beauty of line and form with intense emotional power, would bring a "greater awareness" to those who saw it.

In a 1913 article in *Camera Work*, where Stieglitz published writing aimed at bringing about a greater cultural awareness in America, Benjamin de Casseres had echoed his beliefs.

**Benjamin de Casseres, *Camera Work*, June 1913**

Out of the heart of the most practical people in the world—the Americans—have come . . . Emerson, Thoreau and Whitman . . . [T]hey reported what they felt not what they saw. They let themselves go. They risked the open sea at each moment. . . .

Such emphasis was not the usual one in American visual art of the time and unquestionably Stieglitz felt that in Georgia's work, with its honesty of statement and abandon, there was something that needed to be seen.

She had neither the understanding of the art world nor the self-interest to realize what Stieglitz's championship of her work would mean. In her painting, she was enjoying her freedom from the influence of others and she wanted this freedom to continue.

From the first, Georgia's charcoal drawings on the walls of 291 meant a great deal to those who had the habit of coming there as well as to a new group attracted by this exhibition. In a world whirling with tensions, these black and white drawings expressed something deeply felt. According to Stieglitz, her work communicated something especially to the

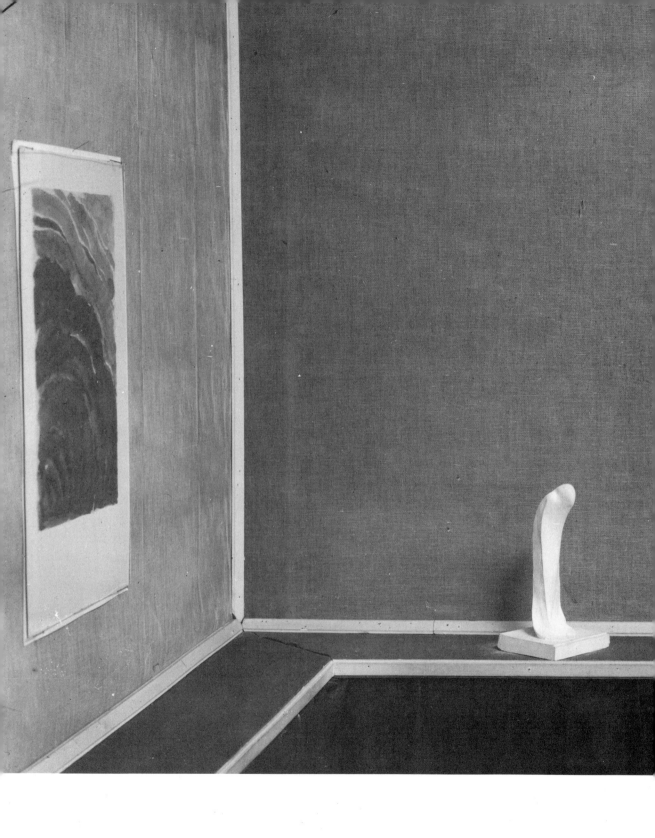

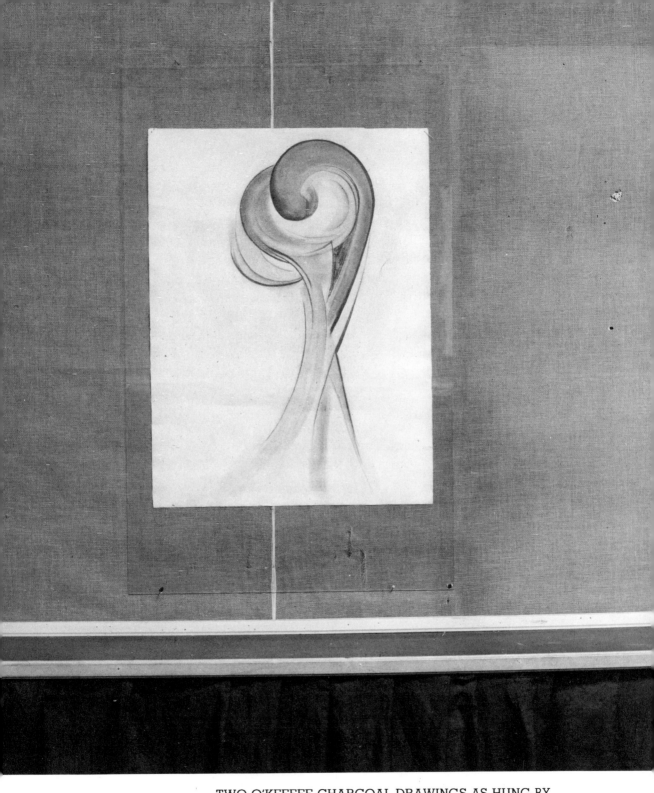

TWO O'KEEFFE CHARCOAL DRAWINGS AS HUNG BY
STIEGLITZ FOR THE FIRST PUBLIC SHOWING OF HER
WORK AT 291 FIFTH AVENUE IN 1916

women who came into the gallery. He said again and again, "O'Keeffe seems to feel what women are feeling but have not been able to say. She is a spokesman for feelings that have not been expressed."

The same thought was expressed by Henry McBride who was in the forefront with his early reviews of the exhibitions of modern painters. He told me in later years that he used to say to Stieglitz: "You see it, you believe in it—I see it, I believe in it—but look at the women who are here. They seem to feel a kinship for O'Keeffe's work. She seems in her work to be speaking directly to them and saying what they understand completely." Then turning to me, he said, "After all, you felt the drawings enough to take them to Stieglitz."

When Georgia's pictures were first seen in 1916, American artists, with very few exceptions, were patterning their work on their predecessors in this country, who had usually looked to Europe for inspiration. No woman in American art, except Mary Cassatt—whose art is identified with the French Impressionists—had broken through to the top ranks of creative painting.

Many who had no previous interest in art came again and again to Georgia's first exhibition. The reception of this work by those who came to the gallery could perhaps be taken as illustrating Havelock Ellis's later statement in *The Dance of Life* (1923): "It is conceivable that the more perfectly a new revelation is achieved, the less antagonism it arouses."

*Camera Work*, October, 1916

## GEORGIA O'KEEFFE—C. DUNCAN—RENE LAFFERTY

In spite of the lateness of the season when the chief art critics of the New York papers had already been laid off for the summer, 291, from May 23 to July 5, presented to the public drawings by Georgia O'Keeffe of Virginia, occupying the walls of the main room; two watercolors and one drawing by C. Duncan of New York, and three oils by Rene Lafferty of Philadelphia, occupying the walls of the inner room.

This exhibition, mainly owing to Miss O'Keeffe's drawings, attracted many visitors and aroused unusual interest and discussions. It was different from anything that had been shown

at 291. Three big, fine natures were represented: Miss O'-Keeffe's drawings besides their other value were of intense interest from a psychoanalytical point of view. 291 had never before seen woman express herself so frankly on paper.

The mysterious aura that was thrown around her work from the start by critics was far removed from her own motives. Their reasonings and explanations helped them to account for such paintings by a woman.

Throughout the months of May, June and July 1916, this first exhibition of her pictures remained on the walls of 291. They were all in black and white—some abstractions of feelings and some semirealistic ideas that now might be called symbolic—not pictures in the pictorial sense of the word. They continued to astonish those who came to the gallery, and they were a great comfort to Stieglitz in the war days.

Of this, her first exhibition, he wrote to Georgia, then at the University of Virginia for her summer teaching: "At 291, your drawings still attract attention. A woman from Buffalo was quite overwhelmed by them. To me, they continue a great quieting pleasure."

Over and over, those who came to see Georgia's drawings, because of the sensation they had caused, saw only the beauty they communicated. The drawings had struck a human and universal note.

Tolstoy, in his memorable essay, "What is Art?", wrote, "Art is a human activity consisting in this, that one man consciously by means of certain signs, hands on to others feelings he has lived through, and that others are infected by those feelings and experience them."

That was exactly what was happening during the showing of her pictures. Every day, Stieglitz was in the gallery, happy with the visitors and their responses, talking to them as only he could talk, about the drawings and about themselves.

**Stieglitz to Georgia, New York City, June 1916**

Your drawings on the walls of 291 would not be so living for me did I not see you in them. Really see.

. . . The streets are full of soldiers—soldiers to be—and they do not strike me with any pleasure. And yet I feel if I were

young I'd join them rather than be so apart from the world as
I am these days.

.  .  . [T]hose drawings, how I understand them. They are as
if I saw a part of myself—Queer! Queerer still that during your
stay here we never had a chance to compare notes—to be
alone to compare.

.  .  . I have been thinking of your new drawings—and have
been telling of them to some of those people enthusiastic
about the drawings now on the walls.

Stieglitz's letters continued—concerned with her work and her health.
His gratitude for the drawings, for feeling responsible for their protection
as works of importance, was with him from the first to a touching degree.

**Stieglitz to Georgia, New York City, July 10, 1916**

Have you drawn any since you left New York? Where is Anita
Pollitzer?—has she left town? .  .  . Little did I dream that one
day she would bring me drawings that would mean so much
to 291 as yours have meant—nor did you dream when you
did them that they would—or could—ever mean so much to
anyone as they have to 291.

**Stieglitz to Georgia, New York City, July 16, 1916**

The pictures are down—not a picture on the walls of 291—
there'll be none all summer. Some of your drawings, I'm hav-
ing framed to protect them—they have meant so much to me
that I can't bear the thought they may be soiled—rubbed—for
they are not fixed."

Then a letter from Georgia marks a transition.

**Georgia to Stieglitz, Charlottesville, Va., July 27, 1916**

.  .  . [N]othing you do with my drawings is "nervy." I seem to

feel that they are as much yours as mine—they were mine alone till the first person saw them—I wonder which one it is you want to keep.

At this time, Stieglitz with all his skill and tenderness had photographed her drawings that were in the exhibit. She wrote to him that she was making more pictures and would send them to him if he wished.

**Stieglitz to Georgia, New York City, July 31, 1916**

Of course I knew you'd be surprised at the photographs—I had fun in doing them. The one I want most is the one that hung on the left wall—to the right of the *seething* one—The one I considered by far the finest—the most expressive. It's very wonderful—All of it—There are others running it a close second—but none gives me what that one does.

. . . The frames are as yet not finished—Will the pictures lose any of their freedom? I don't like the idea of a frame around them—any more than I'd like the *Mountain and Night* framed in—but there is no way out if the drawings are to be protected, and that I insist they must be. So frame goes into that! Life again!

Would you really send up those last?

Quite a few people were disappointed to find your drawings down, but they are coming in the autumn to see them—See what a fine thing it was of Anita Pollitzer to chase down to me with them! And against all orders.

After the exhibit, Georgia wrote to me from the University of Virginia:

**Georgia to Anita, Charlottesville, Va., summer 1916**

Stieglitz has been writing me. Yesterday he told me that he had taken my things down and the place is empty. But his

letters, Anita, they have been like fine cold water when you are terribly thirsty.

Georgia's mother died in May 1616. Through changing fortunes Mrs. O'Keeffe had kept the goals high for her children. Her faith in them had been complete. She had instilled in Georgia the thought that she could succeed in whatever she attempted.

From Lake George, where Stieglitz always went when he closed the gallery for the summer months to be with his mother, brothers, and sisters, and their families, he began writing to Georgia.

She answered him in a letter which touches something deeply felt and expressed probably for the first time.

**Georgia to Stieglitz, Charlottesville, Va., summer 1916**

> I think letters with so much humanness in them have never come to me before—I have wondered with every one of them —what is it in them—how you put it in—or is it my imagination—seeing and feeling—finding what I want— they seem to give me a great big quietness.

Stieglitz needed no encouragement to write. He was a great letter writer. For a person as withdrawing as Georgia, letters undoubtedly brought them closer than conversations would have allowed. To say that she understood Stieglitz would be an exaggeration. But that was not important to him for he did not expect to be "understood." However, from the outset of their correspondence each filled an amazing need in the life of the other. The artist in Georgia reached to the artist in Stieglitz. She had an intense appreciation of what he accomplished at 291.

I think that Georgia's admiration for Stieglitz's crusading spirit, for his characteristics and complexes, so different from anything she had known, had been made more possible by the fact that her grandfather had been regarded as a great individualist and that individualists had been greatly admired in her family. She therefore had no feeling that the standards of Sun Prairie or of Williamsburg were the only ones that counted.

The fact that Stieglitz was always the center of a whirlpool seemed more understandable since her mother, in her own far smaller circle, had always been at the center of activities. But most of all, it was their attitude toward art that drew them together.

**Georgia to Anita, Canyon, Texas, January 17, 1917**

> Tonight I'm doing up all my work—am going to send it off in the morning—you or Stieglitz will get it—I don't know which—won't know till I address it. I'm going to start all new. . . .

Later, she wrote me that the bundle of drawings had been addressed to me by her, left with someone to mail and never sent. She did not consider these drawings as more than work in which she was trying to prove something to herself.

Shortly after that, Georgia sent Stieglitz a bundle of new drawings by unregistered mail. They were the first Georgia had sent directly to him, and the first he had seen since those I had taken to him. They reached him in August at Lake George. For him, they were a very personal affair. Marsden Hartley jestingly called them "Stieglitz's celestial solitaire," and told how Stieglitz carried them around with him.

**Stieglitz to Georgia, New York City, 1917**

> This merely to tell you the drawings are safely in my hands and that I am grateful—as I have ever been to you since I was first given the privilege to see your self-expression.

To have her work so believed in by Stieglitz was a wonderful happiness.

# CANYON: 1916–1918

*J*HE 1916 summer session at the University of Virginia completed, Georgia left for Canyon, Texas, to take up her appointment as head of the art department at West Texas State Normal College. One midnight in the first week of September, she arrived by train at "a place so small, one could count the houses easily in half an hour."

**Georgia to Anita, Canyon, Texas, September 11, 1916**

> Tonight I walked into the sunset—to mail some letters—The whole sky—and there is so much of it out here—was just blazing—and grey-blue clouds were rioting all through the hotness of it—and the ugly little buildings and windmills looked great against it.

> But some way or other I didn't seem to like the redness much so after I mailed the letters I walked home—and kept on walking—

> The Eastern sky was all grey-blue—bunches of clouds—different kinds of clouds—sticking around everywhere and the whole thing—lit up—first in one place—then in another with

flashes of lightning—sometimes just sheet lightning—and sometimes sheet lightning with a sharp bright zigzag flashing across it—.

I walked out past the last house—past the last locust tree— and sat on the fence for a long time— looking—just looking at the lightning—you see there was nothing but sky and flat prairie land—land that seems more like the ocean than anything else I know—There was a wonderful moon—

Well I just sat there and had a great time all by myself—not even many night noises—just the wind—

I wondered what you are doing—

It is absurd the way I love this country—Then when I came back—it was funny—roads just shoot across blocks anywhere—all the houses looked alike—and I almost got lost—I had to laugh at myself—I couldnt tell which house was home—

I am loving the plains more than ever it seems—and the SKY—Anita, you've never seen such SKY—it is wonderful. . . .

**Anita to Georgia, Cambridge, Mass., September 15, 1916**

Pat—your letter was genuinely great—My it did me good— first thing like it I've had in months. Why I simply saw your Sky—I wish I could—gosh this place is—well its Boston! . . .

I never sent you the El Greco I got for you. Look at him very long at once. If I can find him I'll send it. . . .

**Georgia to Anita, Canyon, Texas, fall 1916**

Anita—I wonder what the El Greco does to you—

My eyes just keep going over it—from one part to another— all over it—and then over it again—and I want to see it really—it keeps me moving. . . .

Last night I couldnt sleep till after four in the morning—I had been out to the canyon all afternoon—till late at night—

wonderful color—I wish I could tell you how big—and with the night the colors deeper and darker—cattle on the pastures in the bottom looked like little pinheads. . . .

. . . Then the moon rose right up out of the ground after we got out on the plains again—battered a little where he bumped his head—but enormous—There was no wind—it was just big and still—so very big and still—long legged jack rabbits hopping across in front of lights as we passed

—A great place to see the night time because there is nothing else—

Then I came home—not sleepy so I made a pattern of some flowers I had picked—They were like water lilies—white ones—with the quality of smoothness gone. . . .

. . . Anita—I'm so glad I'm out here—I can't tell you how much I like it. I like the plains—and I like the work—everything is so ridiculously new—and there is something about it that just makes you glad you're living here—You understand—there is nothing here—so maybe there is something wrong with me that I am liking it so much. . . .

Never could anyone have been more in love with the country and less pretentious about her own painting.

**Georgia to Anita, Canyon, Texas, October 1916**

I wish you could see the landscapes I painted last Monday out where the canyon begins. . . . You possibly remember that my landscapes are always funny and these are not exceptions—Slits in nothingness are not very easy to paint—but its great to try—Im going again Monday if it isn't too windy. . . .

The letters—291 letters—have been great—sometimes they knock me down—but I get up again. . . .

Walked out in the plains in the moonlight—there is no wind—so still and so light—I wish you could see it. . . .

It's great—I'm not even having the smallest wish for N.Y.— Isn't it funny?

**Georgia to Anita, Canyon, Texas, fall 1916**

The plains are very wonderful now—like green gold and yel-
low gold and red gold—in patches—and the distance blue
and pink and lavender strips and spots—May sound like a
Dow canyon—but its wonderful—specially in the evening—
I usually go alone—Yesterday rode home on a hay wa-
gon—no it was clover. . . .

The correspondance with Stieglitz continued.

**Georgia to Anita, Canyon, Texas, fall 1916**

. . . This morning under my door when I came from breakfast
were three letters. One from you—and such a nice one Ani-
ta—I read it first—One from Arthur [Macmahon]—such a nice
one I read that second—and last—but not least of all—there
was no least—one from Stieglitz. His address is still Lake
George if you want to write him—Anita—he is great. . . . I'm
enjoying his letters so much—learning to know him—the way
I did you—and Anita—such wonderful letters—Sometimes he
gets so much of himself into them that I can hardly stand it—
it's like hearing too much of Ornsteins "Wild Man's Fancy"—
you would lose your mind if you heard it twice—or too much
light—you shut your eyes and put one hand over them—then
feel round with the other for something to steady yourself by.

**Anita to Georgia, New York City, October 2, 1916**

. . . I don't envy you your Stieglitz letters—I don't believe I'd
be strong enough to stand them. . . .

**Georgia to Stieglitz, Canyon, Texas, fall 1916**

It seems so funny that a week ago it was the mountains
I thought the most wonderful—and today it's the plains—I

guess it's the feeling of bigness in both that carries me away.

**Georgia to Stielgitz, Canyon, Texas, September 5, 1916**

It's very still—only one cricket and myself awake in all the Panhandle—and it's four in the morning. No wind tonight. I rode and rode—from the glare of the middle afternoon till long after the moon—a great big one—bumped his head just a little—enough to flatten one side a little—as he came up out of the ground—light. First plains—then as the sun was lower the canyon—a curious slit in the plains—cattle and little bushes in the bottom pin heads—so small and far away—wonderful color—darker and deeper with the night. Imagination makes you see all sorts of things.

**Anita to Georgia, New York City, November 7, 1916**

Cattle, the heavy fat kind that spend their days eating and roaming, stodgy and unable to care—moving slowly—walking two steps and then back two—just *like* each other, perhaps colored a little differently—but not much else—

That's what I'm like!—just—I've never felt so sick—I feel as though I were a piece of putty or clay—molded after a fashion but poorly done and ¾ accidental—thrown on the sidewalk and there it stayed. Could have changed itself to any shape you know—if someone had only stepped on it—if it had banged itself a bit—but it doesn't—it's too inanimate—too dead—too usual.

Pat I'm nearly crazy—I played on the piano & it helped some. Perhaps I've been reading too much Oscar Wilde—but it's wonderful stuff.

Perhaps & most probably the League and all the League implies is getting on my nerves—I'm too old in ideas to sympathize with the League. They *play* their ideas—but gosh its awfully forced. . . .

I think I'll spend tomorrow with 291—It is a stimulator—why

I breathe there—Talk about asthma cures—Taking deep
breaths! Well I guess it will help. But that's tomorrow. . . .

**Georgia to Anita, Canyon, Texas, November 1916**

Its funny that your letter this morning should say you feel like
cattle—well fed—

I opened it as I went out the front door—and as I opened
the door—I heard cattle—many—in the pens over by the
track—lowing—I wonder if you ever heard a whole lot of cat-
tle lowing—it sounds different here—too—just ground and
sky—and the lowing cattle—you hardly see—either them or
the pens—the pens are of weather beaten boards—take on
the color of the ground it seems—I like it—and I dont like it—
its like music. . . .

Im glad you dont like the League—I don't know that I'm
sorry you are having a bad time—you will get over it—and—
someway or other those bad times make life seem more fun
when it is fun again. . . .

The disquieting sound made by many cattle haunted her; it suggested
shapes and color that she used in certain drawings and in later paintings.

She was reading a good deal: Ibsen, *The Divine Comedy*, George
Moore, Herman Melville, Charlotte Perkins Gilman.

After their mother's death in May 1916, Georgia sent for Claudia, her
youngest sister, to come and stay with her. Together they enjoyed playing
tennis and walking miles in the country. The residents of Canyon used
to say that the art teacher could outwalk any man. Her pupils admired
her athletic skill. Nothing she did was like the behavior of any other faculty
member. Nor did it occur to her that it was usual to conform.

Many of the students were older than the usual college age and very
appreciative of their new art teacher. She told them things about nature
that no one had ever thought of saying to them before. Years later, a
former Canyon student said that as a teacher she had told them, for in-

stance, that a prairie wind in the locust trees has a sound all its own. Another revealed years later how she had first listened to music carefully when Miss O'Keeffe had asked the class to express in pictures what the music in chapel had meant. This was 1916. On their walks, she had them listen to the rustling grass.

Georgia to Anita, Canyon, Texas, October 5, 1916

> . . . I discovered that by running against the wind with a bunch of pine branches in your hand you could have the pine trees singing right in your ears. . . .

In January 1917, she was to be the speaker at the Faculty Circle; her subject was modern art. She worked on the lecture from November to January getting her material in shape; her reading in aesthetics included Willard Huntington Wright, Clive Bell, Wassily Kandinsky and Jerome Eddy. The three-quarters-of-an-hour talk interested the faculty so much that she was asked to continue to talk an hour after the usual adjournment time. The campus buzzed with talk about "modern art," and she was invited to be the speaker again at the next meeting of the Faculty Circle.

At the college, in addition to the usual courses in draftsmanship and color, Georgia was teaching two classes in design—one in costume and the other in interior decoration. In all her classes she encouraged new ideas in her students. She admonished them not only to look but to listen to music and also to the sound of the outdoors. She felt that all the senses contributed to art and went into the painting.

Georgia to Anita, Canyon, Texas, February 19, 1917

> The Spring quarter begins Tuesday—Havent had but about an hour to myself all week—That was yesterday so I got a box of bullets and went out on the plains and threw tin cans into the air and shot at them. It's a great sport—Try it if you never have. . . .

She accepted few social engagements because, after her hours of teaching and studio work, she wanted her spare time for her own drawing and painting. Of Canyon, she later told me, "I belonged. That was my country—terrible winds and a wonderful emptiness."

When the senior class was putting on a play, the head of the drama department suggested that Miss O'Keeffe be called in to help with the stage setting. It was a day of pouring rain. In the room was Ted Reid, one of the older students who was responsible for the lighting. Before entering college Ted had worked from the time he was fifteen, shipping cattle for his father. For years he had taken the herds alone on the road from Texas to Kansas and had known the beauty of wild country. He was strong and big and about the same age as Georgia.

On looking up, he saw Georgia at a window, watching the rain come down in sheets, pouring down as it does in Texas. Most people would have thought it a dreary day, but just as the young man was thinking how extraordinary a spectacle it was, he caught sight of this lithe young woman, standing at the window, fascinated.

He had never seen her before. Here was someone who showed that she felt exactly as he did about this beauty; who loved nature she beheld as he did. He walked over to the window and without a word, put his arm around her. Georgia, startled and furious, pulled away and swiftly left the room.

But as the play had to be put on, they soon met again and worked together in the following days. As they got to know each other, each marveled at the other's knowledge of the outdoors and the love of it. They enjoyed long walks together in this country that she loved. This was prior to America's entrance into World War I, and friendships of well-bred young people were at most conservatively romantic.

It was at this time that Georgia received from Stieglitz the photographs he had taken of her drawings in the 291 exhibition, and some copies of his *Camera Work* with its beautiful photographs. They moved her greatly. She lived in the house of one of the faculty members on the campus and the day she received the photographs from Stieglitz she asked the young man up to her room to see them, for she considered them her newest treasures.

In those days many college campuses were puritanical in their regu-

lations. Probably no other woman faculty member there would have been unaware of the ironclad rule that men students could not visit nor make dates with faculty women. That such a ruling existed had never dawned on her, nor would she have thought it important.

Ted was soon called upon by a small group of women connected with the college, reminded that graduation was near and that he stood high among the seniors. He was warned of the ban against students making dates with faculty members and told that if he went out again with Miss O'Keeffe he would not graduate.

The United States was then on the verge of war. Aviation was in its infancy and the great ambition of Ted's college years, during which he had achieved excellent grades, was to be a pilot. Indignant as he was, there seemed no alternative. He stopped seeing her. He did not tell her why, for he feared that she, with her independence, would make a great protest to the authorities and say things regrettable for both of them. He did suggest icily to the ladies who called on him that they speak with Miss O'Keeffe, but this they were apparently afraid to do. That spring, Ted graduated with high marks and was immediately sent overseas as a pilot.

It was thirty years before Ted and Georgia saw each other again. The occasion was the opening of her retrospective exhibition at the Museum of Modern Art in New York, May 14, 1946. He had by then served in two World Wars. Arriving in New York, he saw the notices in the papers of her large retrospective show to open that evening. He telephoned, and she asked him to come right over.

While they talked, Georgia said, "Do you know that you dropped me like a hot cake at Canyon? Nothing like that ever happened to me before." And then he told her why, and that before his graduation he had not dared to tell her, afraid of the result of her outburst to the college authorities.

That night in 1946, at the party given in her honor, after the Museum of Modern Art opening, she introduced him to me, reminding me that he was "the boy from Texas." Georgia left us together while she greeted some museum officials. I asked him what he remembered about Georgia in those Canyon days.

With a directness that seemed to wipe out the intervening years and the different directions their lives had taken, he answered me: "Did you

ever see the rain with Georgia? Did you ever see her watch a great storm? I knew and loved that country well and here for the first time was someone who felt the same way about it. There was never anyone in the world like her in her appreciation of such things. She always wanted the best and there wasn't any camouflage in her."

It was in April of 1917, while Georgia was still teaching art in Canyon, that the United States went to war with Germany. Canyon, before this, had seemed remote from New York but now as the campus seethed with war activity, and recruiting was accelerated, it seemed very close to the death and destruction of the Marne and Ypres. Boys off the ranches, who knew nothing of the world and certainly nothing of war, were being shipped abroad.

It was also in April 1917, while the world was stunned with the tragedy of war, that Stieglitz presented the second exhibition of O'Keeffe's work at 291. The catalog for this showing read:

> An exhibition of the recent work—oils, watercolors, charcoal drawings, sculpture—by Georgia O'Keeffe of Canyon, Texas, will be held at the Gallery of the Photo Secession—Opening April 3rd and closing April 27th.

People came again and again, saying before even the most abstract of drawings and water colors, "Life is like that." Strangers used the words "sincere," and "beautiful" for her work. The work did not seem to resemble that of any other artist, and there was a complete absence of the contrived. Her famous *Blue Lines—Abstraction, Number 11* (1916) was among the pictures in this exhibit. At a time when most artists were doing very rec- ognizable objects and scenes, much of the work in this exhibition was abstract, with exceptional emotional quality. The lines were sensitive and the forms rich and full.

In this earliest period there were also fine water colors, including *Red Canna* (1915), and *Seated Nude* (1915), which in their feeling seem closely related, in spite of the divergence of subject.

WEST TEXAS STATE NORMAL COLLEGE, CANYON, CIRCA 1916

William Murrell Fisher, *Camera Work*, June 1917

> In recent years there have been many deliberate attempts to
> translate into line and color the *visual* effects of emotions
> aroused by music, and I am inclined to think they failed just
> because they were so deliberate. . . . Quite sensibly, there is
> an inner law of harmony at work in the composition of these
> drawings and paintings by Miss O'Keeffe, and they are more
> truly inspired than any work I have seen; and although as is
> frequently the case with "given writings" and religious "reve-
> lations," most are but fragments of vision, incompleted move-
> ments, yet even the least satisfactory of them has the *quality*
> of completeness—while in at least three instances the effect is
> of a quite cosmic grandeur.

Of all things earthly, it is only in music that one finds any analogy to the emotional content of these drawings—to the gigantic, swirling rhythms and the exquisite tendernesses so powerfully and sensitively rendered—and music is the condition towards which, according to Pater, all art constantly aspires. Well, plastic art, in the hands of Miss O'Keeffe, seems now to have approximated that.

When Stieglitz hung her pictures, he wrote to her in Canyon that he had decided to close 291 and that this would be the last exhibition ever to be shown in this gallery. This closing of 291 had been a dreadful decision for him. He was heartsick about the war and also about the harm it was causing all over the world to creative art. His letters to Georgia kept coming.

At the beginning of the school vacation in June 1917, she decided on the spur of the moment to go to New York for a ten-day trip. Leaving Texas for New York on the first train after this idea had occurred to her, and taking almost every cent she had in the world to do so, was typical of Georgia.

When she arrived in New York, unexpected by Stieglitz, the exhibition was over and her pictures were down. Stieglitz, to whom nothing was ever too much trouble, rehung the entire exhibition so that she could see it on the wall, as it had been. Only those who have ever hung a show will know the labor involved. Only those who remember his exhibitions will know the perfection of placing he aimed for and achieved.

Stieglitz had sold one drawing from this exhibition to a friend and art lover, Jacob Dewald. It was a charcoal drawing of a train coming into the station in the early morning—symbolic clouds and vivid motion. It had been made because of Georgia's desire to tell in a drawing of a dramatic moment. One day in Canyon, she had had to ride quite a distance to teach her class in the early morning. She got into one of the few available hansom cabs and realized after she was in that the other passenger in the cab was drunk. She stopped the cab and got up on top with the driver. The dawn was just coming in—a superb dawn. Suddenly a train whizzed past. Georgia had made a picture of it that evening as soon as she reached

home. This, Stieglitz told her, was the first of her pictures to be sold. He also told her that he could have sold more from the exhibition, but he would not part with them.

Georgia saw Stieglitz at the gallery several times during this brief New York visit. Once he took her with friends of his—Henry Gaisman, an inventor, and Paul Strand, the photographer—to Coney Island. She wrote me what a good time they all had and how she had almost lost her mind over Strand's photographs "that are as queer in shape as Picasso drawings." At this time Stieglitz took his first photograph of her.

**Georgia to Anita, Canyon, Texas, June 20, 1917**

> You see—being in N.Y. again for a few days was great—I guess I did as much in ten days as I usually do in a year—Dorothy [True] is looking better than last year. . . .
>
> Bement is married—An actress quite pretty—about 35 I imagine—Sells his pictures so he says—He likes the combination of wife and agent.
>
> Martin same as ever—A bit discouraged over his work because he doesn't get much encouragement from the college. Of course that is natural. . . .
>
> Stieglitz—Well—it was him I went up to see—Just had to go Anita—There wasnt any way out of it—and Im so glad I went. 291 is closing—A picture library to be there—Pictures to rent out—He is going to have just one little room 8 x 11 to the right as you get out of the elevator—Just a place to sit he says—I dont know Its all queer—But Anita—Everything is queer. . . .

After New York, she returned to the college in Texas for her summer teaching. She wrote me that Stieglitz's letters had continued and that they were "amazing . . . like diaries." And she added: "I am more pleased to have him interested in my things than any person I could think of." She also told me that she had gone "to see the gallery before it was ended, because of the kind of things Stieglitz created in the room."

With the exhibition announcement of Georgia O'Keeffe's pictures still

on the door, Stieglitz closed 291 forever, putting in storage the Marins, the Hartleys and the O'Keeffes, paintings of which he felt himself the protector. The gallery had accomplished the pioneer work of bringing the new art from abroad and of starting to secure recognition for certain American painters whose work Stieglitz felt was significant. When Stieglitz had first begun to show European art, a customs bond had been required for those dealers bringing art into the country from abroad. This requirement had ended, and therefore other galleries were now willing to risk the "new art" from abroad, for which his fight had been made.

Before she had left by herself for New York, Georgia had promised her young sister Claudia, that during the 1917 fall vacation she would take her on a trip wherever Claudia wished to go. Claudia chose Colorado.

The day they were to leave Canyon the rains had washed away the bridges and no trains could go directly north. The only way to Denver was by way of Albuquerque; it was in this way that Georgia had her first glimpse of New Mexico, which was to become so important in her life and in her painting. Claudia had studied about the early days of Santa Fe in her history class. So they went to Santa Fe. "After a few days there," Georgia told me, "in my mind, I was always on my way back to New Mexico."

After Denver, they went to Estes Park, where their vacation was spent camping and mountain climbing, the two girls walking wherever they wished, alone.

In September, Georgia was again teaching at Canyon. At Thanksgiving, there was a Texas State Teachers' Convention in Waco. Georgia, discouraged by the war fever in her college town, went there "to see if the world was as crazy everywhere." Here, she made a notable speech before the state convention on the principles of art teaching.

Back on the campus of the West Texas State Normal College, the tension of war increased; many of the young, unprepared boys who had departed were her students. She had never before been a part of anything that so upset her. She went to the authorities to ask if the boys who were being sent abroad could not have a brief course in what the war was about. The glorification of war that organizations were lending themselves to

filled her with horror.

Her younger brother, Alexius, had by then gone to the front. It seemed to her that the world was losing everything to death and destruction, that the ground was caving in. Under the strain, she became ill and could not go on teaching. She struggled with herself and then decided to ask for a leave of absence, which was granted her. Her position would be held for her, the authorities said, until her return.

Early 1918 she left for her friend Leah Harris's ranch at Waring, near San Antonio—"as extraordinary a farm, and as wonderful as ours had been in Sun Prairie," she wrote.

One day, she went to town and chanced to meet the superintendent of schools for San Antonio who had heard her address the State Teachers' Convention. He asked her if she would come to supervise art in San Antonio. But life was good in the country, she had not regained her strength, and she refused the offer. What Georgia felt she most needed and wanted was a continuation of the isolation and freedom of the ranch. Here, without the teaching, for a while at least, she would have the freedom to paint and to work at whatever she pleased.

**Stielgitz to Georgia, New York City, March 31, 1918**

> You have become a very important factor in 291 [291 was closed; Stieglitz was referring to the continuance of the spirit of its work.]—a concrete force. If you heard and saw me, you'd only smile. Of course I am wondering what you have been painting—what it looks like—what you have been full of—The Great Child pouring out some more of her Woman self on paper—purely—truly—unspoiled.
>
> . . . Your health is my first thought.

In April Stieglitz sent her a paint box and brushes. To him, she wrote from the Texas ranch on April 19: "It's a wonderful place—I wonder why everyone doesn't live here."

Elizabeth Stieglitz, Alfred's niece, had begun writing to Georgia to urge her to come to New York and stay in her studio on Fifty-seventh Street.

**Georgia to Elizabeth Stieglitz, Waring, Texas, 1918**

You ask me to write—even if it's only farming—well—I've in-
tended writing for some time and haven't done it because—
why just because I'm me I guess. I walked to the store this
afternoon to get the mail and you have to walk across a pota-
to patch to get home. I was looking down at the potatoes—
thinking to myself—Why in the devil does she (meaning you)
think I'm worth anybody's caring, if she thinks I'm not going to
do as I please whenever I can possibly find a way. . . .

Just because I want to talk to him, I may go East this
Spring—I don't know—I can't tell. He is probably more neces-
sary to me than anyone I know, but I do not feel that I have to
be near him. In fact I think we are probably better apart. I
don't know but I think we are. Maybe I ought not to send this
to you. It may not sound exactly kind—Still—you have made
me feel a big savage. It's all right—I don't mind—only nobody
can make me feel something I just don't feel.

In Spring 1917, the Society of Independent Artists' first exhibition had
been held in New York City—the result of a long, anticonservative art
struggle. The innovation of this exhibition was that there were no jury and
no prizes. Its emphasis was on American art as the emphasis of the Armory
Exhibit had been on European art. Georgia was represented by two
works— *Expression #14* and *Expression #24*. She wrote me at the time
that Stieglitz had suggested that she send pictures to this exhibition.

A glance at the illustrations in the catalog shows that most of the pictures
were still largely romantic and realistic. Georgia's were subjective and
imaginative. The fact that this show had created ongoing discussion about
her work in New York art circles for its individuality of content and expres-
sion was not of the slightest concern to her. She continued to bask in the
sun at Leah's farm and enjoy the freedom and rest she craved.

Freedom of thought and the ability to work was one thing, but the safety
of this young woman was another. Stieglitz decided that Georgia must
come to New York. It was characteristic of him that once he had made a
judgment, he would sweep aside every obstacle to bring it to pass.

Georgia was angry about this talk of her welfare. In her whole life, she seems not to have known physical fear. She and the out-of-doors had always seemed of a piece; her long country walks in every place she had ever lived, her recent Colorado mountain climbing and now living on the Texas ranch, all seemed part of the repeated pattern of her life.

In her letter to me of April 30, 1918, she wrote from Waring, "I want more than ever to write music." Also, "Tonight a little wind—maybe finer than the stillness." The isolation of the ranch held no terrors for the two young women. Leah's father had been the publisher of the only Republican newspaper in Arkansas and Leah had been brought up knowing how to shoot. On the ranch now she never went out nor to bed without a pistol.

One night Leah and Georgia were startled by car lights down the road. Then they heard a man's voice. They ran out of the house, Leah in her red kimono, her pistol ready for action; Georgia in a pair of old-fashioned flannel pajamas with long legs and feet all of one piece that she had made for herself years before in Amarillo. The whole incident turned out to be merely the driving of an inoffensive old man who lived a distance down the road; but had there been trouble, they felt they could have handled it.

Georgia wrote of the incident along with other events in her life to Stieglitz. She related what had seemed to her just an exciting tale. Reading this, however, Stieglitz, who did not know Texas or ranches, became very anxious. Georgia's safety had become very important to him. It was unthinkable that she should stay there. She must come to New York. Certain that it was for her good, he sent for her to come.

New York, as a place to work, had been a possibility that she had considered when she took her leave of absence from teaching in Canyon but she had dismissed the idea. She was used to abiding by her own decisions; however, seeing Stieglitz again for a short while was nothing she wished to resist.

He was the revered leader to a whole generation of those to whom originality in art counted and when he sent for her, she made up her mind to go to New York and tell him in person that the city had no real place in her life. The world she wanted was different.

# WITH STIEGLITZ IN NEW YORK CITY: 1918

FROM the moment Georgia reached New York in 1918 and Stieglitz began to talk to her about art, about herself and her work, she realized that she had never met anyone like him before. Often since, she has said about him what she realized then: "There was no one like Alfred. He was the man and the idea"—those ideas in art that he held without compromise.

Georgia remained in New York City, living in the studio of Stieglitz's niece, Elizabeth, who had gone to the Lake George home, used by the family in spring and summer.

At the time that Georgia came to New York, Stieglitz was fifty-four and she was thirty-one. He, who had been such a passionate fighter for everything that touched on his beliefs, felt that the day of his battling for ideals was over. The war and the havoc it was causing among the artists contributed to his feeling of defeat. He and his wife had parted and he no longer had his own home. The gallery at 291, with its endless work for which he had so long been responsible, was no longer in existence. All that remained was a cubbyhole he had kept for his photographic equipment.

Shortly after Georgia's arrival, Stieglitz put this question to her: "What do you want to do more than anything?" At her silence, he repeated his sentence adding the question: "To teach art?"

To that she answered: "I would like a year to paint." "I will see that you get it," he replied.

A 1918 PORTRAIT OF O'KEEFFE BY STIEGLITZ

It was the same answer, under the same circumstances, that he would have given to Marin or Hartley or Dove or to any of those who needed an opportunity to paint and in whose work he thoroughly believed.

From the first time that he had seen Georgia's work, he had referred to her as a "first-rate artist," and unlike the views of the other leaders in the arts, the idea of a woman in this position was not a difficult one for him to accept. He had known the "first-rate photographers" among women, and had heralded the outstanding contributions of such leaders as Gertrude Kasëbier and Annie W. Brigman. He did not separate the achievements of women from the achievements of men; he took pleasure in saying, "I stand by the work."

Stieglitz's image of women seemed a composite of the romantic heroines of Wagner and of Goethe whose work he knew so well, and a personal belief in what modern woman could accomplish.

He called woman "the great force in the Universe if only she knew and trusted her strength." Of Georgia's drawings and paintings he said, "Woman is, at last, on paper, expressing her relation to the Universe."

To him, Georgia's art with its depth of feeling came like the fulfillment of a prophecy.

How transformed Stieglitz's world had become! Everyone heard from him of this wonderful young women who had arrived in New York. She represented the independence that he, so courageous in his public life, had always yearned for in his personal life. He talked on and on about her. Again and again I heard him say, "She is innocent." These words, and the special way in which he said them, were so impressed on my mind, that I was startled to come upon this paragraph by Jean Giraudoux, in his *Littérature*:

> . . . [T]he characteristic of the innocent being is the absolute unconsciousness of its own innocence and the belief in the innocence of all other beings.
> . . . The innocent one is he who does not explain, for whom life is both a mystery and a total light, one who does not complain. . . . For innocence admits of neither regret nor dispute. The innocent one assumes all responsibility. . . .

This expresses precisely what Stieglitz recognized and found so
rare in Georgia.

About those New York days, when she was thrown into a maelstrom
of talk, new situations and the interpretations of others, she told me: "I
took it all as it came. Stieglitz was Stieglitz to all of us. I had so much to
work out that I had started on at the ranch, and in New York I went on
working." Sometimes she painted twelve hours a day. She was content
with her life.

To some, love and the intimate companionship of a loved one would
distract from their work. Georgia did not want to be carried out of her
work, Stieglitz did not want her to be, nor was she.

She had tremendous faith in him and because of this, at a time when
he had been so dejected, his world was good again. For him, the whole
of life was here together, fused in one person and her painting.

For her, too, life was good, as Stieglitz was an incredible person— sen-
sitive, brilliant and kind. Nothing in her whole life's experience had pre-
pared her for the New York art "intellectuals" she was meeting through
him or for the discussion that now surrounded her.

"I painted all day," she said, "and when Stieglitz came in the evening,
we went out to dinner, usually to the little restaurant on Columbus Circle
where his group of artists knew they could find him and where the art
talk could go on for hours."

Sitting at Stieglitz's side, Georgia rarely joined in the conversation. She
wondered how people could talk so much. Sometimes they would discuss
her work. She thought their ideas amazing, but ideas were personal, she
felt, and she could keep her own. But what Stieglitz said about art and
the pictures was of supreme interest to her.

As to the others, she was, for the most part, indifferent. Those in the
group around Stieglitz talked about everything they saw in her drawings
and paintings—her work came in for their full share of "interpretation."
When such judgments were proclaimed, if she spoke at all, Georgia would
raise her brows and say, "Have it the way you want it," or "I never thought
of such things."

In June 1917, when Georgia had come to New York to see her second

THREE STUDIES
OF O'KEEFFE'S HANDS
BY STIEGLITZ

exhibition, Stieglitz had begun to photograph her. Now, again, he brought out his camera and photographed her. To this period we are indebted for some of the most sensitive photographs of a woman's body ever made, as attested by his prints of her in the National Gallery of Art in Washington, D.C., the Metropolitan Museum in New York and the Boston Museum of Fine Arts.

Stieglitz had had the idea for some time, long before he knew Georgia, of doing a series of photographs on woman—not woman stylishly gowned or languorously draped—but woman. This was the first period when he did not have a place of his own in which to work, but here at last was someone who understood the importance of his photographs and wished to help him get the pictures he wanted.

Georgia had a profound respect for his work and what he was achieving through it. "I felt somehow that the photographs had nothing to do with me personally," she said. One day, years later, she and I were talking about what we liked most in the world's great art. I had said what I thought, and then Georgia, after thinking so intently that I wondered if she were ever going to speak, said, "I think Alfred's photographs are perfectly beautiful." Another time, when we were talking about his photographs, Georgia said with reverence, "Alfred handled a sheet of paper as if it were a butterfly's wing."

"I had a kind of belief in Alfred that made those days specially fine," she said. "I had a need of him that I had never seemed to feel for anyone else before. His feeling for music, concerts, books and the outdoors was wonderful. He would notice shapes and colors different from those I had seen and so delicate that I began to notice more."

Stieglitz and Stieglitz alone, with his concern for the things she felt important and with a love unlike any she had known, was able to break through the circle of reserve that heretofore she had surrounded herself against any true intimacy.

# LAKE GEORGE: 1918

$\mathcal{I}$N August of 1918, when the weather was at its warmest in New York City, Stieglitz took Georgia to his mother's house on the shore of Lake George in New York State. It was a close-knit family, focused on Stieglitz's mother, who was idolized throughout her long life by family who gathered round her at Lake George every summer. In New York City Stieglitz would visit her every Wednesday night and Sunday morning, as long as she lived, no matter what else of importance might occur.

Once when I asked Georgia about the beginnings of her life at Lake George, she answered thoughtfully: "Why don't you talk to Margaret Prosser. She was at the lake when I was there. I have known her a long time and I have never known her to misinform anyone."

Born in Newfoundland, Mrs. Prosser, a silent, wise person, worked for the family as housekeeper for forty years. Through those years, she kept a rocking chair in the kitchen and there Stieglitz would sit by the hour and talk to her. She was careful and thorough in all that she did, and that he admired. As Georgia expressed it, "Margaret could take a room and find good places for things. She had an eye."

After Stieglitz's death when I met her in New York, I asked her about the years when Georgia and Stieglitz were at Lake George. "Mr. Alfred never would have been the photographer he later was if he hadn't got with Georgia," she told me. "I saw his early photographs, I saw his late photographs, the negatives would hang up in my kitchen to dry. I saw

STIEGLITZ'S 1932 PHOTOGRAPH OF LAKE
GEORGE IN THE VICINITY OF THE
FAMILY SUMMER HOUSE

them all, and I heard him talk about them all, and what they meant. He did wonderful street scenes, portraits, railroad tracks and all that before Georgia came. But after Georgia came, he made the clouds, the moon, he even made lightning. He never photographed things like that before. A smile from Georgia was all he needed to make him happy.

"When he brought Georgia up to Lake George in late August 1918," she continued, "she was a young woman with the makings of an artist in her. Old Mrs. Stieglitz was very nice to her from the start and always. She was glad Mr. Alfred was so happy. When Georgia came up to the lake, what a crowd we had—all the family and the in-laws. At the big table, Georgia's place was between Mr. Alfred and his mother, who would pick out the best of everything at the table for Georgia. Mr. Alfred and Georgia loved their walks and would climb up Prospect Mountain at the lake as if it were nothing."

Mrs. Prosser paused for a moment, obviously moved, and I asked her if she would like to stop telling me about those days. She answered that she liked to think of these memories and would not be talking to me at all except that she had heard Mr. Stieglitz speak of me.

"I was just remembering that quality in Mr. Alfred—his feeling for people," she said. "I was remembering how good he was to everyone, to the man who worked in the field, the people in the village. If he saw something special in anyone, he was for that person. When I went home at night he would say, 'Thank you, Margaret, for what you've done today, money can't pay for it,' and he always stood up when he said good night.

"The servants liked Georgia from the first and we liked to look at her. How she loved good work. I never knew anyone who could do so many things so well. She could clean a room so that not a speck of dust was left in it—and her apron so clean at the end of the work. She could paint all day, pick it up, and there would be the painting before you and nothing disarranged."

Mrs. Prossor told me how for years Stielgitz showed her every photograph he made at the lake. ". . . [T]he knots on the trees, the wrinkles on the faces. He brought them into the kitchen, let the water run over them, hung the negatives there to dry, talking to me about them all the while. But never through the years did he let me touch or move anything that belonged to his photography. Georgia could, though, for she handled them

STIEGLITZ'S 1914 PORTRAIT OF HIS
MOTHER, ENITLED "MA"

as carefully as he did. In the evening, she often helped him with the mats for his photographs, for his cloud photographs especially, and he was so particular."

In my quest to understand those years, I also got this account from Georgia Engelhard, Stieglitz's niece who was later to become well known as a photographer. She was a high-spirited little girl of nine when Georgia first arrived in the Lake George household.

"Grandmother was straight-laced," she said, "and the Lake George household was a perfect matriarchy. Grandmother saw to it that everyone respected Georgia from the moment she entered the house, for Uncle Alfred loved her devotedly and he showed a happiness I had never seen in him before.

"Georgia O'Keeffe was good-looking. But she was so extremely quiet with all of us that she seemed unlike anyone we had ever seen. Once she understood that all the talk that went on in the Stieglitz family was because of their real interest, she relaxed, but no one more different from our family could ever have come to visit us.

"She and Uncle Alfred were tremendously in love. Before that, he had sometimes been touchy and bad-tempered, but now he was very human with all of us." She remembered how all day they were out-of-doors: " . . . Georgia painting like mad, and he photographing, or they both were walking over the hills or rowing on the lake."

In those days there were usually eighteen or twenty at table: Stieglitz's mother, his two sisters, his two brothers, some of the in-laws, the grand-children and various other visiting relatives.

The marathon of conversation, which took place on any subject —music, painting, literature, science and travel—the diversity of interests and the emotional fervor that resulted were like nothing that Georgia had ever known.

The sons of the family enjoyed debate as well as learning. The younger twin brothers were Dr. Leopold Stieglitz, a physician, graduated summa cum laude from the University of Heidelberg, and Julius Stieglitz who headed the Department of Chemistry at the University of Chicago and had received the rare magna cum laude from the University of Berlin. They had definite opinions and gloried in good conversation.

At Lake George, that first summer especially, Stieglitz often held forth on her paintings. Georgia had to suffer while her paintings were being discussed and much as she would have liked to stop him no one could have.

Georgia Engelhard also clearly remembered these discussions. "In the evening," she said, "Uncle Alfred would bring her work into the living room and the whole family, gathered together, would discuss it in animated fashion—Uncle Alfred exuberantly leading the general debate. There sat Georgia, polite, and speaking only when she was spoken to— as detached as though she had had nothing to do with the painting. Sometimes at these gatherings, a member of the family would buy one of her paintings that had just been done—permission being given or dramatically withheld by Uncle Alfred."

In spite of the huge contrast with her past, Georgia somehow felt that here, near Alfred Stieglitz, was all of life for her—moving in the same direction. And for a person whose work and life had always been inextricably interwoven, this was most wonderful.

It has been said that every great artist is first of all a workman and workman indeed, Georgia had always been in her painting. At the lake, she continued to work indefatigably. Stieglitz, who used to say that his own teachers had been life, work and constant experiment, respected this greatly. For him, mediocrity was a vice and he realized that Georgia, too, was contented only with the best. It was a great bond. And how he adored Georgia's spirit and candor, which were in such contrast to the sophistication of those with whom he felt the art world was surfeited.

The Stieglitz ladies, when they went to their summer social functions, would be perfectly accoutered with parasols, fine hats, long gloves and corsage bouquets, while Georgia, utterly unconscious of her looks, and not concerned about the ways of others, would, at most, change from a smock to a simple handmade dress—usually white—draw her long dark hair back smoothly, and put on her low-heeled slippers. No one would have dared to present her with gloves or a corsage, anymore than her classmates at Chatham High School would have dared to suggest ruffles and bows.

She walked with grace, straight as a reed, and seemed so much a part of the outdoors that for Stieglitz it was as though, through great good fortune, some lovely woodland being had become their guest.

# A CAREER BEGUN: 1918–1929

**W**HEN the Stieglitz family returned to the city from Lake George in the fall of 1918, Alfred's brother, Dr. Leopold Stieglitz, one of New York's leading physicians, offered Georgia a big room on the third floor of his family brownstone, where she could live and paint. These New York houses of four or five stories, English basements, and spacious rooms, when owned by physicians, usually served as their offices as well.

For some time, Alfred Stieglitz had lived on the top floor of this house and after the closing of 291, it was here that he received visits from prominent artists, photographers and writers, who wished to talk or seek his advice. Georgia by that time had gained a certain renown and was a person they wanted to meet. Stieglitz was intensely proud of her and would insist that she be present when interesting personalities came to call. She knew the 291 group and at this time she met Sherwood Anderson, Ernest Bloch, Leopold Stokowski and many other creative artists.

Stieglitz grew to depend on Georgia's judgment for many practical things. For instance, his quarters on the fourth floor were dark, and Georgia urged that a skylight, so essential for his photographic work, be put in. Stieglitz agreed, and was given an estimate by a contractor of nine hundred dollars for the skylight, which he could not consider. Georgia went forth, got an estimate of one hundred and fifty dollars and had the skylight put in at once. The sun then shone in on a red plush carpet that had always been in the darkness, and the light made the walls very white.

**GEORGIA O'KEEFFE IN 1919, PHOTOGRAPHED BY STIEGLITZ**

Georgia's paintings were now an unfolding of the work in her exhibitions of 1916 and 1917, and a development of the "abstractions" and flowers begun in her teaching days in South Carolina and Texas and carried forward at Lake George. After the first showing of her work at 291 in August 1916, Stieglitz in Lake George had written to her in Texas, "You under different conditions are always *You*. It's that which attracts me so much to your work." This was certainly true in New York where she remained unchanged by the styles of thinking of the artists she met.

During this early period she was admired and acclaimed in the art world; Marsden Hartley wrote in *Adventures in the Arts* (1921): "She has no preachment to offer and utters no rubbish on the subject of life and its problems. She is one of the exceptional girls of the world, both in art and in life."

In the summers, Georgia was at Lake George with the whole family. Then, after the rest of the family returned to the city, she and Stieglitz would stay up at the lake until cold weather came.

**Stieglitz to Herbert J. Seligmann, Lake George, N.Y., summer 1920**

> O'Keeffe and I have had a week that we can call 100. Really very wonderful. Full up. In the healthiest, sanest manner imaginable. Painting—printing photographs—cooking (she is quite a cook, loves experimenting—is in everything she does what she is as a painter)—dishwashing—occasional walks—a row or so on the Lake—long ones when we do take them— weather 100%.

Since the close of 291 in 1917, Stieglitz had had no public place to present his work, or the work of the American artists in whom he believed. Quite contrary to general opinion, he was far from rich. His father's fortune had nearly vanished in two depressions. In the 291 period, Stieglitz's personal yearly income was only about $1,200, although he was known to set the price of a picture by one of the artists at a thousand dollars, which was his way of demanding respect for the picture and securing income so that the artist could go on working. For years he gave of his material possessions as freely as of his ideas and time.

O'KEEFFE AND PROBABLY ONE OF THE
STIEGLITZ BROTHERS PRUNING A TREE
AT LAKE GEORGE IN 1920,
PHOTOGRAPHED BY ALFRED STIEGLITZ

Now, through the friendship and understanding of Mitchell Kennerly, then president of the Anderson Galleries, two large rooms were put at Stieglitz's disposal for exhibitions in the gallery's building at Park Avenue and East Fifty-ninth Street. There, in February 1921, Stieglitz presented one hundred and forty-five examples from his lifework of photography dating from 1886 to 1921: "The Steerage," photographs of New York, portraits of the artists associated with 291 and the series of prints that he had made of Georgia O'Keeffe.

Paul Rosenfeld, critic of music, literature and art, later wrote in *Port of New York: Essays on Fourteen American Moderns (1924)* of Stieglitz's photographs of Georgia:

> The series of pictures, filled with high cathedral air and religious elevation, constitutes one of the profoundest records of woman's being which we possess. The many scores of infinitely poignant, infinitely tragical, infinitely rapturous moments are from the deeps of the psyche.

Georgia worked indefatigably in New York. She found beauty in Central Park where one could take long walks, in the Park Avenue flower shop windows where she window shopped and in the flower arrangements she made at home.

The delight expressed in Georgia's painting by those who saw the pictures is evident in this letter from Paul Rosenfeld.

**Paul Rosenfeld to Georgia, September 9, 1921**

> I was out at [Melville] Cane's over Labor Day and there saw your purple tulips! Such painting! It seemed to me almost the most beautiful I have ever seen. The lower right hand corner, with its tones of mother of pearl gray and turquoise green!— the entire little canvas, with its dark mysterious center, was so pure and sad and mature! It was different from some of the earlier things and yet it was the self-same you, with some tremendous new wisdom, and the power to make something beautiful out of something sad and not to be helped. It is like

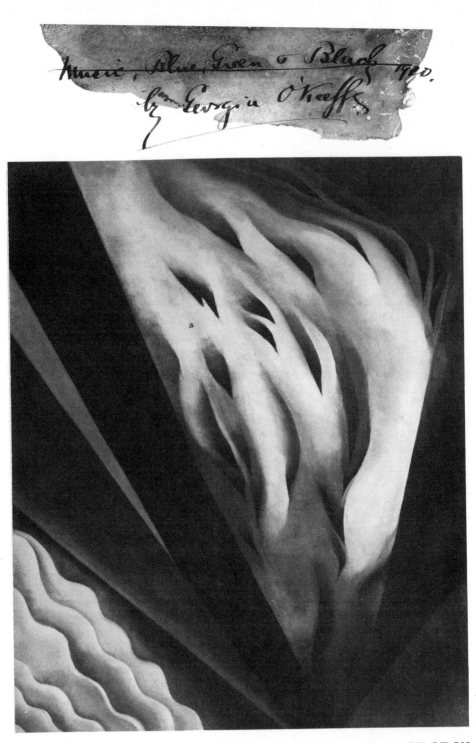

STIEGLITZ'S PHOTOGRAPH OF AN
O'KEEFFE OIL PAINTING, 58.4 X 48.3 CM,
(CIRCA 1920), WITH IDENTIFICATION IN
O'KEEFFE'S HANDWRITING.
COLLECTION: ART INSTITUTE OF
CHICAGO

a new form of language, and when Dove said he was as in-
terested in what you were doing as he was in what Picasso
was about, I seemed for a moment to understand him.

Georgia's work had not been shown publicly since 1917 at 291. Then
on January 29, 1923, at the Anderson Galleries, through the use of the
rooms donated by Kennerly, Stieglitz presented "One hundred pictures,
oils, watercolors, pastels and drawings by Georgia O'Keeffe, American"—
a one-man exhibit and the first O'Keeffe exhibit in six years.

**Georgia, in the exhibition announcement, January 1923**

> I grew up pretty much as everybody grows up and one day
> seven years ago found myself saying to myself—I can't live
> where I want to—I can't even say what I want to—Schools
> and things that painters have taught me even keep me from
> painting as I want to. I decided I was a very stupid fool not to
> at least paint as I wanted to and say what I wanted to when I
> painted as that seemed to be the only thing I could do that
> didn't concern anybody but myself—that was nobody's busi-
> ness but my own. So these paintings and drawings happened
> and many others that are not here. I found I could say things
> with color and shapes that I couldn't say in any other way—
> things that I had no words for. Some of the wise men say it is
> not painting, some of them say it is. Art or not art—they disa-
> gree. Some of them do not care. Some of the first drawings
> done to please myself I sent to a girlfriend requesting her not
> to show them to anyone. She took them to 291 and showed
> them to Alfred Stieglitz and he insisted on showing them to
> others. He is responsible for the present exhibition. . . .

In the interim, between the two exhibitions of 1917 and 1923, Georgia
had painted abstractions such as her *Blue and Green Music*, many small
pictures of solid apples, views of Lake George, the first important Corn
Paintings, with all the love for the strong stalks and the rich shades of

green that she had felt since her childhood years on the Wisconsin farm. Those and paintings such as *Inside Red Canna* have come, in the public's mind, to represent the early O'Keeffes. Her feeling was conveyed through her clear organization of each canvas, the clear-cut forms and colors.

Her flower paintings of this period were small and had strength. The Calla Lily Paintings started in 1923, and in the small paintings there was the feeling that was later to develop into the Big Flowers. Georgia was painting what she knew and loved. Her work followed no fashions or innovations. She had not seen the Armory Show of 1913, which so greatly changed art tradition in America, nor had she ever been to Europe to study its treasures, nor to feel the impact of the work being done by the artists there (except for what she had seen through 291). Her interpretations were her own, as much as that is ever possible. As a child, she had walked among the tall corn stalks and climbed fine apple trees. Subjects were often portrayed with the humor of which she has much; I think of the picture entitled *Cow* which amused her, "with its eyes rolling and its furry tongue out."

Important critics, for the most part, did not yet see the pictures so clearly as the public, which flocked to the exhibition. A week after the opening the New York Sun reported that during its opening days the exhibit had been visited by five hundred people daily.

Henry McBride, who from the outset appreciated the pictures, was one of the first critics of importance to understand their significance.

**Henry McBride, the New York *Sun*, February 4, 1923**

> . . . [W]e have peace in the present collection of pictures. There is a great deal of clear, precise, unworried painting in them.

**Alan Burroughs, the New York *Sun*, February 3, 1923**

> Georgia O'Keeffe's exhibition easily leads the new shows, provided one defines the leading as the most intense, and the most capable in accomplishing what the artist intended. . . . Flowers and fruits burn in her conception of them with deep,

luminous colors that have no names in spoken or written lan-
guage.

Here are masculine qualities in great variety and reserve.
But in this unfair world though the man spends a lifetime in
careful consideration of a question, his answer may seem no
more sure than the one that the woman gets by guesswork.

Georgia's careful results were scarcely guesswork! But such inaccurate
remarks were commonplace in the art world of the 1920s. It is not too
much to say that Georgia's attainment in painting and the consideration
her work received helped immeasurably to change the whole climate of
opinion for women working seriously in the arts.

At the beginning, many critics and artists, in trying to account for the
recognition of her art, found extraordinary interpretations for her colors,
lines and forms that were, she felt, far removed from her actual feeling.
They seemed to forget that she was expressing things seen and interpreted
with emotion, from her own life, and that she had quite another life from
others who were painting. Stieglitz, who was glad whenever talk created
interest in artists and their pictures, welcomed any interpretation. In fact,
one can well believe he was glad if the talk about sex and the Freudian
interpretations of Georgia's flowers made the curious come to view her
work.

Those who wrote of "sex" in her flower paintings had undoubtedly not
studied the flowers to know how true was her expression of them. Georgia
did not care what was said. It was impossible for her not to want to paint
corollas, calyxes, petals, stems—the essential parts of the flower with all
their depth of color and in their wondrous forms. She was painting nature,
as it seemed to her, exciting and wonderfully alive.

Henry McBride provided a partial answer to much of the talk about the
paintings.

Henry McBride, the New York *Sun*, February 4, 1923

Georgia O'Keeffe became free without the aid of Freud. . . .
[T]he outstanding fact is that she is unafraid. She is interested
but not frightened at what you will say, dear reader, and in

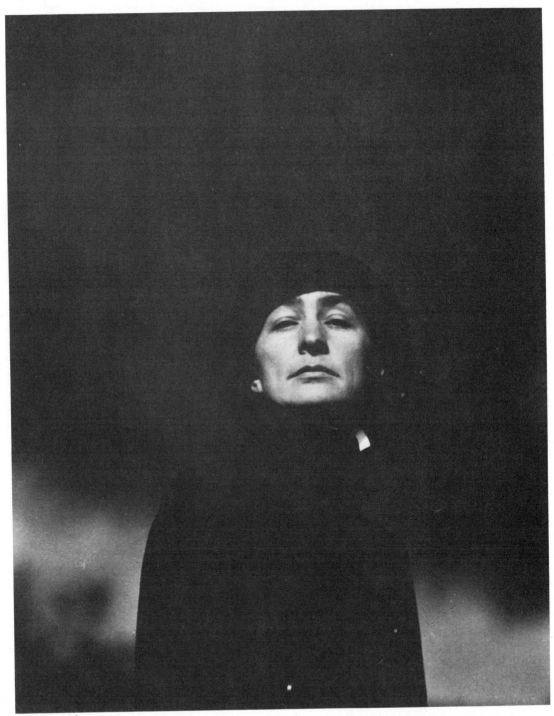
O'KEEFFE BY STIEGLITZ, 1923

what I do not say. It represents a great stride, particularly for
an American.

People now came to the exhibition not only to enjoy the pictures but to
buy them. This was important to her since it was the way she wanted to
support herself. I am sure she had no thought of fame, but she said to me
once: "If you're the only woman painting in a group, and you're being
watched in everything you do, you have to try to be as good in your work
as possible."

She would be the first to acknowledge how greatly Stieglitz helped the
general recognition of her work in these years. When he championed an
artist he fought with his emotions and his knowledge. In Georgia's case
he fought not only for pictures in which he believed but for the acceptance
of a woman as a first-rank painter. There were many occasions on which
he took up cudgels on this point, as when Arthur B. Carles came over
from Philadelphia to talk with him about an exhibition of paintings. Carles
informed Stieglitz that they did not want the work of any woman in the
exhibit, to which Stieglitz replied that if he wanted to have paintings by
Marin or the other men, over whose work Stieglitz had jurisdiction, he
would have to accept the work of O'Keeffe, which he considered equally
important. His emphasis, as always, was on the work.

Knowing art from a historical perspective, he felt sure that her work
was in the mainstream of great art, while still striking a new note. It had
always been so in the arts, he explained, when one felt something strongly
enough. Georgia was feeling a beauty that was everywhere and ex-
pressing it so clearly that others were moved.

Stieglitz was proud of the pictures and so fond of them that—in order
not to part with them—he would advance every reason not to sell such
beautiful canvases. Actually the first picture sold to a stranger was one
that Georgia herself sold to a young woman at the 1917 exhibition, when
Stieglitz was away from the gallery. This canvas brought $1,200—the
amount at which Stieglitz had priced it. After all expenses, Georgia cleared
$3,500 from the 1923 showing of her pictures at the Anderson Galleries—
a large amount then, and almost twice as much as she had received for
a year's teaching in Texas.

When spring came, Stieglitz and Georgia went to the clear blue water and tall pines of Lake George for another wonderful summer of painting and photographing.

**Stieglitz to Sherwood Anderson, Lake George, N.Y., November 1924**

> Tomorrow we leave for town. Boxes are gone. Trunks are ready. The house is clear. On Sunday we had a day of days—a blizzard—snow, knee high. And you should have seen how we enjoyed it. All day out of doors, I photographed like one possessed. O'Keeffe wandering about in the woods—and rushing down to the Lake—all awonder—and we marched ourselves to the post office and enjoyed everything—every step—beauty everywhere—nothing but beauty.
>
> White—white—white—and soft and clean—and maddening shapes—the whole world in them.
>
> It was a rare day and O'Keeffe was as happy and beautiful as the day.

Nineteen twenty-four was a year of great realization. Her painting of Big Leaves and Big Trees began. In a picture such as *The Chestnut Red*, although she unmistakably painted a particular chestnut tree, the general character and feeling of the tree was most important to her. There were handsome purple eggplants and abstract paintings, which she called portraits of her days. It was also a year of beautiful Calla Lilies.

In March, fifty-one of Georgia's recent pictures were shown at the Anderson Galleries, and again highly praised. Henry McBride said in his review, . . ." What I prefer is style which occurs all along the line and makes the whole encounter interesting from start to finish. . . . " This was one of the earliest mentions of a style that was to be so marked and so unfailingly hers, year after year. Unquestionably the fact that Henry McBride had been a painter enabled him to understand modern art ahead of most art critics.

At the same time as Georgia's shows, Stieglitz held a notable exhibition of his photographs, also at the Anderson Galleries. "Songs of the Sky—Secrets of the Sky as Revealed by my Camera and Other Prints," he called

it. The catalog announced that the Boston Museum of Fine Arts had acquired a group of his photographs, which were being added to its permanent collection. He gave them in appreciation of the enthusiasm and wisdom of Ananda Coomaraswamy, its curator of Oriental Art. The acceptance by the Boston Museum of these photographs, which included several great portrait photographs of Georgia, was important in the history of photography; it was the first time that photography would be shown in one of the great American art museums. An article by Dr. Coomaraswamy in the *Boston Museum Bulletin*, pointed out that, "[H]ere, as elsewhere, it is the man behind the tool, and not the tool that counts."

**Stieglitz to Sherwood Anderson, Lake George, N.Y., summer 1924**

> . . . O'Keeffe has done some amazing canvases—Intimately related to the early drawings which so overwhelmed me when brought to me the first time. . . .

She continued to paint with dedication—a life that seemed all to her. Stieglitz was now a part of that life. As she often expressed it: "He was the man and the idea."

On December 1, 1924, Georgia and Alfred, who for almost a decade had known love and respect for each other, were married. John Marin, to whom Stieglitz was like an older brother, was a witness at the ceremony in New Jersey.

It was in 1925 that Stieglitz presented to the public the art of "Seven Americans." He called the challenging exhibition "159 Paintings, Photographs and Things, Recent and Never Before Publicly Shown." It included work by Arthur G. Dove, Marsden Hartley, John Marin, Charles Demuth, Paul Strand, O'Keeffe and Stieglitz.

**Stieglitz, catalog statement, 1925**

> This exhibition is an integral part of my life. The work exhibit-

ed is now shown for the first time. Most of it has been produced within the last year. The pictures are now an integral part of their makers. That I know. Are the pictures of their makers an integral part of the America of today?

That I am still endeavoring to know. Because of that—the inevitability of this Exhibition—American.

Of Georgia's painting, the New York *Times* review of March 15, 1925, declared: "Her flowers . . . they grow . . . how beautifully they grow."

During this year, Mitchell Kennerly had again given Stieglitz space in the Anderson Galleries, this time for a permanent gallery. In December 1925, it opened to the public as the Intimate Gallery with an exhibition of paintings by John Marin. A solo exhibition of Georgia's work was shown from February 11 to March 11, 1926. This was the first year of her Big Flowers and they created a sensation.

**Georgia, catalog statement, 1926**

> Everyone has many associations with a flower. You put out your hand to touch it, or lean forward to smell it, or maybe touch it with your lips almost without thinking, or give it to someone to please them. But one rarely takes the time to really see a flower. I have painted what each flower is to me and I have painted it big enough so that others would see what I see.

Her enlarged paintings of flowers and leaves, or parts of them, were a great innovation in American art. Paintings of flowers, before this, had been true to size or smaller to suggest their delicacy. Though magnified, Georgia's flowers kept the flower quality, the fragility of the petal and the crispness of the stalk. In her painting, the life cycle of each flower was full of the true life of that flower. One thinks of Whitehead's phrase, "the delicate inner truth of art."

Many came to see the gallery to study these paintings of flowers, seeking to learn the secret, but the secret could not be learned, for it was her own

# THE
# INTIMATE
## GALLERY
### ROOM 303
#### ANDERSON GALLERIES BUILDING
489 PARK AVENUE AT FIFTY-NINTH STREET, NEW YORK

announces its Third Exhibition — February 11 to March 11 —

## FIFTY RECENT PAINTINGS BY GEORGIA O'KEEFFE

The Intimate Gallery is an American Room. It is now used more particularly for the intimate study of Seven Americans: John Marin, Georgia O'Keeffe, Arthur G. Dove, Marsden Hartley, Paul Strand, Alfred Stieglitz, and Number Seven.

It is in the Intimate Gallery only that the complete evolution and the more important examples of these American workers can be seen and studied.

Intimacy and Concentration, we believe, in this instance will lead to a broader appreciation.

The Intimate Gallery is a Direct Point of Contact between Public and Artist. It is the Artists' Room. It is a Room with but One Standard. Alfred Stieglitz has volunteered his services and is its directing Spirit.

Every picture is clearly marked with its price. No effort will be made to sell anything to any one. Rent is the only overhead charge.

The Intimate Gallery is not a business nor is it a "Social" Function. The Intimate Gallery competes with no one nor with anything.

The Gallery will be open daily, Sundays excepted, from 10 A.M. till 6 P.M. Sundays, from 2 P.M. till 5 P.M.

———————

Exhibition I   —John Marin, December 7, 1925-January 11, 1926.
Exhibition II  —Arthur G. Dove, January 11-February 7.
Exhibition III—Georgia O'Keeffe, February 11-March 11.
Exhibition IV —Marsden Hartley, March 11-April 7.
Other exhibitions to be announced.

———————

*All but Time-killers are welcome*

ANNOUNCEMENT OF O'KEEFFE'S 1926 SHOW

vision, her own feeling for the flower with its brilliant colors, its variety of whites and its revelation of the mystery of nature. She held the chalice of the flower high.

Even critics were enthusiastic.

*Art News*, February 1926

> Her Petunias grow in richness, intensity, in volume. . . . Never sang an individual petunia with the rich fullness of that flower.

Blanche C. Matthias, the Chicago *Evening Post*, March 2, 1926

> There are on exhibition in the Intimate Gallery fifty paintings by Georgia O'Keeffe. During the time of the exhibition probably every notable in New York will open the door of the little room. All the artists, the writers, the thinkers, the doubters will want to see what O'Keeffe has accomplished since her last exhibit. No woman artist in America is subject to more observation and speculation than is this utterly fine O'Keeffe. No woman artist in America is so daringly herself in all that she does, which fact in itself is enough to provoke widespread discussion and comment.
>
> When Alfred Stieglitz gave Georgia O'Keeffe her exhibition . . . the result was a terrific bombing directed at the unsuspecting and tranquil artist. The art critics began to study Freud and Jung in an effort to catalog and pigeon-hole a blue ribboned bundle labeled Georgia O'Keeffe. But somehow she just managed to escape their hastily garnered strength.
>
> Perhaps one reason was that most of those whose business it is to understand art and relay it to the public, were of the masculine gender, and O'Keeffe's simplicity was profoundly feminine. They were so used to writing about "influences," "traditions," "techniques," "style," "modernism," and so unprepared for all the direct contact with the art spirit of

"woman" that they got all cluttered up and began frantically searching for the magic key with which to illumine their habit-stunted minds. . . .

Nineteen twenty-six was one of the wonderful years for her paintings. Even if it had only produced *Black Iris*, with its beautiful shapes, the velvety texture of its petals, its richness of color and the revelation of Georgia's ability to convey the wonder and intimacy of nature, it would have been a marked year. This was also the year of many of her great flower paintings, and of the Shell and Shingle Series, in which the shells began to be big, and were studied and interpreted in the same detail as her flower paintings.

In his writings Marsden Hartley discussed the general condition of American art during this period.

**Marsden Hartley, 1928**

Real color is in a condition of neglect at the present time because monochrome has been the fashion for the last 15 or 20 years. But joyous or subtle, Georgia's glorious color combinations were in striking contrast: dark iris and petunias of rich purple, red salvia with other flowers of contrasting hues, sweet peas in all their delicacy, roses with an ethereal loveliness, each canvas with its own richness and beauty.

The East River Paintings, which had begun in 1925, flowed on horizontals; the Shelton Hotel which became *The Shelton with Sun Spots* and other city scenes soared vertically. The pictures seemed to give wider and wider vistas. The first exhibition of this work opened in January 1927.

**Charles Demuth, quoted in the New York *Sun*, January 1927**

Flowers and flames. And color. Color as color, not as volume. The last mad throb of red just as it turns green, the ultimate shriek of orange calling upon all the blues of heaven for relief

or for support; these Georgia O'Keeffe is able to use. In her canvases each color almost regains the fun it must have felt within itself on forming the first rainbow.

More and more, light became important as a factor in her painting. She enjoyed differentiating between the sharp and the evanescent. Although light is quite a different factor in photography, association with so great a master of light as Stieglitz undoubtedly made her more conscious of its values in painting.

Nineteen twenty-seven was another remarkable year for Georgia's painting. This was the year that produced *Black Abstraction*, which has been so greatly praised as a painting and so profoundly moved the many who have seen it. There were sparkling New York paintings such as *Radiator Building*, *Night* and the diaphanous *Ballet Skirt*.

In addition to her exhibition at the Intimate Gallery, 1927 was the year that, early as it was in her career for such important recognition, Georgia's work was given a retrospective exhibition by the Brooklyn Museum. Among the paintings in this exhibit—shown from June 16 to September 1st were—*The Red Maple*, *Lake George*, *Petunia and Morning Glory*, *#1*, *Abstraction*, *1926*, and *The Pansy*.

White had always had a special meaning to Georgia. The Calla Lily Paintings were such an expression, and in 1927 came more white paintings. In their great intensities, it was as if a soul was bared to the world. *Black Abstraction*, with its electrifying ball of white and its line of graying white, was a masterful composition. *Abstraction White*, and her White Rose Series, were of this time.

Lewis Mumford, philosopher and social critic, evaluated Georgia's unique contribution to art in his stirring review entitled "O'Keeffe and Matisse."

Lewis Mumford, *New Republic*, March 2, 1927

> Miss O'Keeffe is perhaps the most original painter in America. The present show of her recent work leaves one wondering as to what new aspects of life she will make her own. I do not wish to dwell on her separate canvases, although in *The*

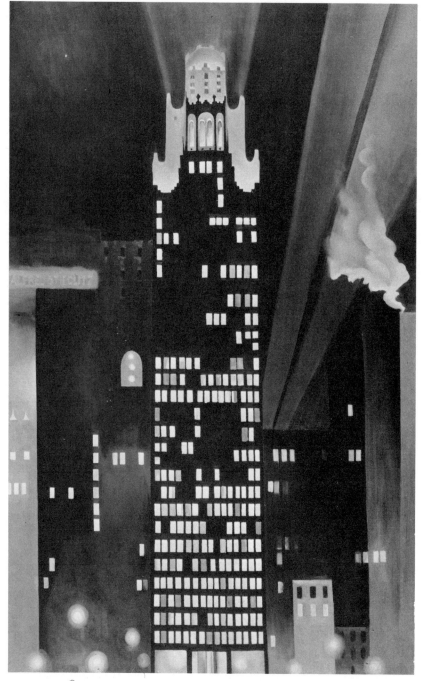

*Kindly Reef o/Cea*
,

*Night—Radiator Building New York*
*by Georgia O'Keeffe*

*With permission*
*an American Place*
*509 Madison are*

PETER JULEY'S PHOTOGRAPH OF *RADIA-TOR BUILDING—NIGHT, NEW YORK* (1927), OIL ON CANVAS, 48 X 30 IN. IDEN-TIFICATION AT BOTTOM IN STIEGLITZ'S HANDWRITING. CARL VAN VECHTEN GALLERY OF FINE ART, FISK UNIVERSITY

*Wave* and *The Sun Blazing Behind The Shelton* and in what is
nominally one of her flower-interiors, as well as in several
more abstract designs, she has produced pictures upon whose
excellence one might well linger for a while. The point is that
all these paintings come from a central stem; and it is be-
cause the stem is so well grounded in the earth and the plant
itself so lusty, that it keeps on producing new shoots and efflo-
rescences, now through the medium of apples, pears, egg
plants, now through leaves and stalks, now in high buildings
and skyscrapers, all intensified by abstraction into symbols of
quite different significance.

Miss O'Keeffe has not discovered a new truth of optics, like
Monet, nor invented a new method of aesthetic organization,
like the Cubists; and while she paints with a formal skill
which combines both objective representation and abstrac-
tion, it is not by this nor by her brilliant variations in color that
her work is original. What distinguishes Miss O'Keeffe is the
fact that she has discovered a beautiful language, with unsus-
pected melodies and rhythms, and has created in this lan-
guage a new set of symbols; by these means she has opened
up a whole area of human consciousness which has never, so
far as I am aware, been so completely revealed in either liter-
ature or in graphic art. . . .

. . . Miss O'Keeffe has found her symbols without the aid of
literary accessories; hers is a direct expression upon the plane
of painting, and not an illustration by means of painting of
ideas that have been verbally formulated. Indeed Miss
O'Keeffe's world cannot be verbally formulated.

. . . Miss O'Keeffe has created a noble instrument of expres-
sion, which speaks clearly to all who have undergone the
same experience or been affected by the same perceptions.
She has beautified the sense of what it is to be a woman. . . .
She has brought what was inarticulate and troubled and con-
fused into the realm of conscious beauty, where it may be re-
called and enjoyed with a new intensity; she has, in sum,
found a language for experiences that are otherwise

too intimate to be shared. To do this steadily in fresh forms, and to express by new expedients in design, her moods and meanings; these are the signs of a high aesthetic gift. A minor painter might achieve this once; and would perhaps carve a prosperous career by doing it over and over again; Miss O'Keeffe, on the contrary, has apparently inexhaustible depths to draw upon, and each new exhibition adds richness and variety to her central themes. Her place is secure.

*If this be madness, and upon me proved,*
*I never writ, nor no man ever loved.*

At this time, when in New York, Georgia and Stieglitz were living on the thirtieth floor of the Shelton Hotel at Forty-ninth Street and Lexington Avenue with a fine view of the East River. In 1928, Georgia made a large painting of the river with its houses and smokestacks on both banks. This picture was a milestone for O'Keeffe herself, as well as in her painting, for the men in the group around Stieglitz had felt that the city was their province, and that she, a woman, should stay with her flower paintings. Even Stieglitz was unhappy about her wish to paint New York. But Georgia was determined to do this canvas and also to paint some of the tall city buildings. In the *East River From The 30th Story of The Shelton Hotel* she launched forward into work quite different from her previous paintings. Instead of the luminous world of abstract shapes or flowers, here was a graphic portrait of the river, and an organization of rectangular buildings, presenting problems different from anything she had heretofore attempted. Here was a realistic portrayal, interpretive of the city, along the banks of the river, with its mist and smoke. It is a clearly defined record of the East River as it will never be seen again now that much of the city has been built up in front of it.

Then followed paintings of skyscrapers with their brightly lighted windows, but, as seen by Georgia, they are not glorifications of the great structures of an age, but magnificent opportunities for a play of light and dark against the sky. The New York Series that followed proved Georgia's unusual craftsmanship in the painting of realistic scenes, to many who had thought of her only as a master of the poetic and lyric.

Summers at Lake George, Georgia, in addition to her painting, planned for everything that concerned the household. At that time, Stieglitz had to be extremely careful of his diet, and Georgia supervised this personally.

**Georgia to Ettie Stettheimer, Lake George, N.Y., September 21, 1928**

> . . . Stieglitz wanted me to write you that he would have written if he had not been sick—particularly concerning the Lawrence book . . .
>
> I have thought often to write you during the summer—we both enjoy your letters—and here I sit—scribbling along with not a thought in my head—unless strained spinach, peas, beans, squash—ground lamb and beef—strained this—five drops of that—a teaspoon in a third of a glass of water—or is it half a glass—pulse this—heart that—grind the meat four times—two ounces—1oz.—½ zweibach—will all those dabs of water make up 2 qts—is this too hot—that white stuff must be dissolved in cooler water—the liquid mixed with hot—castor oil every 15 minutes and so on—divide those 25—or is it 21 ounces into 5 meals—until the girl who helped me grind and measure and rub the stuff through the 2 sieves actually got hysterical laughing about it.
>
> Stieglitz complains about various things today so I'm quite sure he is better. . . .

· And even though she could write "Don't be sorry for me," the actual fact was that she could hardly stand, perfectionist as she was, all that was crowding in upon her.

Every winter for Georgia there was New York with its painting and the large solo exhibitions selected from her year's work. Every summer, there was Lake George, with its painting, and now in addition, the supervision of the home for Stieglitz, his brothers and sisters and their families, all with very definite ideas as to how things were to be done. In addition to

the members of the family, there were often Stieglitz's friends, with whom he thrived on talk.

Stieglitz's mother had died and Georgia, as wife of the eldest son, supervised the summer housekeeping for the large family. This, in addition to her painting, was a tremendous task for one so meticulous. She wanted and needed privacy for her painting. She also needed rest.

Nineteen twenty-eight had been a most successful year for her pictures. From the large income she had realized from their sale, she wanted to build her own house at Lake George, so that she could have the quiet she knew she needed. Even the simplest of cottages where, as she expressed it, she could "get off sometimes, and put my rocks and precious things where I wish" would have sufficed. But Stieglitz could not understand this: to need anything other than the family home at Lake George was incomprehensible to him.

In the O'Keeffe family there never had been any dramatizing of their disappointments. When they came, they silently accepted them. That was true of Georgia now, but from this time on, Lake George became a different place for her. She tried to get off alone and walk, but Stieglitz in his solicitude for her had begun to worry if she walked to the village alone. She, who had been so active and independent always, who had been free to camp overnight in the hills of Virginia, to tramp through Estes Park, to live in the Texas country, now felt herself deprived of both solitude and independence. It was the first time in her life that she found herself repeatedly giving in against her will. Up to this point, she had always felt capable of changing outer circumstances that might interfere with her life or her painting.

On her return to New York from Lake George that autumn, she was badly run-down. Three physicians were consulted. Two said that she was very ill; one of them said that, in his opinion, she had only a brief while to live; the third said that in his judgment she should take a real rest and live for a time at her own pace. There were months of intense worry for both Stieglitz and Georgia.

By the winter of 1928–1929, Georgia had not regained her strength. Dr. Dudley Roberts, held in high esteem by many, told her that he felt it imperative that she go away for the summer so as to stop expending herself in the busy summers at Lake George.

There was a passing thought in her mind of a trip to Europe, for talk of Europe was all around them, the artists were coming and going, but Europe seemed far away and Stieglitz would have worried.

Into her mind came a picture of the West; the West of her childhood stories, of her Panhandle teaching days, of sky and space. She would go to New Mexico, which she had seen briefly on the trip with her sister Claudia in 1917, and for the summer months she would leave Lake George with its responsibilities, family, art, visitors and the daily excitements about her comings and goings.

She and Rebecca Strand, wife of Paul Strand the photographer, who was a member of the 291 group, decided they would go West together. Surely this would make Stieglitz less anxious, Georgia felt. Thousands of wives take summer trips without so real a reason. But to those who heard of Georgia and the West from Stieglitz, it seemed that the most dire of calamities had befallen them. It was only for two-and-a-half months in the summer of 1929 that she was to be in New Mexico, but art circles echoed and reechoed Stieglitz's sufferings. He spoke of her going West to everyone who came into his gallery. He talked of her going as he had talked of her coming—to those who understood, and to those who did not—and they in turn talked.

The thought that he had lost in this battle with the West was a great blow to him. No one could dissipate his worry. For Stieglitz, it was indeed true that: *Un nuage sur l'âme, couvre et décolore plus la terre qu'un nuage sur l'horizon; le spectacle est dans le spectateur.* (Lamartine, *Les Confidences*: A cloud on the soul covers and discolors the earth more than a cloud on the horizon; the spectacle is in the spectator.)

Georgia was troubled, but much was at stake for her. "The Amarillo art books were the hardest fight of my life," she once told me, "but going West was the hardest decision I ever had to make."

# THE NEW MEXICO PAINTINGS: 1929–1940

*a*S Georgia and Rebecca arrived at Santa Fe shortly before an Indian Dance was scheduled to take place at the Indian pueblo village of San Felipe, they set off to see it. They were enchanted by the dance. Mabel Dodge, who was also there, came up and talked with them, and invited them to come to live in one of her cottages in Taos. The next morning, she came to the place where they were staying and said that she had sent their trunks ahead from the railroad station to her ranch, and that they should follow in the car with her.

So, with Mabel Dodge, Tony Luhan, her husband, a full-blooded Pueblo, and Ella Young, Georgia and Rebecca Strand set out for Taos. While there, they took many trips into the Taos country on horseback, often camping out overnight in their sleeping bags.

Soon after their arrival in New Mexico, they rode to the D. H. Lawrence ranch near San Cristobal. There, after Lawrence's death, Frieda Lawrence had continued to live in their house on the side of the mountain, in the midst of the big trees, with a view of the plains of Taos, below, in the distance.

Years later, while talking with Frieda Lawrence at Georgia's New Mexico home, I could almost visualize the day in 1929 when Georgia first arrived in Taos.

"It was a beautiful day. I was out-of-doors with Angelino [Ravagli]," Frieda told me. "All at once two young women on horseback appeared, high on the crest of the hill nearest to us. They sat there in their saddles,

handsome and straight as Indians, turning their horses around and around so as to see the view on every side. In a little while they were gone, but I never had seen such women, so unconcerned about everything except the beauty around them."

Freida then went on to say, "That summer, I came to know Georgia. In her I always felt a detachment from the things that fritter away other people's minds. Hers seemed always very clear. In later summers, we would go camping together and would sleep out so that she could begin to paint early, catching the morning lights. Often after breakfast over our outdoor fire, she would paint the whole day, wrapped in interest in what lay before her." Freida admired how in everything she did, Georgia was always as she seemed that first day—"beautiful and unmuddled."

Georgia bought a car while she was in New Mexico and drove to the faraway places that interested her. At that time in New Mexico, one did not need to have a driver's license or even to report owning a car. The chief thing was to be careful not to hit the cows and horses that roamed the lonely highway. Friends said that Georgia would drive silently for miles and then exclaim: "Well! Well! No one told me it was like this."

### Georgia to Anita, Taos, N.M., 1929

> The grain is ripe in the little fields along the Rio Grande valley, and as you drive along the country roads you see tall, wild sun flowers against the sky or against the mesa and pink sand hills and mountains the other side of the river—the people living in the little mud houses along the way.
>
> In the evening I go up in the desert where you can see the world all around—far away. The hours I spend each evening watching the sun go down—and just enjoying it —and every day I go out and watch it again. I draw some and there is a little painting and so the days go by.

The somber country and its silence met her need. This was the summer that she first saw and painted some of the great Black Crosses of the region, of whose influence, she said, "lay like a veil over the country." She painted Ranchos Church, with its simplicity of line and the beauty of its adobe;

also flowers and hills against a sweep of an intense blue or blood-red sky.

She was drawn to the austerity and mysticism of the country's symbols; life as a struggle, sadness and resurrection. What had seemed sinister and strange to others, who had come to paint the New Mexico country, had truth and meaning for her. She entered into its spirit. She would drive to places of great beauty, sit in the car for hours and look and paint. Because of her complete identification with it, for her New Mexico became a triumph and a victory.

The same summer, she first drove to the tiny village of Abiquiu in Rio Arriba County in the Chama River valley. Abiquiu, with its handful of tiny houses, lies on the rocky edges of hills at the foot of a long, black mesa. The town, built near the sites of earlier Pueblo Indian ruins, an admixture of Indian and Spanish peoples, is predominantly Spanish in its customs and language. That summer there were no Anglos in Abiquiu, and no place she knew of where she could stay or, she says, she would have remained at once. It was so extraordinarily to her liking—an untouched feeling, the magnificent rock formations, steep cliffs and hard earth.

It was also that summer that she went up the Ghost Ranch way, sixteen miles north of Abiquiu. Because of the winding overgrown road, the arroyos and the dense sage, she could not find her way in.

The summer months over, and with a harvest of paintings, Georgia went back East—greatly renewed in health and back from a great experience. "You can't imagine the beauty I saw around there, it was too good to describe," she told me soon after. It was always in her thoughts that some day she must find her way into this region and see what lay beyond.

Stieglitz was intensely proud of her work, even though he still resented her going to New Mexico. As the crates were unpacked, and he showed each canvas to friends, he would say triumphantly: "That's Georgia!"

Going West had not been a break with her earlier paintings, for some of the feeling of the Big Flowers remained. But now there was a difference of emphasis. The warm, exciting colors had receded and something

majestic and stoic had taken their place. She had recorded this land of
the early Spanish padre Missions, not as other Eastern painters who had
come to visit it, but as one who had found her spiritual home. She admired
the courage and the kind of living that the desert called for, and she felt
close to the plants that pushed through hard ground. There was no hour
when the sky and cliffs did not seem wonderful.

Her return to New York that fall came at the time of the great economic
collapse in the United States. Stieglitz was thinking not only of his own
holdings, on which her personal life and all that he could do for other
artists depended, but of the dwindling of purchasers for the work of his
protégés. His friends in the financial world were suffering disasters daily.
At the depth of the Great Depression, following the crash, Georgia's pic-
tures continued to sell for large amounts and Stieglitz enjoyed discoursing
on the security of art as compared to the insecurity of business.

The Intimate Gallery at the Anderson Galleries, where Stieglitz had
shown American art through the spring of 1929, had closed; yet in the
winter of 1929, when the world was trembling with uncertainty and busi-
nesses were closing, Stieglitz opened An American Place, his new gallery,
in rooms on the seventeenth floor of 509 Madison Avenue, at the corner
of East Fifty-third Street. The quiet atmosphere of the rooms, their im-
maculate whiteness, were in startling contrast to the tension on all sides
and to the hurly-burly seen from its windows that looked upon the heart
of Manhattan's business district. Art within the walls of An American Place
had to be extremely vital, Stieglitz often said, to exist with such pressure
from without.

As was his custom, he opened the season in December 1929, with a
Marin exhibition. In February 1930, Stieglitz showed Georgia's New Mexico
pictures, painted the summer before. There were twenty-seven in all, in-
cluding some abstractions, a New York at night, three paintings of the
Mission Church of Ranchos de Taos, and paintings of the sand hills, trees
and flowers of the South West, including *The White Flower*, four large
paintings of the great dark Crosses, and the canvas that she called *The
Lawrence Tree*, which people coming to the gallery would ask for years
afterward.

Critics were astonished at her identification with whatever she painted—
the flowers, the Lake George country, New York City, the Wisconsin

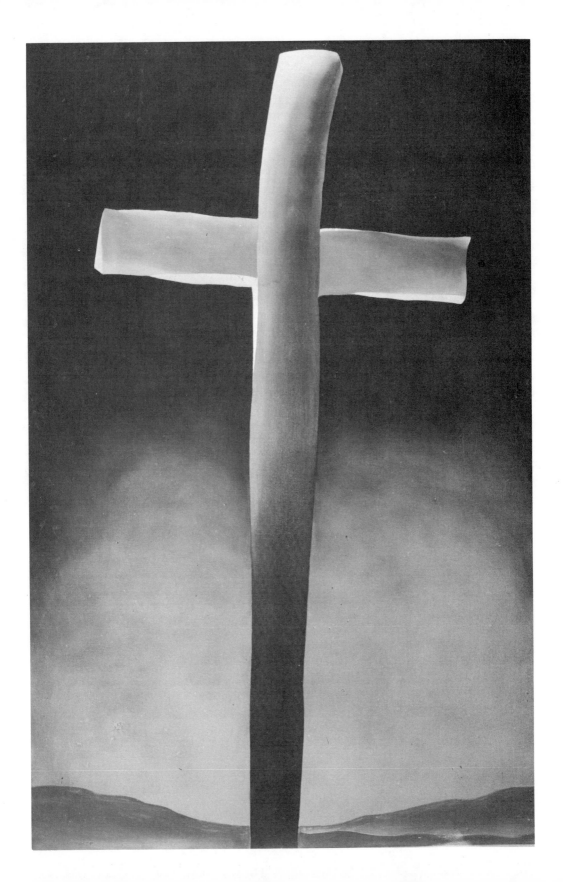

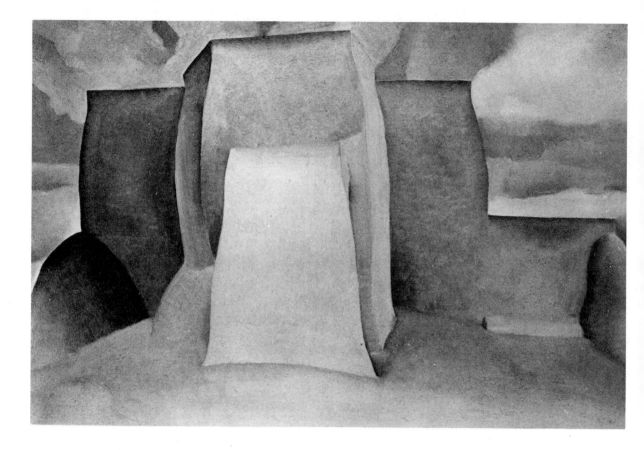

OVERLEAF: *GRAY CROSS WITH BLUE*
(1930), OIL ON CANVAS, 36 X 24 IN.
PHOTOGRAPHED BY JULEY. COURTESY
THE ALBUQUERQUE MUSEUM:
PURCHASE 1983-1985 G.O. BONDS.
ALBUQUERQUE MUSEUM FOUNDATION,
OVENWEST CORP., FREDRICK R.
WEISMAN FOUNDATION

ABOVE: *RANCHOS CHURCH* (1930), OIL
ON CANVAS, 24 X 63 IN. METROPOLITAN
MUSEUM OF ART, ALFRED STIEGLITZ
COLLECTION

barns—and now the great Southwest with its shapes and space. They did not hesitate to praise her work unreservedly. By now they were talking about the work itself, the excellence of her painting, and not the interpretation they were reading into it. She often acknowledged the praise of her work by saying, "I am a lucky person." This contentment showed in her painting. I share the excitement that many of the critics wrote about.

**Edward Alden Jewell, the New York *Times*, February 9, 1930**

. . . What you will find at An American Place is the most exciting O'Keefe show this writer has ever seen. The pictures look perfectly beautiful—beautiful in themselves and beautiful in their new setting. . . . Objective and subjective have reconsummated their mystic marriage, enlarging the scope without betraying that most precious of the artist's gifts, sensitiveness to forms unglimpsed and to voices unheard. Lines by Æ interlard one's participation:

> *Our hearts were drunk with a beauty*
> *Our eyes could never see.*

*A sharp monumental vigor has come into the work revealing itself especially in the things done in New Mexico. Black crosses replace the delicate flower shapes of yesterday. Pine Tree with Stars is an amazing performance; objectifying for us an experience that must have amazed and delighted the artist. Here is solitude—and how extraordinary is the gift that can take up "picturesqueness," breathe upon it, and release a transformed image absolutely devoid of picturesqueness, thrilling with the vision that pierces through to sheer spiritual experience.*

The time had come when many heads of art museums also expressed their appreciation of her work. In 1930 the Cleveland Museum of Fine Arts purchased Georgia's painting, *White Flowers.*

**Willliam M. Milliken, director of the Cleveland Museum, to Georgia, November 1930**

> . . . [L]et me tell you again the real thrill that your picture gave me. I am just back from Europe and when I came into the gallery where it hung it gripped me more than it did when I went away. I do not think that there could be any greater tribute to a work of art than that.

I believe that Georgia's reply to that letter reveals the key to her feeling about color better than anything she previously said.

**Georgia to William Milliken, reprinted in the Cleveland Museum Bulletin, April 1937**

> At the time I made this painting—outside my door that opened on a wide stretch of desert these flowers bloomed all summer in the daytime. The large White Flower with the golden heart is something I have to say about White —quite different from what White has been meaning to me. Whether the flower or the color is the focus I do not know. I do know that the flower is painted large to convey to you my experience of the flower—and what is my experience of the flower if it is not color.
>
> I know I cannot paint a flower. I cannot paint the sun on the desert on a bright summer morning but maybe in terms of paint color I can convey to you my experience of the flower or the experience that makes the flower of significance to me at that particular time.
>
> Color is one of the great things in the world that makes life worth living to me and as I have come to think of painting it is my effort to create an equivalent with paint color for the world—life as I see it.

The pictures were now beginning to be known to a large public nationwide through the important museums. In 1934 the Metropolitan Museum of Art, New York, bought one of Georgia's Big Flower Paintings— *Black Flower and Blue Larkspur* (1929).

Beginning with the summer of 1930, Georgia asked Stieglitz to go West with her to see for himself the wonders of the country she visited. She hoped that would stop him worrying. But he never would go. Except for his early years of European studies, he had gone to the Lake George home every summer of his life—it was a great emotional attachment. Also the Lake George home had become a proof to him of one of his cherished beliefs—that the artist did not need to travel to new lands. He would not go West "just to see," as she put it to him.

It was a real wrench for her, each time she left for the West, even though she tried not to show it to casual acquaintances. In 1939, I went with her and Stieglitz to the railroad station, when she was leaving for her summer in New Mexico. She wrote back to me from the train, "I was glad you came to the station. Glad to see you and glad to think the little man was not going back alone."

She never refuted the talk caused by Stieglitz's conversations with everyone who came into the gallery, people who knew Georgia and those who had never seen her, about her leaving for summers in the West. To her the fact was, "I must go for the summer months if I am to continue to live and to paint." Also, she had begun painting the great Southwestern country and had to continue.

It was in her second summer in New Mexico that she began to notice especially the bones of the desert. She had long painted white flowers, white clouds, white shells, with skill and with sensitive variations of their tones and textures; therefore, when she came across these bleached bones, polished by wind and sand, she was fascinated. While off in her car, to paint the hills and the sky, she would pick up bones or a cow's skull, and take them to the ranch. She spoke and wrote of them as her "treasures."

"When the time comes to go East each fall, I wished I could take the whole country back East with me," she told me. "I decided, however, that the bones of the desert were something that I could take. So I packed and crated a barrel of bones to send to Lake George. To keep the bones from rattling, I put some of the pink and white paper Calico Roses from the Fiestas in the barrel."

In February and March 1931, at An American Place, there was a second

exhibition of New Mexico paintings. The early flowers, so full of intense emotion, the lyric songs of Lake George, which had later given way to tall buildings, had now made way for the majestic hills and canyons and abstract inventions.

**Georgia O'Keeffe to Henry McBride, Alcalde, N.M., July 1931**

> . . . I see that the end of my studio is a large pile of bones—a horses head—a cows head—a calfs head—long bones—short bones—all sorts of funny little bones and big ones too. . . .
> —There is also a beautiful eagle feather
> When I leave the landscape it seems I am going to work with these funny things that I now think feel so much like it
> —but maybe I will not. . . .

**Paul Rosenfeld, *The Nation*, April 8, 1931**

> A new detachment has evidently permitted the painter to control her medium and conceive her paintings more completely than ever before in terms of the plastic problem—It is significant that O'Keeffe's latest successes are chiefly mountain landscapes, great concepts of the impenetrable, the abiding, the impersonal.
> There is absolutely no "imitation" of nature in these singularly calm, simple, spacious South Western pictures, works of a veritable modern Fra Angelico or Suor Angelica. . . . No contemporary handles oil paint more absolutely than she; or communicates there—with a feeling of life more ardent or more deep.

Before departing for her summers in New Mexico, Georgia would go up to Lake George to put the house in readiness for Stieglitz. Almost always she would return there in the fall, before both she and Stieglitz came to New York for winter and spring. It was in 1931 at Lake George, from the contents of the barrel from the previous summer, that she painted the first of her famous Cow's Skull Paintings, against the "sky-blue background

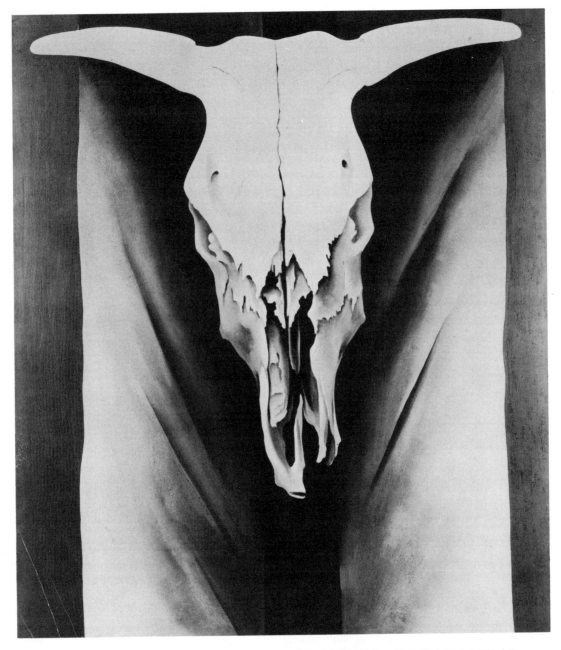

PHOTOGRAPHED BY STIEGLITZ OR
JULEY, *COW'S SKULL: RED, WHITE AND
BLUE* (1931), OIL ON CANVAS, 00 X 00 IN.
METROPOLITAN MUSEUM OF ART,
ALFRED STIEGLITZ COLLECTION

of the pajamas of Margaret Prosser's little boy." When I asked Margaret Prosser about those paintings, she could still remember the morning that Georgia came into the kitchen and said, "I've thought of something, Margaret, that I want to do and I want to be alone, so you take the day off."

"I did take the day off," said Margaret, "and I went walking in the woods. In the late afternoon I came home. Georgia had been painting all day and there was the painting of a cow's head sitting on the table, beautiful like a cross, and not a muss around. There was her easel cleaned off and the whole picture finished."

**Anita to Georgia, in conversation, circa 1931**

> Your picture was the beginning of an era in painting. So many writers and artists have been talking about America "creating something American." I know you are bored with this talk because you feel that most of them have not seen America and actually know very little about it. You feel you know America as they never will and love its West as few Easterners do.

**Georgia to Anita, in conversation, circa 1931**

> I painted my cow's head because I liked it and in its way it was a symbol of the best part of America I had found. Cattle were important to America, as I knew from my days in Amarillo when they were only beginning to think about oil. I painted my head of a steer and as I worked on it, I thought to myself, "Just for fun I will make it red, white and blue—a new kind of flag almost." It always amused me as my idea of something American.

*Cow's Skull: Red, White and Blue*, was chosen in 1950 by the Metropolitan Museum of Art as the catalog cover for the exhibition, "One Hundred American Painters of the 20th Century."

Stieglitz, for some time, was just as opposed to the idea of Georgia's bone paintings as he had been in the beginning to her paintings of New

THE STIEGLITZ FAMILY SUMMER HOUSE
IN 1932, PHOTOGRAPHED BY
ALFRED STIEGLITZ

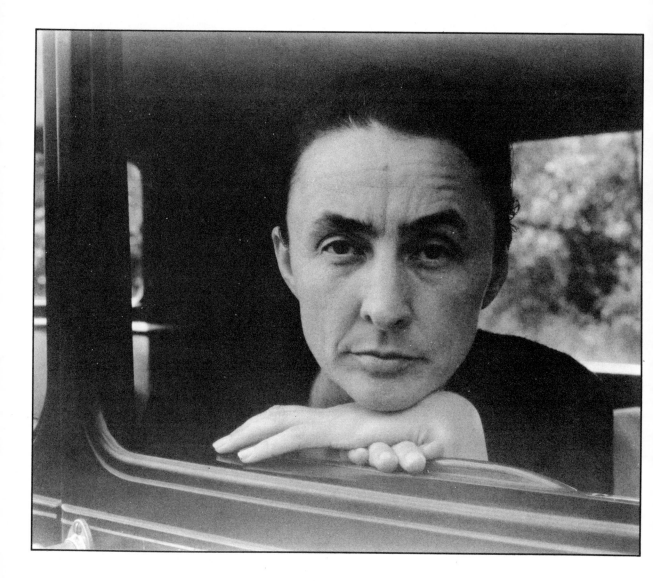

O'KEEFFE BY STIEGLITZ, 1933

York skyscrapers. Although he applauded the new steps of others, he would have been content to have Georgia continue to paint her lovely flowers endlessly. About every new move of his own in the presentation of art or in photography, he was completely unafraid—but for Georgia's paintings, with which he was tremendously happy when they were actually in the exhibition, it was as in his personal life, he dreaded change.

In the early summer of 1932, Georgia went from Lake George with Stieglitz's young niece, Georgia Engelhard, to the Gaspé country in Canada. They rented a cabin off the Gulf of St. Lawrence, and Georgia painted. This pleasant, two-and-a-half-week Canadian trip produced several distinguished canvases, including the immaculate White Barn Paintings, the sensitively moving *Cross By the Sea, Canada* and the vibrant *Green Mountains, Canada.*

On her way West that summer, Georgia stopped in Wisconsin, visited her aunt Ollie in Madison, her sister Catherine Klenert in Portage and saw her childhood farm home at Sun Prairie. She wrote me then, "I have seen nothing finer here than the barn my father built."

Again praise from the public and critics for the exhibition—including the Canadian pictures—hung in December 1932 at An American Place and remaining up through March 1933. In the paintings, she had left the heavy Spanish crosses and had portrayed with equal understanding the light French Canadian Crosses. She had left the earlier dark barns and painted with equal craftsmanship and equal understanding the White Canadian barns.

Reviews of the 1932-33 exhibition, called "Paintings Old and New," show how closely critics were watching Georgia's development.

Elizabeth McCausland, Springfield *Republican*, January 22, 1933

> Five years are covered by the exhibition, years in which O'Keeffe has ranged from the flower paintings to New Mexico and back again. . . .
> It is, in short, the distance traveled, not in space, but in thought and feeling, that makes the 1933 O'Keeffe exhibition so emphatically an aesthetic fulfillment. In the inner room where six canvases are hung, dating from an earlier period

(1926–29), one sees O'Keeffe at a mystical and ecstatic apogee, the beauty of life translated into the beautiful *Black Iris*, or again simplified and synthesized in the abstractions. In the paintings done in 1932 it is another O'Keeffe that speaks, an O'Keeffe aware not only of the beauty of life but of its pity and tremendous terror. No tour de force now, no merely personal concentration on loveliness for its own sake, no matter how rapturous such loveliness may be; rather life caught up wholly and completely, the cross embraced as well as the flower.

Yet the flower has not been lost nor the rapture repudiated. . . .

**Henry McBride, New York *Sun*, January 14, 1933**

In my own case I find I am more mystified and impressed this year by the series of pictures of barns than by anything else. They are very elegant . . . the solidity of these edifices patiently built of tenderly pure pigment is something I do not understand. The little one in the corner gallery has all the force of a statement by Picasso, yet in a Picasso you can see the artist applying power, while in the O'Keeffe barn the artist seems to stand aside and let the barn do it all by itself. That's why I say the best O'Keeffe's seem wished upon the canvas —the mechanics have been so successfully concealed.

From October 31, 1932, to January 31, 1933, the Museum of Modern Art held an exhibition of "American Painting and Sculpture, 1862–1932." One hundred fifty examples of painting and sculpture were shown. The work of two women was represented, Mary Cassatt, who had died in 1926, and Georgia, two of whose paintings were on exhibit: *Pink Dish and Green Leaves* (1928), a pastel, and *Cow's Skull and White Roses* (1931).

In 1934, she explored the region north of Abiquiu. She was so happy with the grandeur and untouched beauty of the country that when she reached Ghost Ranch, and found they had a place for her to stay, she

went back to where she had been living, packed her things, and returned to stay. There she rented a little one-room cottage with kerosene lamps and wide board floors. She ate at the Lodge, and spent her days out-of-doors painting.

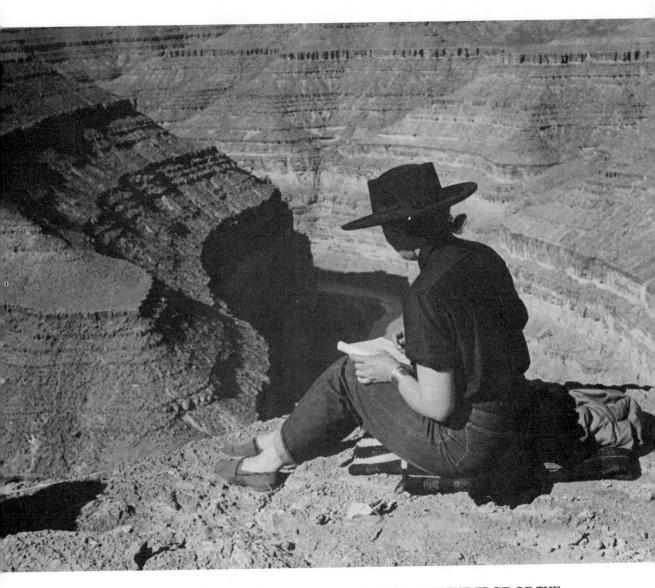

O'KEEFFE AT THE EDGE OF THE
CANYON DE CHELLA, ARIZONA,
PHOTOGRAPHED BY ANSEL ADAMS.
COURTESY OF THE TRUSTEES OF THE
ANSEL ADAMS PUBLISHING RIGHTS TRUST.

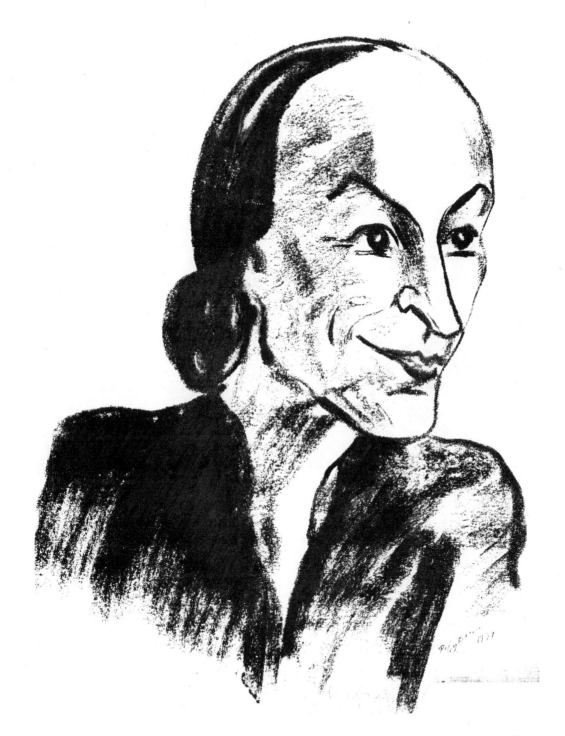

STIEGLITZ AND O'KEEFFE (1934) BY
PEGGY BACON

Georgia to Ettie Stettheimer, on train from New Mexico to New York, August 24, 1929

> . . . I am on the train going back to Stieglitz—and in a hur-
> ry to get there—I have had four months west and it seems to
> be all that I needed—It has been like the wind and the sun—
> there doesnt seem to have been a crack of the waking day or
> night that wasn't full. . . .
>
> —I feel so alive that I am apt to crack at any moment—
>
> I have frozen in the mountains in rain and hail—and slept
> out under the stars—and cooked and burned on the desert
> . . . my nose has peeled and all my bones have been sore
> from riding—I drove with friends through Arizona—Utah—
> Colorado—New Mexico till the thought of a wheel under me
> makes me want to hold my head
>
> —I got a new Ford and learned to drive it—I even paint-
> ed—and I laughed a great deal—I went every place I had
> time to go. . . .

From the time she had first gone to New Mexico its landscape held her
enthralled. Painting the bones, with their subtle graduations, and places
with depth and distance, now had great meaning to her. Her arrange-
ments of deer's horns and cow's skulls with clouds, mountains or flowers
were not weird or strange to her. On her daily walks, she was struck by
the beauty of their shapes and colors, by their contrasts. Along with the
starkness of the country, she felt its rhythms; along with its realism, she
felt an inner depth. She was now able to convey the feeling she wished
through greater knowledge of the land and greater mastery of technique.

In 1935, An American Place held a retrospective showing of her work
from 1919 through 1934—paintings of the Red Hills, over New Mexico
scenes, two extraordinary drawings of Kachinas. It was also the year of
the fine Red Hill Paintings, of the beautiful *Ram's Head with White
Hollyhock*. The critics praise paralleled my own.

Edward Alden Jewell, the New York *Times*, January 12, 1936

> . . . *Dark Hills, Ghost Ranch, New Mexico* is such a picture. It

moves and yet is still. This is the earth that Tolstoy liked to think, in its monumental brooding patience, not inanimate. These are hills that the artist has loved. Their immemorial life, apprehended at the source, drawn forth in symbol language, becomes the thews and sinews of a created image containing all and giving all.

Lewis Mumford, the *New Yorker*, January 18, 1936:

. . . The epitome of the whole show is the painting of the ram's head with its horns acting like wings, lifted up against the gray, windswept clouds; at its side is a white hollyhock. In conception and execution this is one of the most brilliant paintings O'Keeffe has done. Not only is it a piece of consummate craftsmanship, but it likewise possesses that mysterious force, that hold upon the hidden soul, which distinguishes important communications from the casual reports of the eye. Here one notes the vast difference between those who are able to draw upon the unconscious because they face life at every level, and the Surrealists who have been playing with the unconscious—O'Keeffe uses themes and juxtapositions no less expected than those of the Surrealists but she uses them in a fashion that makes them seem inevitable and natural, grave and beautiful.

The ram's head is not alone. The same health and mastery pervade the rest of the show; witness the swirling waters of the *Chama River* and the *Dark Hills*—Here are serenity, poise, craftsmanship, command; above all a simple love of beauty. Indeed beauty, an almost forgotten word, becomes real again in her work.

In New York, from their room on the thirtieth floor of the Shelton Hotel, where they had lived since 1925, Georgia and Stieglitz moved in 1936 to a fine penthouse apartment at 405 East Fifty-fourth Street. There was a broad terrace with a magnificent view, directly overlooking the East River. After painting almost all day in the studio, she and Stieglitz enjoyed the

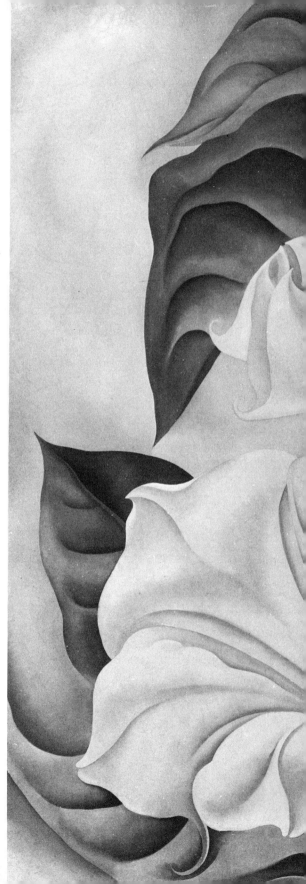

*JIMSON WEED* (1937), LINEN ON CANVAS,
70 X 83 IN. DONE ON COMMISSION FOR
ELIZABETH ARDEN'S EXERCISE SALON.
ON LOAN TO THE INDIANAPOLIS
MUSEUM OF ART BY THE ELI LILLY
COMPANY

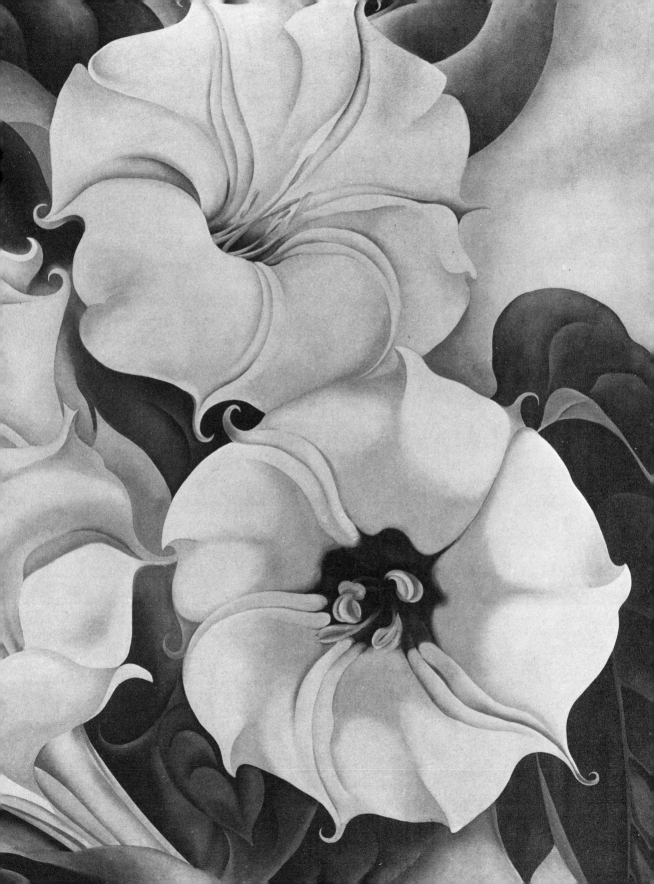

evening sky, the water and the lights.

She painted a variety of things at this time. "Often the things I paint come to my door," she said to me. For instance, one day her Swedish maid, Saga, came in to her saying, "There's a tree at the door. What shall I do with it?" It was a luxuriously blooming, potted magnolia bush, the size of a young tree, that someone had sent to Georgia, the sort of plant achieved by a select greenhouse. Each flower on the tree was carefully done up in a piece of white tissue paper so as to protect it. As it was pouring rain outside, Georgia said to Saga that they certainly could not leave the tree out on the terrace in the rain. They kept it in the studio until the weather was good. "It is very funny to have to keep a tree out of the rain but you can't put a tree with its flowers carefully wrapped in tissue paper out in a cold New York rain," she said. And for this unexpected present, Georgia stopped all else and painted magnolia blossoms with her characteristic bigness.

**Georgia to Anita, in conversation, 1937**

> I painted the flower big to give the feeling I had in me when I looked at it. At the time it seemed to me as though the flower I was painting was the only thing in the world. I didn't think of it as small. It was all there, was for me, and it was very lively. And when the bloom came out, I felt as though a skyscraper had gone up overnight.

When Georgia painted a flower she would not make an engagement until the bloom was faded. As a rule, not even Stieglitz saw the pictures until they were finished.

The catalog of the annual New York exhibition of Georgia's paintings held December 27, 1937, to February 11, 1938, at An American Place included some letters.

**Georgia to Stieglitz, fall 1937**

> The wind is blowing hard . . . I have been painting all day—

a painting that should be very good if I can really get it right—another cedar tree—a dead one, against red earth, but the red earth is more difficult—if this one doesn't go I'll try it again. At five I walked—I climbed way up on a pale green hill where I could look all around at the red, yellow, purple formations—miles all around—the color all intensified by the pale grey green I was standing on. It was wonderful—you would have loved it too—walking by yourself in the evening—up the hill too—if I had been there I would have encouraged you—I wonder should I go to the lake and have two or three weeks with you before you go to town—I will if you say so—Wire me and I will pick right up and start.

The wind blowing tonight is like being on the water—a really lovely wind. . . .

It is very hard work to turn out anything that looks like a good painting. I seem to be busy all day from six o'clock on. . . .

In September 1938, after her New Mexico summer, she took a brief trip to Yosemite with Ansel Adams, photographer and friend of Stieglitz, who knew the region as few do.

**Ansel Adams to Stieglitz, Yosemite, Calif., September 10, 1938**

. . . We leave tomorrow morning for the high mountains—about 14 mules, guide, packer, cook—much food, warm bedding—photographic equipment and great expectations in general.

I met O'Keeffe at Merced and drove her to Yosemite Tuesday . . . As we climbed through the mountains, the scene rapidly changed and as we entered Yosemite she was practically raving—"Well—Really, this too wonderful!!" Yesterday, we drove to the Big Trees and had lunch there; later we drove to Glacier Point, where we had supper . . . it was an incredible moonlight night . . . To see O'Keeffe in Yosemite is a revelation. . . . Her mood and the mood of the place—not a con-

flict, but a strange new mixture for me—she actually stirred me to photograph Yosemite all over again.

She says very little, but she looks and once in a while something is said that sums everything up in a crystal, inevitable clarity.

This quality you perhaps have seen a million times to my once or twice, but it explains a lot—everything in fact.

The exhibitions and catalogs continued.

**Georgia, "About Myself," catalog statement, 1939**

. . . A flower is relatively small. Everyone has many associations with a flower—the idea of flowers. You put out your hand to touch the flower—lean forward to smell it—maybe touch it with your lips almost without thinking—or give it to someone to please them. Still—in a way—nobody sees a flower—really—it is so small—we haven't time—and to see takes time like to have a friend takes time. . . .

So I said to myself—I'll paint what I see—what the flower is to me but I'll paint it big and they will be surprised into taking time to look at it—I will make even busy New Yorkers take time to see what I see of flowers.

Well—I made you take time to look at what I saw and when you took time to really notice my flower you hung all you associations with flowers on my flower and you write about my flower as if I think and see what you think and see of the flower—and I don't.

Then when I paint a red hill, because a red hill has no particular associations for you like the flower has, you say it is too bad that I don't always paint flowers. A flower touches almost everyone's heart. A red hill doesn't touch everyone's heart as it touches mine and I suppose there is no reason why it should. The red hill is a piece of the bad lands where even the grass is gone. Bad lands roll away outside my door—hill

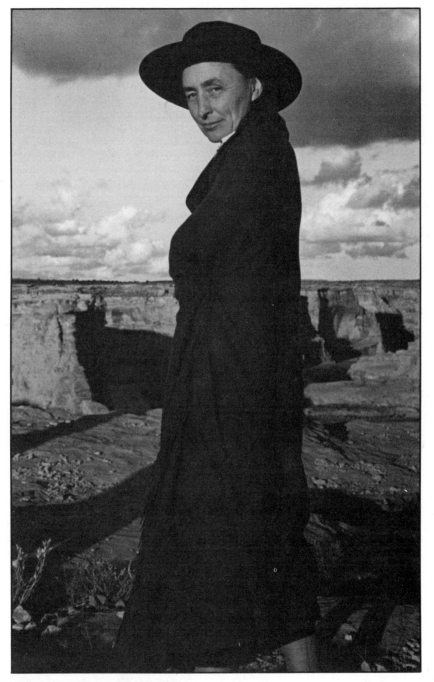

O'KEEFFE AT THE EDGE OF THE
CANYON DE CHELLA, ARIZONA,
PHOTOGRAPHED BY ANSEL ADAMS.
COURTESY OF THE TRUSTEES OF THE
ANSEL ADAMS PUBLISHING RIGHTS TRUST.

*21 New Paintings ——*
*(Hawaii)*

*Georgia O'Keeffe*

*February 1 – March 17/1940*
*An American Place*
*509 Madison Ave. — N.Y.*
*Weekdays: 10 A.M. – 6 P.M.*
*Sundays: 3 – 6 P.M. ——*

STIEGLITZ WROTE BY HAND THE AN-
NOUNCEMENTS FOR ALL O'KEEFFE'S
EXHIBITIONS AT AN AMERICAN PLACE

after hill—red hills of apparently the same sort of earth that you mix with oil to make paint. All the earth colors of the painter's palette are out there in the many miles of bad lands. The light maples yellow through the ochres—orange and red and purple earth—even the soft earth greens. You have no associations with those hills—our waste land—I think our most beautiful country—You may not have seen it, so you want me always to paint flowers. . . .

I have wanted to paint the desert and I haven't known how. I always think that I can not stay with it long enough. So I brought home the bleached bones as my symbol of the desert. To me they are as beautiful as anything I know. To me they are strangely more living than the animals walking around—hair, eyes and all their tails switching. The bones seem to cut sharply to the center of something that is keenly alive on the desert even tho' it is vast and empty and untouchable—and knows no kindness with all its beauty.

Except for 1939, the year she made the trip to Hawaii, she returned to the New Mexico ranch country every summer, from the time she discovered it. The rest of each year was spent with Stieglitz and her work in New York. The trip to Hawaii was made in order to do a series of commissions for a pineapple fruit company. Not until she returned to New York did she or the company realize that she had not painted the particular plant they were interested in, and it was then flown to New York where she painted the plant and its bloom. Even when she had been in Hawaii, it had been too hard for company officials to realize that a woman could really want to make the hazardous trips by car and on foot to the plantations to see the plants in their habitat, instead of having them brought to her. But as much as she could, she was, in a brief visit to Hawaii, trying to get the feeling of this region totally different from others she had painted.

Georgia's exhibit of February and March 1940 was of the Hawaiian waterfalls, the black lava bridge, fish hooks, the clear blue water, the exotic flowers, the papaya tree, the pineapple bud painted in New York on her return.

# THE WAR YEARS: 1940–1945

SUMMER 1940, while in New Mexico, she bought her own place in the Ghost Ranch region, near Canjilon Creek or "Arroyo Seco," in the northwestern part of the state. Her ranch is on land sixty-five miles from Santa Fe, ninety-five miles from Taos, forty miles from the nearest "big" town of Espanola, and sixteen miles from the nearest post office in the town of Abiquiu. This meant that she could live and work in her own home for the summer months and have a place to keep rocks, horns, beads, bark—her treasures that no one else wanted.

From the patio of her adobe house, the great flat-topped mountain called the Pedernal, which she has painted so often, is centered in the distance. On the other side of the house is a wide circle of great pink, red and yellow cliffs.

**Georgia to Ettie Stettheimer, Abiquiu, August 15, 1940**

> . . . Colored earth—rattlesnakes and a Siamese Kitten for news is all I have. [I]t is quiet here—I have no radio—and no newspaper—only *Time* that the girl gets when she goes to town—for food . . . I've only been to town twice since I'm here—I'm having a lovely time. . . .

"This is the magical country for me," she said.

The sunrises and sunsets and hours of painting gave her the kind of life she had longed for.

Soon after she began to live at her own ranch, she engaged a strong young girl from a nearby town to do the household work. Very shortly Georgia saw that all too soon there was to be a baby. The ride to a doctor was refused. There was no husband, the young woman said, so there could be no baby.

Finally, Georgia insisted on driving her to the hospital, sixty-five miles away. Even on the ride, no confidences were shared.

After a few days, Georgia drove there again, and found the young woman was about to be discharged from the hospital, and ready to come back to her work. "But where is your baby?" Georgia asked. She answered that she was leaving it for adoption. "But don't you want your baby?" Georgia continued. When the answer was "Yes, but I am going back to work," Georgia replied: "Then we'll get the baby and take it home."

Convincing the authorities was a harder problem. They wanted to know if Georgia would promise to have the baby seen by a doctor every few weeks. She would not agree to take the baby so many miles in the summer heat to see a doctor, unless it was necessary, she said, but she would treat it like any other healthy baby. Then came her request for the formula and the bottles for the long journey to the ranch. Georgia, true to her nature, sat quietly waiting while conferences were held. Finally the young mother appeared with the strapping boy, the bottles and the formula. The three departed for the ranch.

Once there, Georgia realized that she knew nothing of taking care of babies. Because of "Auntie's" life with them, her help had not been needed with her younger sisters and brothers. She therefore telegraphed New York for the best current baby book to be rushed to her. She studied it assiduously, trying to know as much about a baby's care as she knew about the care of her brushes and canvases, so as to really do the job well.

A great part of the summer was devoted to bringing up this healthy infant. Since the young mother still did not wish the baby to be seen, should anyone chance that way, the baby and the clothesline with diapers were put out-of-doors early each morning, to be brought in before others passing by might be astir. The baby's schedule was kept carefully,

O'Keeffe regulating her own time by his feedings. The baby thrived and the few who came to know about it, referred to it as "their baby."

September finally came, and she knew she must go back to New York. What could she do with the girl and the baby? She could not leave them at the ranch miles from the nearest mailbox. Georgia decided that she would have to find the father, whose existence up to now had been denied.

Nothing that Georgia asked produced more information about the baby's father. Finally she learned his name and address. At once she wrote to him that he had a baby at her house and better come down and see about it as she had to go away, and that she would look forward to seeing him the following Sunday. Time passed and he didn't come. So one morning Georgia, a friend who was staying with her, and the young mother in the front seat, and the baby, dressed in as fine an outfit of clothing as a baby could have had, in a Montgomery Ward packing box, in the back seat of the car, started off for the CCC Lumber Camp in Colorado where the young man was supposed to be employed. When they went through the town where the young mother lived, they left her at her mother's house and drove off with the baby she wasn't supposed to have. It was also the home town of the young man and there they learned that he had gone farther on, up into the mountains—forty miles on wood roads where they could certainly get lost. It was already late but on they went. They finally came to another lumber camp where there was a man to be seen. Georgia's friend got out of the car. She walked over and asked if he knew where they could find the person they were looking for. He laughed and said that it was he. She asked him to walk over to the car and there he saw this baby who looked enough like him to be his younger brother. Names were exchanged. Georgia told the young man she was taking him back with her. She then went to the head of the camp and made arrangements for him to get the necessary leave.

He went along with them gladly and at once told them that he had started out before the Sunday she had suggested he come, and had almost got to her ranch but he didn't know what Georgia would be like, weakened, and went back home.

Her next step was to call for the young mother. The two, who had not seen each other over the long period, were blissfully happy. Satisfied as to this, Georgia, with her swift decisions for action, offered to give them

the wedding. Arrangements for this, in traditional style, are elaborate. Every relative on both sides must be invited or it is a serious slight, growing in importance. Georgia assumed all responsibility for the wedding, took charge of all preparations, invitations, and the cost.

The young people were married and the baby was baptized all before nightfall. There were little delays for there was nothing to prove that the young mother had been born for she had come from another village and had changed her Christian name to something she thought was prettier. They could not for some time find two witnesses who qualified for the ceremony signing. Georgia offered but as a non-Catholic, did not qualify. Night was coming and Georgia announced that she would do everything necessary but that she would not stay overnight. Finally witnesses were secured, and all was in order. The wedding took place, while outside in the car the baby was cooing happily in his packing box, lined with shelf paper, cared for by Georgia's friend. At the end of the wedding ceremony, it occurred to her that the baby, for all their trouble, should certainly be at the wedding, and she rushed in to the ceremony with him. The new family was happily launched.

Georgia returned to New York as she always did in the fall. When she told me this story, she said to me in her graphic way, "I drove over a thousand miles to get that baby married, but there wasn't a finer baby in the region than we had at the end of the summer."

Later Georgia showed me the touching letters that she received from the young man, while he was a serviceman in the Pacific and his wife and baby were with the wife's family. One of his letters ended with, "To think I wouldn't have had my wife and baby if it hadn't been for you, Miss O'Keeffe. Good Luck, and May Our dear Lord Bless You." The parents and the baby continued to come to see Georgia almost every summer.

With the summers in New Mexico, there were her winters, autumns and springs in New York City. In the wartime of 1942, when taxi stands vanished from the East River section of New York, and Stieglitz could not ride to An American Place as he previously had, Georgia found an apartment at 59 East Fifty-fourth Street, so that he only had a block and a half to walk. The apartment was so simple that people who did not know her

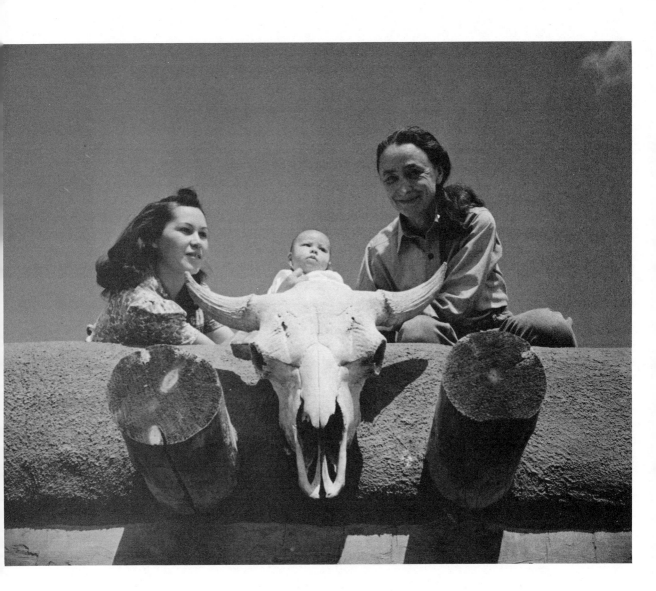

O'KEEFFE WITH MOTHER AND CHILD ON
THE ROOF OF THE ABIQUIU HOUSE

well would ask when her furniture would be moved in. There were no pictures on the wall. Only a silvery collage by Arthur Dove, entitled *Rain*, was on the living room mantle. Sometimes there were pieces of dried grass, coral formations or shells on the mantle, tall green plants in very white pots near the uncurtained windows. The one purely ornamental thing in the apartment was a beautifully shaped crystal bowl. Some seasons before, a few well-known artists had been asked by Steuben to make designs for their glass pieces. Georgia made a flower pattern for the center of a large shape, and characteristically enough the bowl she chose to keep was their original clear glass model, without her flower design.

If, during the day, Georgia had been working on a picture, by evening it stood on the easel, turned to the wall. If it was something she wasn't sure of, she put it in the closet for a while.

In New York, Georgia often went to hear music, particularly chamber music. Her attention at concerts was as concentrated as the time when she took me with her to the home of Louis Ledoux to see his rare Japanese prints, which he showed us one by one.

In 1942, she started her series of paintings of the Black Place, a formation of black sandhills. When there is a series of paintings of the same scene, the work often starts with more realism and ends with her vision. Or it may begin with lines and shapes and end with the aesthetic organization of the whole, largely abstract in feeling. The same year she painted *Grey Hills*, camping out in the late fall, in a desolate place with no water, no trees, no grass and only a little sage to catch the spirit of the hills in her painting. This was the summer of the fine Kachinas and the beautiful *White Place in Shadow*.

Nineteen forty-three was another great year for her work. She went on painting the Black Place, the cliffs—realistic and yet far beyond. She began painting the big cottonwood trees—*Dead Cottonwood Tree*. The same year marks the start of the pelvis paintings against the intense blue sky of New Mexico—*Pelvis with Distance*, is a great example of the lyricism in her Bone Paintings—the white bone that soars even above the mountains to reach the sky. *Pelvis with Shadows and the Moon*, that she later gave to Frank Lloyd Wright, also conveys this spirit. In these paintings she is close to Shelley's "white radiance of eternity."

In 1943 the Art Institute of Chicago held an important representative

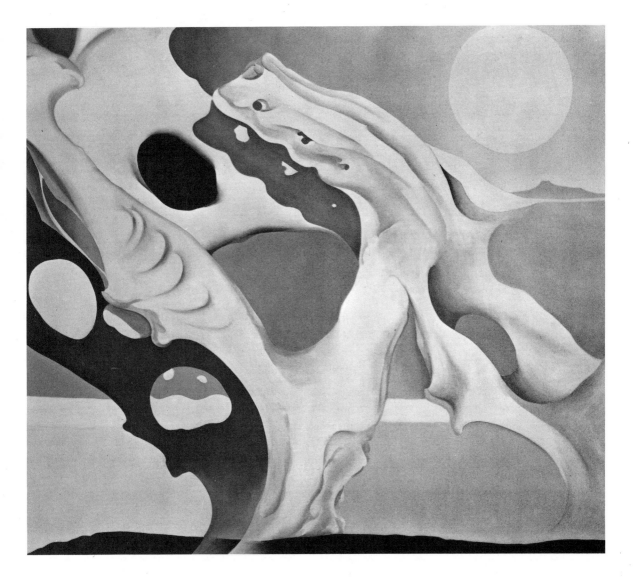

JULEY'S PHOTOGRAPH OF *PELVIS WITH SHADOWS AND THE MOON* (1943) OIL ON CANVAS, 40 X 48 IN. PRIVATE COLLECTION, COURTESY OF THE WASHBURN GALLERY, NEW YORK CITY

exhibit of sixty-one examples of Georgia's work, all oils, except the wa-
tercolor *Blue Lines* (1915), and a charcoal drawing from 1915. This was
the second time that a major museum held a retrospective showing of her
work.

**Daniel Catton Rich, director of the Art Institute of Chicago, in the catalog for 1943
exhibition**

> Seen in the whole her art betrays a perfect consistency. It has
> undergone no marked changes of style but has moved out-
> ward from the center. In her art that feeling before nature
> which she once eloquently described as "sort of sparkling and
> alive quiet all at the same time," has been conveyed through
> superbly original design and consummate technique. Ameri-
> can painting of our day is infinitely richer for her triumphant
> vision.

As Stieglitz had usually objected to the pictures' traveling or leaving
his care, this exhibition introduced a large number of Georgia's paintings
to the Midwest.

In 1944 more New Mexico paintings were shown at An American Place
from January 11 to March 11.

**Georgia, in the exhibtion catalog, 1944**

> "About Painting Desert Bones"
> I have picked flowers where I found them—Have picked up
> sea shells and rocks and pieces of wood where there were
> sea shells and rocks and pieces of wood that I liked
> When I found the beautiful white bones in the desert I
> picked them up and took them home too
> I have used these things to say what is to me the wideness
> and wonder of the world as I live in it
> A pelvis bone has always been useful to any animal that
> has it—quite as useful as a head I suppose. For years in the
> country the pelvis bones lay about the house indoors and

out—always underfoot—seen and not seen as such things can be—seen in many different ways. I do not remember picking up the first one but I remember from when I first noticed them always knowing I would one day be painting them. A particularly beautiful one that I found on the mountain where I went fishing this summer started me working on them.

I was the sort of child that ate around the raisin on the cookie and ate around the hole in the doughnut saving either the raisin or the hole for the last and best

So probably—not having changed much—when I started painting the pelvis bones I was most interested in the holes in the bones—what I saw through them—particularly the blue from holding them up in the sun against the sky as one is apt to do when one seems to have more sky than earth in one's world—

They were most wonderful against the Blue—the Blue that will always be there as it is now after all men's destruction is finished

I have tried to paint the Bones and the Blue.

In 1944 she painted the Black Place again and again. *Black Place #2* is at the Metropolitan Museum of Art. She went on painting cottonwood trees. She painted *Red Hills and Sky*, *Flying Back-Bone*, and a pastel of rocks, amazing in skill and its solidity of structure, which she satirically called *My Heart*. These paintings were shown by Stieglitz from January through March 1945.

~~~~~~~~~~~~~~~~~~~~~~~~~~~~~~~~~~~~~~~~~~~

# AT THE RANCH: 1945–1946

WHILE Georgia had achieved a successful career as an artist, I had found fulfillment in a completely different sphere. I moved to Washington, D.C., where I met Alice Paul and joined the National Woman's Party. My work with the Party included speaking at many conferences and political rallies. These efforts were, in part, responsible for the Equal Rights Ammendment being first placed on the Senate calendar in 1938. In 1928 I had married Elie Charlier Edson, a freelance press agent, and at that time, before it was even fashionable, I retained my maiden name. Elie was a firm support in my equal rights efforts. When Alice Paul stepped down in 1945, I became national chairperson of the National Woman's Party.

In the summer of 1945, Margaret Cottier Williams and I went to visit Georgia at her ranch near Abiquiu. She met us at Santa Fe and drove us to her home in the Ghost Ranch region in Rio Arribe County, near where the Chama River flows into the Rio Grande.

I was not prepared—even after Georgia's descriptions—for the beauty of the hills, the red and black earth, the skies, and the distance from human habitation. This is wild country. It is in this region that some of the earliest evidences of animal life on this continent have been found. As we drove through the dense junipers and pinons, the adobe house was hidden, until we were actually at its door. No road passes the house, and the only occasional sounds are of coyotes, or the crashing of an antelope through

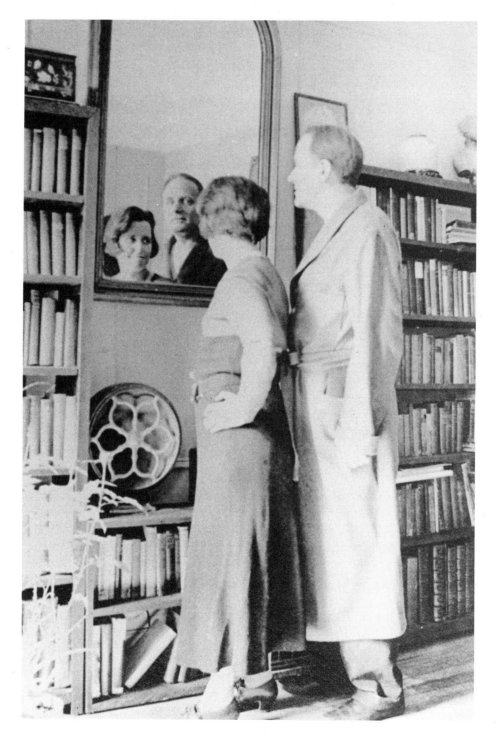

ANITA POLLITZER WITH HER HUSBAND,
ELIE CHARLIER EDSON, IN THEIR APART-
MENT ON MORNINGSIDE HEIGHTS, NEW
YORK CITY

the nearby brush. There were five antelopes ahead of our car lights one evening as we rounded the curve of the road.

Her big studio with wide picture glass looks out on the cliffs. The Pedernal, the great symmetrical flat top mountain of her paintings, which rises 3,500 feet above the surrounding country's high plain of 6,500 feet is directly opposite her patio, and stands silhouetted against the sky. Sunset was over the long mesas to the northwest and the heavens were ablaze with brilliance.

Because of the earth colors of its adobe, her house is hardly visible until one arrives. Inside, there is great restfulness—fireplaces, no pictures on the walls. An early Calder mobile hangs from the center of the bedroom ceiling, making leaflike shadows on the wall. All her fixtures and equipment, even in this far-off place, are models of comfort and simplicity.

In front of the house at roof level is a large whitened buffalo skull, one of her "treasures."

The patio, at the season we were there, was full with wild purple asters, yellow daisies and the handsome white jimsonweed of her paintings. She counted the jimsonweed blooms one night when the moon was full and there were one hundred and eight. What others might consider weeds are her most precious flowers. She covered the low blooms with chicken wire to keep her Siamese cats from nibbling them. There were two Siamese that season—Annie and Anselmo. Originally there had been El Gato and his children whom she named Liti, after the famous Chinese landscape artist, known for his buffalo plunging through the snow, and Suiko, named for a Japanese empress who built the first Buddhist temple in Japan. Annie and Anselmo ran wild in the fields in the day and went walking with Georgia after dark. She does not suggest a walk for exercise, but rather because the earth and every growing thing is wonderful to her. When a storm was approaching, we would take our chairs outside to watch the excitement in the sky. She invited us to climb the ladder to the flat roof to watch the myriad of stars.

The event of each day was a drive before sunset to some high place from where we could watch the sky while we ate a delicious picnic supper, including the loaf of homemade bread, baked either by Georgia or by her young Spanish-speaking helper, Orlinda, and a thermos of hot tea, because Georgia knew that Margaret Williams, British in origin, liked tea. Georgia drove us to the Black Place, the White Place, and other wonderful

spots which she has painted. While driving, we practically never saw another car, except on the highway.

One evening at the ranch, we sat around the table with Georgia from dinner until almost dawn, watching the bloom of a century plant unfold. It had been brought to her early in the evening and her interest in the coming of this beautiful blossom was intense. It is that sort of interest that she puts into painting.

One day she drove us from her ranch in the country to the little town of Abiquiu, to see the ruin of a large adobe house that had become so dilapidated in recent years that it was being used to house pigs. Georgia loved it, because of the glorious view of the mountains in the distance, the sweep of the green valley below, the patio and the fine adobe-walled garden space. In the days of its early glory, it had been the great house of the region. Now boarded up, some of its former rooms crumbled, its beams fallen, Georgia told us, to our amazement, that in addition to the ranch, she wanted to own it. At this Abiquiu house, she could grow her own food, while this was impossible in the very hard earth at the ranch. It would be easier to live in town when the road to the ranch was impassable at certain times in winter. As she described the sunsets and the sunrises she would have from its high ground, we could visualize the restored house and the terrace from which she would look down upon the valley and out to the mountains; we were sure that with her determination and ability, this house, restored, would become her New Mexico townhouse. The property belonged to the Catholic Church and was not for sale. For ten years Georgia had persisted in trying to get it. She finally succeeded in late 1946.

On arriving in New York, after our two-week visit at the ranch, I went directly from the railroad station to give Stieglitz a first-hand report. In spite of the fact that he so much admired her paintings that came out of the West, he was still telling of his worry that Georgia, "so frail a person," should be in the wilds of the Western country. I was glad to describe to him her joy in the outdoors; how she worked from dawn to dusk, climbed the crags like a mountain goat; drove the car to places with extraordinary views and looked so wonderfully well.

Although Stieglitz was never wholly reconciled to these summers in the West, he had slowly come to realize what they meant to Georgia and to her work.

STIEGLITZ, UNDATED PORTRAIT
PROBABLY BY IDA O'KEEFFE

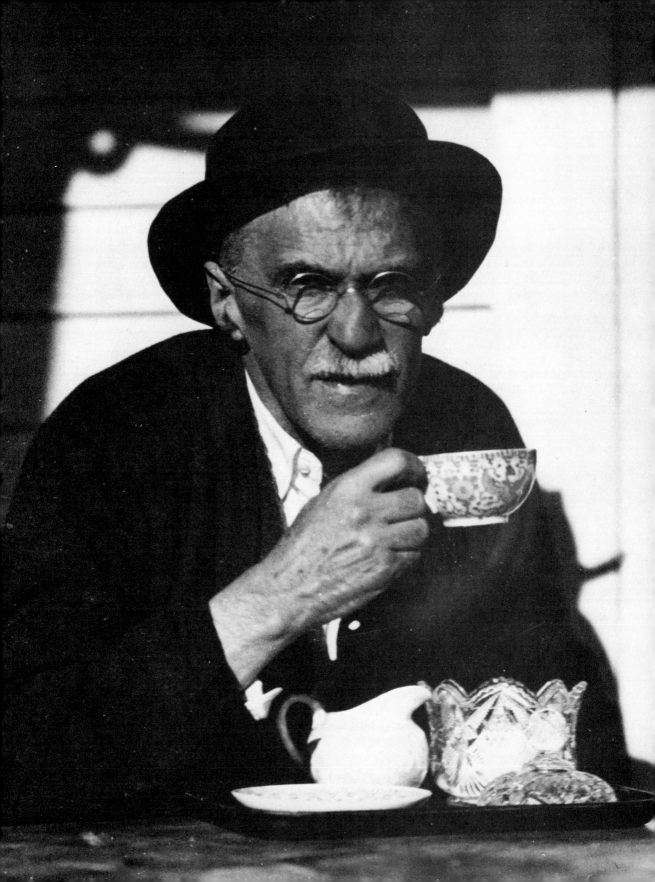

**Georgia to Maude and Frederick Mortimer Clapp, Abiquiu, N.M., June 9, 1945**

> It is San Antonio day—The Spanish people do not work and say it always rains. There has been no rain since I came out but today a little came—enough to wet the sage and moisten the top of the dry soil—and make the world smell very fresh and fine—I drove up the canyon four or five miles when the sun was low and I wish I could send you a mariposa lily— and the smell of the damp sage—the odd dark and bright look that comes over my world in the low light after a little rain—it is still as can be . . . every little dry plant and cedar bush so still—it makes the birds seem very noisy. . . .

On May 15, 1946, before Georgia left for her summer months in New Mexico, the Museum of Modern Art opened its exhibition of her paintings, which was to continue for three months, through August 25. This was the first time in its seventeen-year history that a "one man exhibition" of the work of a woman artist had been held at the Museum. Here were early and late O'Keeffe canvases, selected and superbly hung by James Johnson Sweeney.

The fifty-seven oil paintings, charcoal drawings and a single watercolor occupied four great galleries. On the evening of the gala opening, the attendance was so large that one could only see the pictures by returning another day.

For Georgia, the day of the opening was a difficult one, as it was the first time in the twenty-two years of her annual exhibits that her pictures were to be shown in New York City under auspices other than those of Stieglitz.

Two weeks before, knowing how great Stieglitz's emotion would be, she had telephoned to me asking if she could count on my husband and myself dining with them at their apartment on the night of the opening. "He will be miserable that evening, and it will help to have you," she said. Of course, we agreed to go. Two days before the opening, she telephoned again, saying: "It seems the trustees are expecting me to have dinner with them before the opening." I assured her that we would be with Stieglitz, and she said she would ask John Marin to be there too.

That evening, Marin, my husband and I dined solemnly with Stieglitz at their apartment on East Fifty-fourth Street. There was something about

success and acclaim that always depressed him. Had we been able to tell him in advance how splendid her pictures would look or how laudatory the reviews would be, it would have made no difference. All of this he knew.

After dinner, the three of us left Stieglitz, who no longer went out at night, and on this fine spring evening walked the short distance to the museum. As we neared it, we were astonished by the long line of private cars, and upon entering, by the number assembled.

It was like the opening night of grand opera with the patrons of arts, the socially prominent and the critics in attendance. Upstairs in the large gallery, we found those of the public who had already arrived, the museum officials and Georgia. This was one of the few times that she had made herself attend an opening of one of her own exhibitions and it seemed that all eyes that evening were on the artist herself—a distinct personality. Straight, slim, handsome in her simplicity, the only person not in evening dress, she was moving quietly among the guests. She wore a black silk, which she has often duplicated but rarely changed in style. Her bearing, her naturalness, her assurance, her wide grayish eyes, dark hair drawn tightly back in a knot at the nape of her neck, her sensitive strong hands, revealed an unusual woman.

The most discerning words about this retrospective exhibit were written by Stieglitz to James Johnson Sweeney. The letter was never mailed to Sweeney because of Stieglitz's death, but at a later date it was sent him by Georgia with a note saying she knew Stieglitz would want her to send it.

**Stieglitz to James Sweeney, July 3, 1946**

> I have had you so much on my mind. Every thanks for the magnificent job you have done in presenting O'Keeffe at the Museum. As I told you I feel as if you had taken two eyes and the two charcoals—those earliest O'Keeffes—and built up something akin to a bachfuge. Something as solid as that, as perfect. . . . I say once more it is a glorious exposition. In a sense a miracle in a time like this when that good-enoughism has become a more and more prominent factor. Personally I am glad to live to see this day. . . .

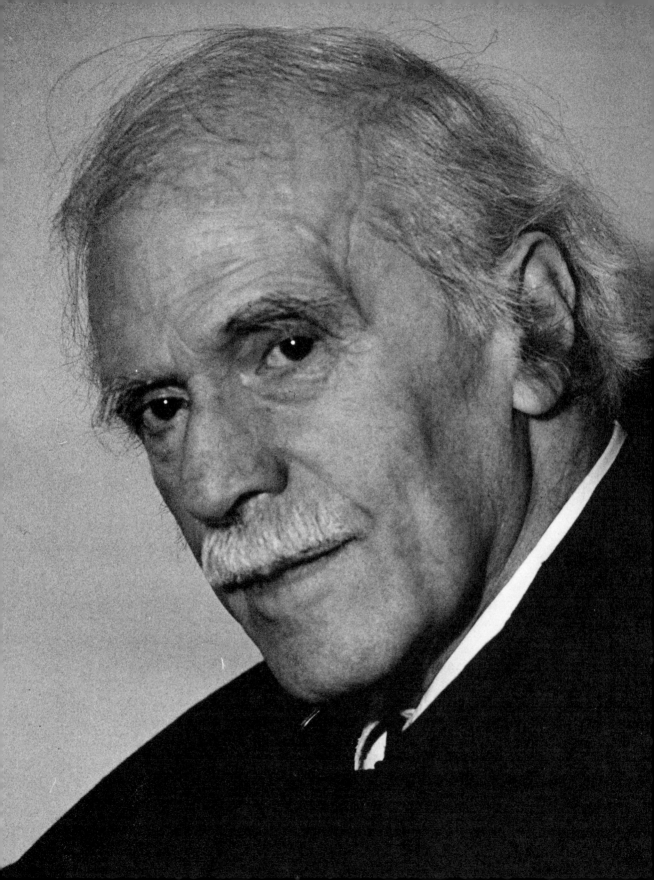

# STIEGLITZ'S PASSING: 1946

*F*OR some time, Stieglitz had suffered from heart disease. But in New York he continued daily to go from the apartment on Fifty-fourth Street to An American Place, around the corner on Madison Avenue. There he would see those who came in to visit and to look at the pictures he so much believed in.

He could no longer expend his efforts of previous days nor undertake new activity. But the same devotion to integrity was there and, at times, the same caustic challenge. For some time, he had been told not to photograph, as waiting for a leaf of one of his beloved Lake George poplars to fall, or whatever the mood he wanted to catch, had become too exacting for him. It was his habit to wait endlessly for the right moment.

In 1946 he stayed in the New York apartment longer than usual. Members of the Stieglitz family had left for Lake George where he expected to join them. Georgia left for New Mexico on June 5.

For over twenty-five years, Georgia and Stieglitz, when away from each other, had written almost daily. In summer, while she was still with him in New York, he would start to write her before she left for Abiquiu—letters timed for her arrival there.

Stieglitz to Georgia, New York City, June 3, 1946

> And this to be mailed to Abiquiu!! Number 1 of 1946. . . . I greet you on your coming once more to your own country. I

A LATE PORTRAIT OF STIEGLITZ BY HIS
NIECE, GEORGIA ENGELHARD

hope it will be very good to you. You have earned that. A
kiss. I'm with you wherever you are. And you ever with me I
know. Goodnight. Goodnight. . . . Thanks for all the thought
and trouble.

**Stieglitz to Georgia, New York City, June 4, 1946**

Incredible Georgia—and how beautiful your pictures are at
the Modern [Museum of Modern Art, New York]—I'm glad. I'm
glad we were there this morning. All of it like the pictures
themselves—Oh Georgia—we are a team—yes a team. Can't
believe that you are to leave and that you are reading this in
your country.

**Stieglitz to Georgia, New York City, June 5, 1946**

It is very hard for me to realize that within a few hours you
will have left. . . . But there is no choice. You need what
"Your Place" will give you. Yes you need that sorely. And I'll
be with you, Cape and all. And you'll be with me here and at
59 [East Fifty-fourth Street]. . . . goodnight with much love.

**Stieglitz to Georgia, New York City, June 6, 1946**

Found your letters and notes gradually. Ever surprised. And
ever delighted. Ever so you.

**Georgia to Stieglitz, Abiquiu, N.M., early July 1946**

When I have a pleasant time[,] . . . I always wish you were
here too. You would like it. So you go to the Lake in a week
from today.

He wrote to her July 7 that he had had another of the heart attacks at
An American Place, but was all right and there was nothing to worry
about.

Stieglitz to Georgia, New York City, July 8, 1946

> Nearly all right. Nothing for you to worry about. Lucky that I
> had decided not to go to the Lake today.

Then came another letter, his handwriting still strong and black.

Stieglitz to Georgia. New York City, July 9, 1946

> I am sitting in your room. At your desk. . . . . Your letter one
> of 3 letters. Read it first. As I always read your letters first.
> Kiss—another kiss. Tomorrow I'll go to the Place for a while.

That day he fell.

Those letters had not reached her when the boy from the country store in Espanola, delivering the wire to Georgia that told the news of Stieglitz's last illness, met her on the highway, as she was driving to town. He handed her the telegram, and she continued straight on to the airport without going back to the ranch. She did not realize until she reached New York that she had left New Mexico in her work shoes and her red cotton dress that she had been wearing outdoors that morning.

Stieglitz had the heart attack when one of his friends had come to call for him to go to An American Place. The maid was also there. He was rushed to the hospital and was still alive when Georgia reached New York. Maybe he knew her.

The services were attended by the family and many of his close friends. Those assembled stood silently in the presence of the unadorned black cloth-covered coffin that somehow seemed related to the first black-cloth-covered camera that had engaged Stieglitz's attention in the early days of photography more than sixty years before.

There were no words spoken, no music, no flowers. Just before we saw the last of the coffin, when the silence seemed to overflow with meaning, in came Edward Steichen, bearing a branch of green pine that he placed on the black box. It was from a tree that Steichen had planted on his property years before, and had always called "Alfred's tree." How Stieglitz had always loved the sincere and the unexpected.

In this gathering, there seemed to be a oneness of feeling—something Stieglitz had so greatly prized. For along with his idea of the importance of the individual went the idea of the group sustaining the individual. To the young poet, Hart Crane, he had once written: "We are all after Light. So let us seek it together in an unsentimental spirit."

A few days after the services, Georgia left for New Mexico to close her ranch in order that she might return to New York and commence the large task which lay ahead of her as executrix of Stieglitz's estate.

In New York, for three years after Stieglitz's death, Georgia undertook the colossal task of sorting and arranging Stieglitz's photographs and collection. She could do for him now what he would never do in his lifetime— put his monumental contribution to photography and the world in order. Her work involved the division of his photographs and the paintings he had collected into representative groups, so that the interest of the institutions that were to receive the gifts, the public, the artists, as well as Stieglitz's own ideas, might best be served. To this task she brought her extraordinary mind and undivided devotion. Except for brief intervals in New Mexico, Georgia put aside her painting and stayed in New York. Every day, from early to late, she worked at this important task single-mindedly and meticulously, in a way that is hard to visualize. Doris Bry assisted her.

In distributing the pictures, she kept in mind Stieglitz's idea that if the artist is of interest, then his evolution—which she tried to preserve—is of interest. She also tried to distribute the collection to institutions in different parts of the country, so that his wish to have it belong to all people might best be achieved.

In her forthright way, she wrote in an article in the New York *Times*, December 11, 1949: "He didn't know what to do with the Collection. Wouldn't do what he could with it. So he left it for me to decide. . . . He would not mind my doing what it was impossible for him to do."

The Stieglitz Archives—letters, clippings, scrapbooks, material relating to his whole life in the field of photography and art, files of correspondence dating from 1881 to 1946—were presented by Georgia to the Yale University Library's Collection of American Literature. The collection constitutes one of the most important sources in existence for the study of the twentieth-century American cultural history.

After Stieglitz's passing, a tribute to him in the New York *Times* read:

> Late in the Eighteen Nineties and at the turn of the century,
> two new art forms were struggling for existence. Photography
> was still in its crude stages, and modern art was not to be
> mentioned in polite drawing rooms. The years that followed
> saw both develop into potent forces in American culture—and
> leading the way was Alfred Stieglitz.
>
> . . . The emergence of these art forms to their present plane
> was accomplished only after a long, uphill fight. Stieglitz, in
> the dual role of craftsman and prophet, helped win the fight
> with concrete proof that his ideas were right by taking pic-
> tures thought to be impossible and by affording a rising gen-
> eration of artists a place to show their work.

Spring 1947, Georgia worked closely with James Johnson Sweeney on
the large memorial exhibition of Stieglitz's photographs and a selection
of works from the Stieglitz collection of drawings, paintings and sculpture,
held at the Museum of Modern Art.

In 1949, there was a showing of the Stieglitz collection at the Art Institute
of Chicago, after which Georgia once again resumed her painting in New
Mexico, which now became her year-round home.

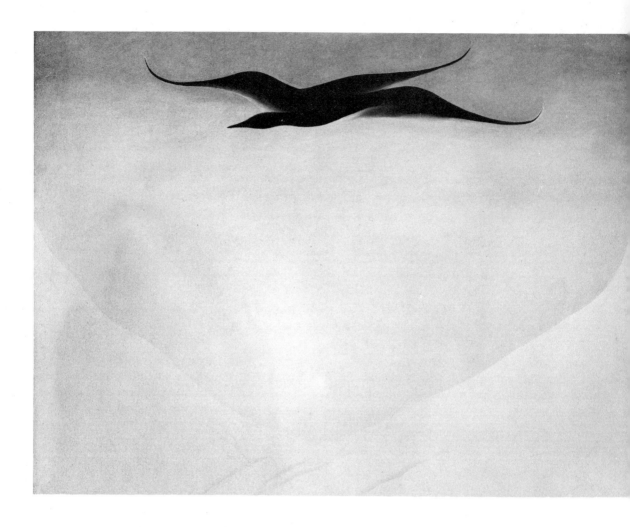

*BLACK BIRD WITH SNOW-COVERED RED*
*HILLS* (1946), OIL ON CANVAS, 36 X 48 IN.
PRIVATE COLLECTION

# TRAVELS: 1949–1962

WHEN, in 1949, Georgia was elected Member of the National Institute of Arts and Letters, her citation, read by its president, William Rose Benét, declared:

> Again the Institute is especially honored in electing to its ranks a distinguished woman, probably one of the most widely known painters in America. The impressive singularity of the works of Georgia O'Keeffe needs no additional encomium. At the recent New York World's Fair she was chosen one of the twelve outstanding women of the past fifty years. Her work may be seen in the Metropolitan, the Museum of Modern Art, the Whitney, the Phillips Memorial Gallery. . . .

I went with Georgia to the ceremonial at which we heard E. M. Forster's memorable address with its exultant:

> Art for Art's sake? I should think so, and more than ever at the present time. It is the one orderly product which our muddling race has produced. It is the cry of a thousand labyrinths, it is the lighthouse which cannot be hidden. . . .

From the fall of 1946, the rooms of An American Place were shared by Georgia and Marin. She continued sorting, assembling and bringing to

a close, in an orderly fashion, Stieglitz's lifework. Her work completed, the last exhibition to be held at An American Place was shown from October to November 1950, an exhibition of Georgia's work, painted since Stieglitz's death. After that the gallery was closed. There were several pictures of the cottonwood trees—*Bare Trees With Snow, Dark Trees With Trunks,* a large view of Brooklyn Bridge and her *Black Bird Over the Snow*—the bird winging straight ahead and alone over a huge expanse of whiteness; it has a tint of pink in the sky—a picture of great beauty, with poignant meaning.

**Georgia, alone for the first time in a presentation, wrote to William Howard Schubart from Abiquiu on October 26:**

> . . . I know I haven't done my show as anyone else would do it—but let me say to you—and believe me—it is alright—no matter what comes of it—I have no expectations so I can not be disappointed—I feel oddly secure in just letting it work for its self. If it doesn't make any headway—well—then it just doesn't—but I some way feel that it can get along alone. . . .

Having hung that last exhibition at An American Place, Georgia returned to her New Mexican home before the opening, leaving Doris Bry in charge during the exhibit. The moment the pictures were on the walls, Georgia's only desire had been to get back to the solace and peace which New Mexico brought to her.

It was a beautiful showing, of which Carlyle Burrows wrote in the New York *Herald Tribune,* October 22:

> Georgia O'Keeffe, who is no stranger to the abstract process, offers a group of recent paintings which testifies to a calm, philosophic acceptance of her convictions as a painter. Most apparent in these pictures is the sharpening of poetic perceptions to be seen in her concentration upon the themes of the desert. Her technique, always a matter of peculiar concern to the artist remains extremely fastidious. . . . While Miss O'Keeffe uses the abstract process in its simplest effect, it is her taste which is the final determinant of quality in the

PAINTINGS FROM LEFT TO RIGHT: *SPRING* (1948),
*IN THE PATIO I* (1946), *EARLY SPRING TREE* (1950),
*IN THE PATIO II* (1948), *POPPIES* (1950), AND *DARK
TREE TRUNK* (1946)

O'KEEFFE'S FINAL EXHIBIT AT AN
AMERICAN PLACE, 1950

painting. Her taste and her consummate clarity of form. . . .

With the closing of An American Place, Georgia chose the Downtown Gallery to represent her. With Edith G. Halpert as its director, the gallery had shown chiefly American art since its opening in 1927. From time to time, Stieglitz had sent pictures by certain of his American group there, and the Downtown Gallery represented the works of Marin, Dove, and Demuth. Outside New York, the Dallas Museum of Fine Arts exhibited her work in February 1953.

In Abiquiu, and its quietness, Georgia painted, enjoyed cultivating her garden and observing local life.

**Georgia to William Howard Schubart, Abiquiu, N.M., December 23, 1950**

> . . . I've been doing odd things—You know there are men and women out here who dance and sing to make the corn grow—to bless the home—to cure the sick—Indians of course—Ive gone to two all night dances—one in a village about 250 miles away—the Shallico—at Zuni—the blessing of the home—The other about the same distance, in another direction—up a very rough mountain road newly built—or cut for the occasion. . . . [S]ome 1200 people gathered out there in the night—built big fires—particularly a big central fire—surrounded by some 15 or more smaller fires within an enclosure of pine boughs—teams of 20 and 30 came in and danced and sang all night—they all bring food and eat around the fires— evening and morning—the singing and dancing amid the green—the smoke—the fires and the stars. . . .

Early in the spring of 1951, O'Keeffe went to Mexico, driving some 5,600 miles on the trip. While in Mexico, she flew to Yucatan and spent several weeks with Rose Covarrubias, the wife, Miguel Covarrubias. She saw the Rivera murals, the Orozcos and Yucatán—"with its old civilization that had gone before the Spaniards came"—which she called the best thing she had seen on her travels—and Old Mexico.

In spring 1952, while visiting California, she was made Doctor of Letters by Mills College, Oakland, for which her citation reads: "[a] painter who opens to use the beauty both of flower and of skull, matriarch of American Art."

Georgia took her first trip to Europe in 1953. She was met by her friend Mary Gallery, a sculptor. When they arrived in France, they drove from the boat through Brittany, then up through Chartres to Paris and later through Vézelay and Autun to Spain.

Of Chartres Cathedral, she said to me, "It seemed about as beautiful as anything made by the hand of man could be. It was like being under great trees." She arrived there on a gray day, so cold that after seeing the cathedral, they thought of going on, but Georgia went back to the hotel, put on her woolens and said she wanted to stay overnight, so as to see the cathedral and its windows again in the early morning light. The following day was gloriously sunny and she kept returning at different hours to see the light through the great windows.

Vézelay, the twelfth-century church where Saint Bernard preached the Second Crusade, on the site of an abbey founded in 864, meant a great deal to her. She described its great simplicity to me and the beauty of the sculptured panels as though she were recreating the designs in her mind.

Then she went with William Einstein, a painter living in Aix-en-Provence and a relative of Stieglitz, to see some of the country near Aix. He drove her to Paris by way of le Puy, so that she could see the Massif Central— the great mountainous plateau of central France—the kind of nature she loved best. Then to Paris, through the back roads so that she could see more of the French countryside and its planting; on to Beauvais with its spire; to Amiens where, even more than the church, she loved the countryside of Picardy with its neatly arranged fields and its trees; to Laon; then to Rouen, where the cathedral because of the war damage was still closed but the fruit trees and the pruning interested her greatly.

She thought it certainly apparent that the men who then did the planting of the carefully arranged French farms were descended from the careful artists of the Middle Ages who had made the great cathedrals and their glass windows.

In Paris it was Sainte-Chapelle and its exquisite glass, some of the Fra Angelicos and the sculpture in the Louvre and the spring green and flow-

ers in all the parks that moved her most.

Then they drove through the Basque Country to Spain, the land of her dreams, since her childhood reading of *The Alhambra*. On the way, they visited the prehistoric caves in the Dordogne—Lascaux with its amazing wall paintings, some of which go back 30,000 years, the earliest known traces of man's self-expression in the form of art.

They stopped in Altamira in Northern Spain. Then came visits to Madrid, Toledo, Cordova, Seville, Granada, Malaga, Barcelona. Every day that she was in Madrid, she visited the Prado, with its Goyas, Grecos and Velasquezes—it moved her as no other museum ever has.

Although she had never seen Europe until this 1953 trip, by the spring of 1954, she returned to Spain as there were paintings in the Prado she felt she had to see again. Again she chose the same Spanish cities with their great galleries, and had the same pleasure and identification with the country. Interesting as she found feast week, with her usual devotion to nature, she wrote: "Others can have the festivals, I will take the olive trees."

In the spring of 1956, for three-and-a-half months, she fulfilled a lifelong dream of going to Peru, taking with her a young, Spanish-speaking New Mexican, Betty Pilkington.

From New Mexico they flew to Lima, and then began a drive of a thousand miles along the coast from Trujillo to Camina, stopping at the towns with ruins and museums to see the stonework, textiles and pottery. They traveled on narrow roads, with scarcely a foot of earth to spare, across bridges without side railings, not wide enough for one car to pass another, and where the outcome often seemed as uncertain as with the bridge of San Luis Rey.

The coast was real desert, which O'Keeffe so loved: on one side the ocean, and on the other, rising abruptly, bare mountains, which the inhabitants call "foothills." They spent five or six weeks in the high country of the Andes, usually between 11,000 and 12,500 feet above sea level, and up to 16,500 feet. In order to see the great Inca stone work, which she described as "powerful in feeling, exact in execution," they took perilous roads, and stayed in towns that had been almost swept away a few years before by rushing waters from the lakes above.

She was interested in everything—the high stepping horses raised for

riding in the cane fields; the five hundred different kinds of potatoes grown by a man they met; a hacienda that employed three thousand people, and whose pens housed six thousand pigs; the Indians in the town, clothed in fine, handmade material; and people so oblivious to strangers "that they don't even ignore them."

**Georgia to Anita, after her visit to Peru, New Mexico, 1956**

> There is something dreamlike about it—the days were so wonderful—it was so beautiful one was often left speechless and by night one thought maybe it wasn't real—maybe it was a dream. . . . everything in Peru in some way seems to be a peak, the desert is more desert—the mountains are more high . . . and up there in the heights, there was the most beautiful colored earth I have seen. We had a very fine time even if it was hard—and it was very beautiful and often very funny. Of course one doesn't have to go to the places I went to but why go to Peru at all if you don't do the good things?

This was more than a comment on her visit to the Peruvian country. It is a graphic picture of Georgia herself: her passion for "the good things" even when hard, for "the mountain heights"; her clear way of seeing, her independence. Each time she reached home, she thought she would stay, but she is always interested in what lies on the other side of the hill.

When, in October 1958, the Metropolitan Museum of Art held its exhibition "Fourteen American Masters, Paintings from Colonial Times to Today," Georgia was included as one of the fourteen masters, with a whole room devoted to her canvases. Their tribute concluded with:

> . . . There is no doubt that the purity of her style has had considerable influence on applied design and even on the architecture of our day. Georgia O'Keeffe has been said to be our greatest living woman painter.

Certain American paintings and sculpture by representative artists from 1918 to the present were to be chosen by a committee of leaders in the

arts for exhibiting at the United States National Exposition in Moscow in the summer of 1959. Georgia sent *Ram's Head, White Hollyhock and Little Hills*—so full of the feeling of our Western country.

To spend weeks in Japan and in India in January 1959 she flew around the world by way of San Francisco, returning to New York late May. The masterpieces of Asian and Oriental art are particularly dear to her. She feels a closeness to their dignity and perfection of workmanship. And in those months, with a group able to stand the rigors of the trip, she went by air to Tokyo, Kyoto, visiting nearby shrines and temples, to Hong Kong, Saigon, Singapore, Calcutta, Darjeeling, with sunrise over Kanchenjunga, Bombay, New Delhi, Kashmir, with a week on a houseboat and the view of the high Himalayas—"one of the most beautiful places in the world, I am sure," she wrote me. Then to Teheran, Baghdad, Beirut, Baalbek, Damascus, Jerusalem, Cairo, Luxor, Thebes and Rome. She saw ruins and art treasures, and enjoyed the climbs to great heights.

In 1960, again by air, she went to the Far East, Australia and the South Pacific. Fascinated by the patterns of rivers, their colors, lights and shade, as seen on her trips by air, by the summer of 1961, she decided to take the rugged trip on a rubber raft down the Colorado River with a small group. The fact that it was considered dangerous was no deterrent. This venture took about a week and she described it afterward as one of the great events in her life. But traveling with a group, she had not been able to stop to watch the swirling currents or study the beauty of light and colors as long as she wished. So, soon after returning, she made this Colorado River trip again with the boatman and a photographer who had been on the first trip and who also wanted to stop where the view from the banks seemed most wonderful. Out of this trip came some wonderful water paintings—that seemed like blue-green abstract paintings.

In 1962 she took a six-week air trip to Greece, Egypt and the Middle East. With time there was no slackening of her intellectual curiosity, her love of adventure—or her eagerness to see the fine in art and nature. But, back from each world site, she reached her New Mexico home and the ranch with joy—and with a keen readiness to paint.

# THE PAINTING IS THE PERSON

N touch with the bigness of the elements, Georgia O'Keeffe has kept as great a simplification in her painting as in her life. "It interests me," she will say, as she climbs a slope to pick up a shiny pebble or takes a circuitous path to see how a certain white flower that has come up through hard ground is getting along. Whether she paints a white pelvis bone against the cerulean blue or the seeing infinity of space or the petals of a flower, she conveys the spirit of each.

She lives in New Mexico because the sky, the sunsets, mountains and wide spaces mean most to her. "My world," she calls this country. D. H. Lawrence, who lived and wrote in the great Southwest, not far from where Georgia made her home, expressed in these lines, the feeling that is in much of the artist's life and work:

> Be alone, and feel the trees silently growing.
> Be alone, and see the moonlight, white and busy and silent.
> Be quite alone, and feel the living cosmos softly rocking . . .

To Georgia, nothing is inanimate. The blanched bones she finds in the desert live for her in all their whiteness as she paints them. They take on a white spirit quality of something that cannot die. These are not surrealist bones, any more than Dürer's skeleton that rode with the knight or Ryder's figure of Death on the Racetrack, or their accompanying landscapes, are surrealist. They are testaments of life in her desert country.

And just as we are considering the idea or the symbol of the more abstract paintings, we reflect on one of O'Keeffe's barns, so structurally real that it looks as if it could house the hay and all the gathered grain. Of these, Georgia says quite simply, "That's the way they are."

Dr. Edwin Colbert, then curator and chairman of the Department of Vertebrate Paleontology of the American Museum of Natural History, a foremost authority on bones and their structure, headed the expedition in the Ghost Ranch country of New Mexico that discovered the remains of the "Small Dinosaur," the ancestral dinosaur of all others. He knew Georgia, and her country. He said to me that even an artist with special geologic training rarely has an eye accurate enough to catch the forms, colors and textures of rocks and bones with the certainty that Georgia does, and in addition, he pointed out, there is her ability to present the spirit underlying the whole. On the wall of his office at the Natural History, Dr. Colbert has a framed copy of O'Keeffe's painting, *Cow's Skull, Red, White and Blue*, beside photographs of actual bones.

A horticulturalist, to whom I once showed photographs of certain of her early imaginative flower compositions, thought they were photographs of actual flowers. It is because her works range from the real to the subjective that the art of Georgia O'Keeffe defies classification.

Her work grows out of her life and the direction that her life has taken. We cannot place her in any one school although her painting has influenced many in its time. No one in our day had painted large canvases of "big flowers" or parts of flowers for their own sake until she did, although she was highly pleased when she found that the Chinese had done so hundreds of years before her.

She is certainly a modern in her disregard of rules but in using the word modern, we should remember William Blake's fine line: "Genius is Always Above the Age."

Space is important in her canvases as it is important in her life, space that establishes a relationship between the forms and accentuates the experience she wishes to stress. She sees beyond exterior boundaries and physical shapes. There is often the suggestion of something beyond the seen—of space that is ours to create with. What she conveys is the result of unusual comprehension and unusual technique in which nothing seems lost.

Georgia, in her life and her painting, seems at one with lasting values. Hers is a deeply reverential attitude toward the nonmaterial side of life. It is as though she had taken to heart permanently from her mother's reading aloud of the Bible: "Look to the earth and it shall teach thee." At all periods of her life, the hours spent in contemplation and meditation have produced works of great integrity.

Her own point of view seems akin to the old Chinese who in their paintings accentuated the greatness of mountains and the insignificance of men. Her life seems motivated by the same feeling that caused the Indian mother to take her babe-in-arms to the woods and say to him: "Listen."

Realistic as certain pictures seem, there is always more than the representative in her paintings. Before her work was seen in exhibitions, she had liberated herself from the limitations of representation and her work had taken on another dimension.

In an illuminating answer to his own question, "What is the object of art?" Henri Bergson in 1900 gave this answer in *Le Rire*, sixteen years before O'Keeffe's painting with its double strength of the real and the imaginative was seen:

> . . . [Art] has no other object than to brush aside . . . the conventional and socially accepted generalities, in short everything that veils reality from us, in order to bring us face to face with reality itself. . . . So that we might say, without in any way playing upon the meaning of the words, that realism is in the work when idealism is in the soul, and that it is only through idealism that we resume contact with reality.

I feel that Bergson's statement perfectly evaluates the strength we feel in O'Keeffe's work.

The image is clear in her mind before she begins to paint. The idea of the painting comes quickly but then follows a long period of preparation. She usually makes a small line composition in pencil which structures the form the painting is to have—at times, maybe several versions of the composition. She plans the scheme of colors on the palette before touching the canvas. If several pictures are painted on the same theme, in the last one painted, more is suggested, less is stated. Of symbolism in her work,

Lewis Mumford wrote: "Georgia O'Keeffe has carried the symbol both close to actuality and close to pure abstraction." Georgia painted abstractions when they would best convey what she wished to present, and they are not of any one period of her life but parallel her entire work. Her first drawings that Stieglitz saw were abstract lines and forms. Alfred H. Barr, Jr., director of collections of the Museum of Modern Art, wrote:

> Georgia O'Keeffe has produced few abstract paintings, but
> they are among the most memorable in American Art. Even
> in her paintings of objects—barns, mountains, trees, lakes,
> enormous flowers, clam shells, or white desert bones that fill
> the whole sky—she has the gift of isolating and intensifying
> the things seen, or destroying its scale until it loses its identity
> in an ambiguous but always precise beauty.

I have heard the Corn Paintings, in deep living greens, called abstract patterns: yet Georgia has so minutely observed the growing corn that, in the paintings, she has considered the dewdrop which runs down the vein of the leaf into the center of the cornstalk to water it each morning.

Stieglitz's repeated statement was that O'Keeffe's paintings "could only have come from a woman and from America." In her pictures there is always a complete abandon to the beauty of the moment. In her own words she has felt close to "the wonderful part of America that city people, who talk of an American art, forget."

Dr. F.S.C. Northrop, professor of philosophy at Yale, in his book, *The Meeting of East and West*, cites the appearance of O'Keeffe's work as illustrative of "the spirit of a free and adventurous United States turning its attention from the culture of the past to that of its future." In the development of his theme of the different ideological assumptions of the East and the West and the essential connection of art with this world problem and its solution, he considered O'Keeffe's work an important bridge. In his words:

> A new aesthetic approach to the nature of things different
> from that of the European West is possible. . . . [S]uch a form

of art has arisen in the United States—a form indigenously
American yet portraying something of universal validity. It ap-
pears in the painting of Georgia O'Keeffe.

He recalls her resolution to be herself, her resolution to see "something
coming out of her free and open America which had never quite been
shown before, yet, to use her own words 'so simple and so obvious that
it is right before one's very eyes.' "

Dr. Northrop's important conclusion is that "not until the French Impres-
sionists in the nineteenth century, and until Georgia O'Keeffe in this cen-
tury, did Western art have an aesthetic which conveyed the aesthetic
component in the nature of things for its own sake." Of O'Keeffe's work,
this philosopher declares: "One has also the demonstration that this im-
mediately apprehended portion of reality bereft of the references beyond
itself which habit and thought add . . . is superbly beautiful and spiritually
sustaining."

In striking contrast to the many moderns whose work reflects the tension
and conflict of the age, Georgia's paintings express a cosmic order and
unity, inspired by that aspect of the world which is not man-made.

The great art of all time has been individual in its expression. It has
been born through the desire and need of the artist to express that which
has special meaning for him, the object of his devotion. It is this which
dictates his subject matter and style.

Henry Thoreau in his journal, May 6, 1854, expressed a great truth in
this way: "All that a man has to say or do that can possibly concern man-
kind is in some shape or other to tell the story of his love . . . and if he is
fortunate . . . he will be forever in love."

Georgia O'Keeffe to an exceeding degree has been "forever in love"
with the varied rhythms of the universe and she has told the story of her
love vibrantly in paintings, personal in style and universal in spirit.
Through a half century of great change around us, they have remained
a constant factor in America's culture, and have enlarged the horizons
of art.

THE ABIQUIU HOUSE

# ABIQUIU: AT HOME WITH GEORGIA: 1951

*D*URING the summer of 1951, my husband and I visited Georgia at "the Abiquiu House" as she calls it, to distinguish it from her nearby ranch. Abiquiu, at an altitude of 6,000 feet, overlooks the valley and the highway, and remains strikingly apart from progress or communication. At night, in the distance, the occasional, glimmering lights of slowly moving cars may be seen on the lower level of the road.

This sleepy little old-world town, which few had ever heard of until it became the subject of many of Georgia's paintings, is her home for the greater part of each year. In Abiquiu, nothing interrupts her life but what she invites. For its unusual beauty, she has exchanged the ease and adulation that could be hers in metropolitan centers.

One of our first mornings there, at about 4:30, we heard a peremptory knock on our door, and Georgia, who had come swiftly across the yard in her kimono and sandals, called out to us, "Come quickly. You mustn't miss the dawn. It will never be just like this again."

We rushed out through the garden gate to her strip of land in front of the house, which with a precipitous drop of about a hundred feet, overlooks the sweep of fertile valley below, made green by the Chama River. The sky was a flaming orange and cerise, with black and silver streaks. Straight ahead was the large purple mountain, the Serro Negro, and to the right the Abiquiu mesa, both a part of the long flat volcanic structure through which the Chama River flows into the Rio Grande on its way from Colorado down to the Gulf of Mexico. When we arrived on the embank-

ment, Georgia was already there with Chino, her big black standard poodle, cropped so closely that he looked like any other powerful dog, and with Yellow, her cat. Looking up at the sky, she said proudly, "Isn't it worth coming to New Mexico to see this?" It was the first of the many mornings we got up to see the dawn, which was always unforgettable.

Georgia is completely at home in this community, so different, of course, from anything she knew in the East or the South. The inhabitants take it for granted that she should live alone and work at her paintings or whatever she chooses. Women do much of the work in this place of Indo-Spanish traditions. Fine work is respected. Every adobe wall, on the inside and outside of their houses, has been finished by the palm of a woman's hand. Georgia often stops and admires such work.

Except for the nights when there is a dance, most of the village is quiet from early evening and dark at night. Georgia sits out in the early evening on the embankment in front of her house or, on a moonlight night, starts out in the car to see the mountains that she loves.

The big Abiquiu house was rebuilt and restored with the assistance of Maria Chabot while Georgia was in New York classifying the Stieglitz collection. When she wishes, she has the help of women of the region for housework and cooking. With them, and with the men who work for her out-of-doors, there is a good understanding. Independent and interested in the outdoors and her freedom to paint, although an "outsider" Georgia belongs. She likes it there because "the world is big and wide and wonderful even if the life is hard." One night during our visit, just before my husband and I went to our room, she reminded us in the most matter-of-fact manner to look under the bed to be sure that a rattler had not settled down for the night.

In the town of Abiquiu, where Indians and Spaniards have left the impress of their civilization, we saw the two centers where people gather—the long, low church with its pink walls on which hang huge crosses reminiscent of the region's feeling and history, and the cantina where the people dance and are riotously gay, especially on a Saint's Day and Saturday nights.

Though greatly modified by law, there are still remnants here of the stern rituals of the Penitents Sect. The singing and processions at Easter continue. Georgia, with her awareness of sounds and colors, and her

VIEW OF THE PEDERNAL FROM
O'KEEFFE'S FRONT YARD, ABIQUIU—
THE SUBJECT OF MANY OF HER PAINTINGS

interest in the spirit of the people, was fascinated.

Georgia to William Howard Schubart, Abiquiu, N.M., April 6, 1950

> . . . I have never experienced anything like this week—the
> church overpowers the little group of houses—and there is so
> much praying—so much parading—with sad doleful sing-
> ing—tunes that seem to come from a long long old experi-
> ence—every day feels like Sunday—I've just been up on the
> roof listening—The old fellows who were important handed
> down the word that they should sing so that the hills would
> ring back the song to them—the songs are short and get their
> strength from being repeated again and again as the proces-
> sion comes down from the hills and goes to the church—then
> after a time leaves the church and goes back up the hills—It
> is oddly moving with the faintest touch of green just coming—
> and the long dark mesa back of it all—
> Sad—a remnant of an old faith—

The Abiquiu house is spacious. Georgia wakes early and, those morn-
ings that she is not out in the garden, she looks out from her bed upon a
wide panorama of sunrise and mountains. The two very large windows
meeting at right angles make the small bedroom appear to be made almost
entirely of glass.

Her very large studio, about sixty feet in length, adjoins her bedroom.
In it she has put an unusually fine sixteen-foot single-pane window that
flanked by two smaller windows, gives a stupendous view of the fertile
valley below. For hot weather, there are willow branches jutting out over
the doorways as in native houses, to keep the room cool. Some of the
ceilings are of trunks of young aspen that grows at high altitudes in the
mountains, and some are the house's original beams. Her large neat desk
is of smooth light wood and there is a reason for each carefully sorted
pile of papers held in place with a small rock. On a table nearby, which
she can wheel around, is whatever she is working on, and on another a
few inches away, is a large glass palette, always very clean, with little
piles of color and brushes of all sizes and shapes. There are usually no
pictures on the walls, except those in progress, no ornaments, but on the

wide window ledge are bright bird feathers, bits of bark, rocks and leaves that she has picked up on her walks or that her friends send her from time to time for their color and texture. For these she has a child's feeling. She has always loved such things, as other women love jewelry. Through the years, I remember Georgia wearing only one piece of jewelry, a handsome O. K. initial pin made for her by Alexander Calder.

When the summer heat comes, before Georgia goes out to the ranch she moves into a small sunless room with one small window facing on the patio. This is the patio of many of her later paintings, for its great contrasts of sun and shadow interest her.

She has made the large parlor of the original house into a spacious storeroom for pictures. This is not a room that others may enter.

There are rooms for guests with white adobe walls, maximum comfort and a complete absence of nonessentials. It is hard to believe there could be such rooms in a town so untouched by modern living.

The large sitting room of about sixty by thirty feet with light adobe walls has extraordinary beauty. Art is not only something done in this house, it seems to be everywhere, for taste and love of simplicity are evident throughout. Ceiling-high bookshelves are filled with books that Georgia has had through the years as well as new favorites—fine illustrated books on Chinese art, stars and plants. There are very comfortable couches and chairs for the many hours in the evening when she and guests enjoy Casals playing Bach or Monteverdi or hear Beethoven, Schubert and certain chamber music on her high fidelity phonograph.

There is electricity. This means that in the midst of desert country, she has lights, refrigeration and a deep freeze. When the electricity goes off in the town at intervals, the adobe rooms are lighted by long white taper candles and with the adobe walls and bare tables, one seems to be back in the Spain of the Middle Ages.

They were beginning to break ground for telephone service to Abiquiu when we were there and blasts rang out from the dynamite drilling for the telephone poles being lowered into the rocky ground. A few people would gather round to see the first inroads that man was making here against the mountains. But Georgia, in order to telephone, still had to ride to a portable house twenty-five miles down the road to wait her turn with the people of the region. Often at this little road station, she places calls

for those who do not know how to use the telephone by themselves—the sheep man, calling for aid, worried about his sheep in the mountains in the coming storm, an Indian woman trying to rent a truck to take her pottery to town and not knowing how to say it.

Georgia's living style is austere. She was as precise about meals as if she were still being called to the large family table of her childhood on the farm. Breakfast is at seven, lunch at twelve and the last real meal of the day is at four-thirty, so as to have the evening drives through the wonderful countryside.

In season, she spends hours in the garden each morning, beginning, as she does with all her work, before dawn. Planting her turnips, yellow squash, tall beans and weeding the garden, working the hard Abiquiu soil, with the fine compost pile of her own mixing, she is extremely happy.

Off the big white kitchen—with its handsome equipment—is a splendid little room where the thyme and marjoram and chili hang drying. It is so colorful. Away from the embankment, to the town side, is a lane of tall hollyhocks and white chrysanthemums. Although Georgia sews, cooks and enjoys her housekeeping, the garden, second only to painting, is her chief preoccupation. Her rose bed is a special joy.

**Georgia to Anita, Abiquiu, N.M., spring 1955**

> I have been working—or trying to work my garden into a kind of permanent shape—so that if I live for twenty-five years, it will be pleasant to walk about in . . . good things are some-times a long time growing—trees—and such things. At the moment, I have rose bushes so full of red and yellow roses that they look on fire—they are certainly astonishing—and iris—lavender and yellow—very handsome.

And again:

> The wind today has been terrible—the ground rises up in a kind of fury and the wind whips away with it like something in a mad rage. . . . I watched the shadow creep across the valley as the sun went down—The bare light rocks on the

dark Mountain are so sharply drawn in the last light as if the heart of the mountains [were] of whitish slabs of rock.

I was driving—had just gotten up on the desert above the Rio Grande valley—and there stretched out across the road was a snake about four feet long that was like brilliant transparent polished copper—It was like a streak of sunset sky across the road—impossibly elegant, like things out of the Arabian Nights—or other Far Eastern stories—then it was startling to see how fast its brilliant length moved off into our everyday dry grass and dust. It was a very fine sight. . . .

And this in early spring:

Tonight I am driving up on the mountain. I'll sleep up there by a very lively stream—under just ordinary big pine and spruce trees—in the morning drive on to a friend's house for breakfast and to see the peonies blooming . . . in an area where there are pine trees. But I will come back to my dry world and like it.

Some think Georgia aloof and hard as far as people are concerned. "Meeting new people and hearing a lot of talk takes too much out of me and I can't do my work," she says. But when a need arises that must be met, she will often throw herself into its solution generously and the warmth and emotions are there, in her life as in her paintings.

Georgia told how she had helped some of "the supposedly bad little boys" in the town to paint. She became particularly interested in one very poor youngster.

ABIQUIU

In a town with no clubs, library, no playground, where families live in the pueblo, often close together, in small houses, and where nature seems so much the controller of what people can do, one winter, she fixed up a room in the Abiquiu house with a work table and a radio for some of these growing boys. There, with her brushes and paint, they painted big letters on their basketball sweaters and often made the town signs. She often takes them in her car to ball games in neighboring towns. When I was visiting her, I would hear her call to one of them to come and get the orange juice she had prepared for him. "He is growing and needs it before he starts to weed," she would say.

One of the bigger boys, an adventurous seventeen-year-old with many problems, came for several Christmases to put candles the length of her adobe house and wall, along the embankment, and in full view from the main highway. She loved seeing the candles burn at night, their lights flickering in the clear air.

Later the boy, then in a nearby state, sent this letter to her as Christmas was approaching:

> Well Miss O'Keeffe this letter leaves me okay and I hope that when it reaches your lovely hand it will find you in good health which thats what I allways pray to God. Well I am still working. I am saving all the money I can. I now have $1.40 in the bank. I don't know if I will be able to save some more or not because I am going home for Xmas if God is with me. So I can light my candles, my invention in Abiquiu, remember? I was the first to do it in Abiquiu.

There are two flowers that grow in Georgia's Abiquiu garden. One of them, a fragile, extraordinary poppy—so sensitive that when you pick it, you make sure that nothing can mar it. The other, a thistle—a very handsome thistle—standing alone. You can't touch it, and you don't try. Georgia has the quality of both of these flowers. The thistle side, her independence and her standing alone, dating back to Sun Prairie, is what we usually see. But the other tender side is there too, and has been a part of important moments.

One day, while we were there, one of the little boys of the town came

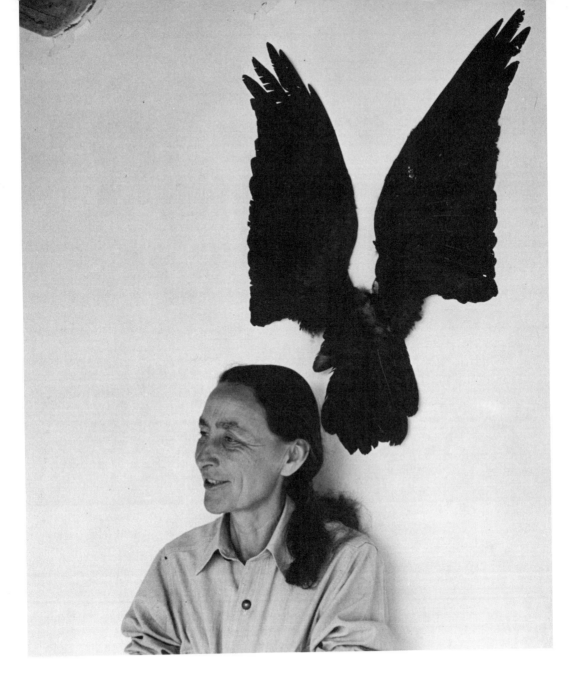

O'KEEFFE PHOTOGRAPHED IN FRONT
OF RAVEN'S WINGS AND TAIL

running through her lane of white chrysantheums, calling out: "Miss O -
kee - fee, the little girls are dancing," and Georgia, picking up a wide-
brimmed felt hat for each of us, led the way through the scorching noon
sun to the porch of the small convent across the road, where six little girls
were dancing Indian dances to the clapping of an old Abiquiu woman
who has brought the girls. The audience consisted of the sisters, ourselves,
and this old woman. "Why, they should be dancing to a drum!" Georgia
said indignantly and she told one of the children where a drum could be
found in the village. When it was brought, the dancing recommenced
with increased fervor and an appreciative nod to Georgia from the old
woman. Although one of two Anglos to settle in the village, Georgia seems
at such times to be closely identified with the people.

   Georgia invited me to go with her to a well-attended town meeting,
held in the general store, called to consider the water situation. The water
system was administered under a federal project. The president had re-
signed. Enforcing the rules interfered with his business. The argument
about who should be president went on and on in such lengthy, lively
fashion that they could not get to the voting. Finally Georgia stood and
said to Jo Ferand, one of Abiquiu's prominent citizens, who was secretary
and treasurer, "Jo, why do we need a president? You attend to everything
anyway." Jo looked surprised, closed his books remarking, "I guess we
don't," and the meeting was over.

   During our five-week visit, she drove us through the country to see the
little villages with their clusters of adobe houses and strings of scarlet chili
hanging outside the doors to dry; the beautifully proportioned Ranchos
de Taos, the famous adobe church, of which Georgia made paintings the
first summer she was in New Mexico; the great terraced Taos Pueblo in
front of the beautiful Taos Mountain, the San Ildefonso Pueblo and the
Jemez Mountains, with their spruce and aspen; Espanola, her nearest real
town; and again to the unforgettable Santo Domingo Corn Dance.

   Deeply religious, the Corn Dance is held annually at the pueblo of the
Santo Domingo Indians, thirty-one miles south of Santa Fe, one of the
oldest settlements along the Rio Grande. The moving ceremonial has been
handed down from generation to generation; it goes on all day. Men and
boys, bodies bare from the waist up, sometimes greased, with deerskin
loincloths and colorful headgear. The women and girls, in black tunics

with woven red sashes, the costumes bedecked with the fine handmade silver and turquoise necklaces for which the region is famous, were dancing in relays—on and on—repeating the same songs till the repetitions filled the air. In this dry and bare country, in the heat of the sun, they dance their prayer for rain, for crops, for the blessing of fertility, in a strange unceasing rhythm, to the chant of the chorus of old men, the best of drums and the rattle of gourds held by certain of the dancers. The men and boys wear moccasins, the women and girls dance barefoot on the scorching earth. We stood for hours, with other spectators, near the spot where the two alternating groups came, after their preparation in the kiva.

Georgia tries to see the Indian dances, even when they are held at a great distance; she drives to this Santo Domingo dance each year and stands apart and alone on the low roof of one of the pueblo houses, watching intently. When she is watching something outdoors, it is her habit to go quite away from others when she can, and to the highest level possible, so that nothing will distract her.

At the end of our five-week visit with her, when my husband Elie Edson and I rounded the curve of the highway, we looked back. For as long as we could see, there was Georgia, standing on the top of her adobe wall, silhouetted against the intense blue New Mexico sky, waving good-bye with a long, yellow silk scarf—and with a great rhythmic sweep.

**THE ABIQUIU ROAD**

# MY AUNT ANITA

## BY WILLIAM S. POLLITZER

Chapel Hill, North Carolina
December, 1987

"BILLY, Georgia O'Keeffe is in town. Do you want to have lunch with us?"

My Aunt Anita's voice conveyed her usual warmth and enthusiasm, combined with a tone of authority and a hint of impatience. Then in my late twenties, of course I was delighted to meet the world-famous artist. So, that day, Anita, O'Keeffe and I had lunch in a modest New York midtown restaurant.

O'Keeffe wore her usual black dress and seemed relatively stately and calm. My aunt was her usual bubbling self. And then the three of us discovered that we were low on cash and with laughter just barely raised enough to pay the bill. So impromptu, so informal and so unforgettable.

At that time, the early 1950s, I saw a lot of my Aunt Anita Pollitzer and her husband, Elie Edson. Their apartment lay just across Amsterdam Avenue from Columbia University, where I was a graduate student, combining physical anthropology and genetics.

But the bare numbers of their address, 419 West 115th Street, cannot convey the warmth and vitality of those rooms that were home to Anita and Elie and so often to me, too. For nearly every week I dined there on some delicious meal that my aunt had put together with art and skill, and often with haste, following some appointment. She was a superb cook, preparing a dish as she did everything else, more by feeling and instinct than by recipe and measure. She took a justified pride in her culinary talent and sometimes said without self-consciousness, "Isn't this the best thing you ever tasted?"

In my mind's eye, I can see the rooms of that apartment now, crammed with furniture, pictures, books and a hundred mementos of their long life together: the dining room, with the adjacent tiny crowded kitchen; the more spacious living room with piano, couches, chairs, desk, bookcases and paintings. Then there was the dark corridor so jammed with books and newspaper clippings that it was well nigh impassable. Running from the living room to the front door was another long, book-lined hallway. Although there were two bedrooms, one was largely filled from floor to ceiling with clothes and more books and newpapers.

But how can I convey the essence of Anita herself? I can see her now, small in stature, big in brains and spirit, a whirlwind of energy, brushing her dark hair away from her face. Sometimes hasty and domineering, yet always kind-hearted, Anita was easily moved by beauty everywhere, in a painting or in nature; and she was deeply touched by sadness or injustice in the lives of others. Somehow she was always a patrician and yet a democrat.

From the end of World War I Anita had been drawn to the movement for woman's suffrage. Still in her twenties, she had campaigned vigorously for the vote and was arrested on the steps of the Capitol in Washington, D.C. She joined the National Woman's Party under the leadership of that perseverent "little Quaker," Alice Paul.

Anita once told me of her experience of calling on Woodrow Wilson in the White House; her purse accidentally opened, spilling pennies on the floor. The President of the United States got down on his hands and knees and picked them up for her.

Anita's persuasive talk with legislator Harry Burn of Tennessee caused him to cast the deciding vote for suffrage that made that state the thirty-sixth one to ratify the Nineteenth Amendment, thus providing the three-fourths majority needed to make it part of the Constitution in 1920; and her dogged persistence is generally credited with putting the Equal Rights Amendment on the Senate calendar for the first time in 1938.

Dedication to equal rights for women led Anita to campaign in forty-three states, pointing out inequities in laws and economics. Among her many successes was securing the right of married women to work in government service. She served as national chairperson of the National Woman's Party from 1945 through 1949, and honorary chairperson in sub-

sequent years. She was inner-directed, never doubting her mission in life. As she put it simply of her campaign of equality for women, "I know I am right."

In her presence one felt exhilaration, the pulse beat of the adventure of life, and above all her love. It was as though a small child, open-eyed, uninhibited and filled with affection, had grown up in body and achieved brilliance in intellect, yet retaining those childlike qualities. But she could also be tough, stern and persistent when the occasion demanded it. And her career in the rough and tumble of politics often demanded it.

I remember best the 1950s in New York—the apartment, the activity, the stream of friends. It is one of those friends, Kay Boyle, who more than anyone kept alive the hope that Anita's manuscript and letters, documenting her early relationship to O'Keeffe, would be published.

It was with great enthusiasm that Anita had undertaken writing a book about O'Keeffe. After all, her friend had suggested it and encouraged her. Anita even made trips to O'Keeffe's childhood home in Wisconsin and interviewed many people, including O'Keeffe's sisters—Anita and Catherine—and Doris Bry. Over several years she labored to collect information, organize her material and find just the right words to express her feelings and ideas. She and Elie spent time with O'Keeffe in Abiquiu and later exchanged a number of letters as the book progressed. Often she read passages to me, asking my reaction.

ANITA POLLITZER WORKING ON *A WOMAN ON PAPER*, CIRCA 1952

When the final typescript was sent to O'Keeffe, she wrote back to complain. "You have romanticized me. I do not recognize myself. I cannot give permission for its publication."

Anita was heartbroken. She attempted to make changes based on O'-Keeffe's comments, but they were not sufficient for O'Keeffe, who objected to Anita's subjective, impressionistic style of recounting events. Anita seemed to lose something of her lust for life.

Then, in 1971, when Elie died, she said to me, "I didn't know it was possible to miss someone so much."

A devoted housekeeper continued to help Anita and gradually assumed the role of nursemaid. Her mighty spirit declined and she grew more feeble. She spoke less and less, and finally not at all. That once gifted mind grew silent. Her beloved nursemaid took her to her own home in Queens.

Anita died on July 3, 1975. She was buried beside Elie in a family plot in Chester, Pennsylvania.

Toward the end my family and I went to the old Manhattan apartment. We salvaged all we could of value—china, furniture and family heirlooms. We pored through piles of papers and books, and saved her letters and several copies of her precious manuscript.

Back in earlier days, Anita's sisters—my aunts Carrie and Mabel—would vacation in the cool Blue Ridge of North Carolina to escape the heat of Charleston. Our family sometimes drove up from Greenville, South Carolina, to visit them on weekends. On one occasion in the 1960s Anita and Elie joined us. While driving on one of those winding roads for a view of the majestic mountains, Aunt Mabel exclaimed, "This reminds me of a poem. 'God give me mountains to climb and the strength to climb them.' "

To that Anita replied, "Huh. I don't want God to give me mountains to climb. I want to find my own."

That is a fitting epitaph to a unique individual. She did indeed climb many mountains of her own choosing. With the publication of this book she has reached yet another plateau.

# SELECT BIOGRAPHICAL NOTES

SOME OF THE PERSONS WHO APPEAR IN
*A WOMAN ON PAPER*

Bold numerals at end of each entry indicate references in text.

**Adams, Ansel** (1901–1984), American photographer, noted especially for his photographs of Yosemite and other natural wonders of the American West. His portraits of O'Keeffe are noteworthy. **225**

**Anderson, Sherwood** (1876–1941), American author. Best known for *Winesburg, Ohio (1919)*, a novel consisting of short vignettes of small-town life. His realistic depiction of everyday life in the Middle West was considered revolutionary in its day. **177, 187–188**

**Anthony, Susan B.** (1820–1906), American social reformer and suffragist. She began as a temperance advocate and was an early supporter of black rights. She was a founder of the National Woman's Suffrage Association and is generally regarded as the leading feminist of her generation. Her life and work were important influences on Anita Pollitzer. **xiv**

**Barr, Alfred H., Jr.** (1902–1981), American art historian and curator. After 1929, he was associated with the Museum of Modern Art in New York, where he mounted hundreds of exhibitions. Generally regarded as one of the most influential persons in the field of modern art. **266**

**Bell, Clive** (1882–1964), English art critic. A leading member of the Bloomsbury Group, his writings on art greatly influenced the modernist movement. Among his works: *Art* (1914) and *Landmarks in Nineteenth-Century Painting* (1927). **151**

**Bellows, George** (1882–1925), American painter, lithographer, and illustrator. His work depicts ordinary subjects and street life. Taught at the Art Students League and the Art Institute of Chicago. One of the most influential painters of the 20th century. **38**

**Bement, Alon** (1875–1954), American art teacher, a disciple of the teaching philosophy of Arthur Wesley Dow. He taught O'Keeffe at the University of Virginia and urged her to study at Teachers College, Columbia University, where he was assistant professor. He later taught her there and is regarded as an important influence in her development as an artist. **2, 6, 24, 40, 102, 127–131, 157**

**Benét, William Rose** (1886–1950), American poet and editor, especially of *Century* magazine and the *Saturday Review of Literature*. **255**

**Bluemner, Oscar, Jr.** (1867–1938), American architect and experimental painter. Exhibited at both 291 and the Intimate Gallery. **37**

**Boyle, Kay** (b. 1903), American novelist and short story writer. Among her writings are

*Plagued by Nightingales* (1931), a novel, and *Nothing Ever Breaks Except the Heart* (1966), a collection of short stories. **116**

**Brigman, Anne** (1868–1950), American photographer. Self-taught, she became one of the earliest successful women photographers. She joined the Photo Secessionist group in 1906. She often used her sister, Elizabeth Nott, also a photographer, as subject. **164**

**Brancusi, Constantin** (1876–1957), Rumanian sculptor, worked mostly in France. His work introduced to America in *Camera Work.* **113**

**Braque, Georges** (1882–1963), French painter, exponent of Fauvism and an early experimenter in collage, his works first seen in America in *Camera Work.* **33, 43, 113**

**Bry, Doris** As Stieglitz's assistant at An American Place, she helped O'Keeffe catalog Stieglitz's archives after his death. The two women became close and after 1963 she acted as O'-Keeffe's agent. The relationship deteriorated in the 1970s and ended with various suits and countersuits brought against each other. **256**

**Calder, Alexander** (1898–1976), American sculptor. Famous for his huge, heavy, and delicately balanced mobiles. **273**

**Cassatt, Mary** (1845–1926), American artist. Worked in France after 1874, a disciple of Degas and much influenced by the Impressionists. Most influential American woman artist before O'Keeffe. **xxiv, 138**

**Cezanne, Paul** (1839–1906), French artist. His Impressionist paintings and drawings greatly influenced the American modernists. Received his first American showings in *Camera Work.* **40, 113**

**Chase, William Merritt** (1849–1916), American still-life artist and teacher. Taught O'Keeffe at the Art Students League. As president of the Society of American Artists, he opposed the traditionalism of the National Academy. **xiii, 87–88, 127**

**Coburn, Alvin Langon** (1882–1966), American photographer who worked mostly in England. Known for his portraits of European artistic celebrities and for his urban and marine scenes. Exhibited at 291. **110**

**Coomaranswamy, Ananda Kentish** (1877–1947), Ceylonese art historian and metaphysician. As curator of Indian and Islamic art at the Boston Museum of Fine Arts, he mounted a Stieglitz photography exhibit in 1924, one of the first by a major museum. **188**

**Covarrubias, Miguel** (1902–1957), American artist. He was a successful illustrator, stage designer, and caricaturist. His works, noted for their flamboyance and brilliant color, appeared in *Vanity Fair* and the *New Yorker.* Later he wrote extensively on the American Indians of the Southwest. **258**

**Crane, Hart** (1899–1932), American poet, whose works on the the urban scene were highly innovative. His best known book was *The Bridge* (1930). Many of his poems appeared in Stieglitz publications. **252**

**Dabo, Leon** (1868–1960), American painter. Work much influenced by Whistler and Japanese landscape paintings. One of the organizers of the 1913 Armory Show. Famous for Hudson River scenes and seascapes. Also designed stained glass. **112**

**Davies, Arthur Bowen** (1862–1928), American painter. After early work in the style of Watteau, he became more venturesome in both color and subject. Noted for his dense and elaborate abstractions. An early supporter of 291, he was in general one of the foremost promoters of the modernists. **112**

**De Casseres, Benjamin** (1873–1945), American art critic. He contributed numerous essays to Stieglitz publications. **135**

**Dell, Floyd** (1887–1969), American author. His *Women As World Builders* advised women to give up their conventional roles and develop their natural talents. It was read and admired by both O'Keeffe and Pollitzer. **12**

**Demuth, Charles** (1883–1935), American painter. He specialized in semi-abstract still lifes and illustrated novels by Henry James and Zola. Exhibited at the Intimate Gallery in 1926 and 1929 and at An American Place in 1931. **188, 192, 258**

**De Zayas, Marius** (1880–1961), American artist, born in Mexico. He was noted as a caricaturist. He exhibited at 291 and was a long-time associate and friend of Stieglitz. He helped edit *Camera Work*. **32, 46, 113**

**Dodge, Mabel**. See Luhan.

**Dove, Arthur Garfield** (1880–1946), American painter. He met Stieglitz in 1910 and held his first one-man show at 291 in 1912. His series of pastel abstractions was an important early contribution to the modernist movement. **116, 164, 188, 236, 258**

**Dow, Arthur Wesley** (1857–1922), head of the fine arts department at Teachers College, Columbia University. He was a noted art teacher whose teaching techniques were regarded as revolutionary at the time. O'Keeffe studied under him at Teachers College. **2, 24, 40, 102, 130, 131, 148**

**Eddy, Jerome** (1859–1920), American art critic. His iconoclastic theories on art were highly influential among the modernists. O'Keeffe read and admired his *Cubists and Post-Impressionists* (1914). **151**

**Einstein, William** (1907–1972), American artist. He became a disciple of Stieglitz and a long-time friend of both Stieglitz and O'Keeffe. **259**

**Engelhard, Georgia** (b. 1906), American writer and photographer. She was a favorite niece of Stieglitz. **174, 175, 215**

**Gauguin, Paul** (1848–1903), French painter. His flat planes and bright, non-naturalistic paintings of primitive subjects, especially his surroundings on Tahiti, were influential among the American modernist painters. **40**

**Gilman, Charlotte Perkins** (1860–1935), American social reformer and educator. Her writings on feminism, especially *Women and Economics* (1898), were an important influence on Anita Pollitzer. **150**

**Glackens, William James** (1870–1910), American painter and illustrator. President of the Society of Independent Artists, one of the Eight. He was a major organizer of the 1913 Armory Show. **112**

**Halpert, Edith Gregor** (1900–1970), American art dealer and agent. She was the director of the Downtown Gallery. After Stieglitz's death, she represented O'Keeffe at the Downtown until 1963, when the association broke up. **258**

**Hapgood, Hutchins** (1869–1944), American journalist and art critic. Contributed to *291*. A close companion of Stieglitz. **46**

**Hartley, Marsden** (1877–1943), American painter. One of the most influential of the modernists, noted for his landscapes and still lifes, much influenced by contemporary German and French art. His first show was at 291 in 1909, followed by one in 1912. He exhibited at the Intimate Gallery from 1926 to 1929 and at An American Place in 1930, 1936, and 1937. **43, 46, 113, 116, 117, 118, 143, 164. 178, 188, 192**

**Haviland, Paul** (1880–1950), French painter and photographer. A member of the French porcelain family, he remained in the United States after attending Harvard. He was a financial supporter of 291 and his works were displayed under Stieglitz's aegis for many years. **46**

**Henri, Robert** (1863–1929), American painter, one of the the most influential of his generation. One of the Eight, he nevertheless rejected cubism and abstraction. A contemporary of Stieglitz, the two men maintained a long, unremarked rivalry for the position of leader of the modernist movement in American art. **112**

**Jewell, Edward Alden** (1888–1947), American art critic. As critic for the New York *Times*, he was highly influential and was an early supporter of O'Keeffe's work. **207, 220**

**Monet, Claude** (1840–1926), French painter, regarded as one of the greatest of all landscape artists. He was closely allied with the Impressionists: Pissarro, Cezanne, Renoir, Sisley. Known collectively as the Barbizon School. His enormous water-lily paintings, in particular, had a profound effect on modernist painters. **195**

**Mumford, Lewis** (b. 1895), American social philosopher. Known as a critic of the dehumanizing effects of modern technology. Long the architectural critic of the *New Yorker* magazine and author of such works as *The Culture of Cities* (1938) and *The City in History* (1961). As a young man, he was part of the Stieglitz circle. **193, 221, 266**

**Nadelman, Elie** (1882–1946), Polish-American sculptor. He was represented at the 1913 Armory Show, came to America in 1914, and had his first one-man exhbibit at 291 in 1915. **113, 118, 122, 130**

**O'Keeffe family.** Georgia O'Keefe's paternal ancestors. Pierce O'Keeffe entered the United States through the Great Lakes in 1848 and settled on a farm in Sun Prairie, Wisconsin. Four sons were born there: Boniface, Peter, Francis, and Bernard. Francis Calixtus married Ida Totto in 1884, and they had seven children: Francis Calixtus, Jr., Georgia Totto, Ida Ten Eyck, Anita Natalie, Alexius Wyckoff, Catherine Blanche, and Claudia Ruth.

**Orozco, José Clemente** (1883–1949), Mexican muralist and genre painter. One of the leaders of the Mexican art renaissance. **258**

**Picabia, Francis** (1878–1953), French painter. He began as an Impressionist, then embraced Cubism, then became one of the originators of Dada. He became associated with the Paris surrealists. He was first exhibited in the United States at 291. **32, 33**

**Prendergast, Maurice Brazil** (1861–1924), American painter. One of the Eight. His early work was light-hearted and sparkling, but after 1914 it became more abstract and purely decorative. A highly influential painter among the modernists. **112**

**Rivera, Diego** (1886–1957), Mexican mural painter. One of the leaders of the Mexican art renaissance. **258**

**Rodin, Auguste** (1840–1917), French Sculptor. His work was introduced to America in Stieglitz publications. **3, 6, 112, 113, 119**

**Rosenfeld, Paul** (1890–1946), American critic of music, art, and literature. His essays, devoted mostly to the modernist movement, appeared in the *New Republic, Dial, Seven Arts, Nation,* and *Vanity Fair.* A long-time friend and supporter of Stieglitz. **118, 180, 210**

**Rousseau, Henri** (1844–1910), French painter. His paintings, often depicting fantastic jungle scenes in outrageous colors, were naive and imaginative. He was first exhibited in the United States at 291. **113**

**Ryder, Albert Pinkham** (1847–1917), American painter. Although he produced only about 150 works in a long career, his paintings strike one as spontaneous and original. A master of design, he was highly regarded by the modernists. **263**

**Shinn, Everett** (1876–1951), American painter and illustrator, the youngest member of the Eight. He is noted for his street scenes and vignettes of the theater. **112**

**Sloan, John** (1871–1951), American painter and etcher, member of the Eight. He was an organizer of the 1913 Armory Show and one of the founders of the Society of Independent Artists. He was a highly regarded teacher at the Art Students League and became its president in 1930. One of the most influential painters of his generation. **112**

**Speicher, Eugene E.** (1883–1962), American painter. While they were both students at the Art Students League, he painted a highly regarded portrait of Georgia O'Keeffe. **93**

**Steichen, Edward** (1879–1973), American photographer. Credited with transforming photography into an art form. He was associated with Stieglitz in the founding of 291 and was for many years the director of the photography department of the Museum of Modern Art. Although Steichen and Stieglitz eventually quarreled and went their separate ways, they reconciled before Stieglitz's death. **6, 110**

**Stieglitz family.** The ancestors of Alfred Stieglitz emigrated to New York from Saxony in the 1840s and 1850s. His father, Edward, married Helga Werner in 1862 and began married life in Hoboken, New Jersey. They eventually had six children. Edward's fabrics business, Hahlo and Stieglitz, prospered, and he later moved his family to a large brownstone house on East 61st Street in Manhattan. They also maintained a large summer house at Lake George, New York.

**Stettheimer, Ettie** (d. 1955), American novelist and long-time friend and correspondent of Georgia O'Keeffe. Her sisters, Florine and Carrie, were also friends of O'Keeffe. **197, 227, 244**

**Strand, Paul** (1890–1976), American photographer. A disciple of Stieglitz, he had his first exhibit at 291 in 1916. His subjects include Manhattan street life and 20th-century machinery. In the 1920s, he turned to delicate landscapes and nature photographs. He also made documentary films in the United States, Mexico, and the Soviet Union. **157, 188**

**Totto family.** Maternal ancestors of Georgia O'Keeffe. Georgia's grandfather, a former officer in the Austro-Hungarian army, settled on a large Wisconsin farm in the mid-nineteenth century. He later returned to Hungary but left his family in Wisconsin.

**Toulouse-Lautrec, Henri de** (1864–1901), French painter and lithographer. His subjects include music halls, circuses, brothels, and Parisian cabaret life. Employing garish and artificial colors and bold structure, his work met with little success in his own day. He was first exhibited in the United States at 291. **113**

**True, Dorothy**, Friend and correspondent of both Anita Pollitzer and Georgia O'Keeffe. She also posed for Stieglitz. **1, 10, 15, 24, 27, 28, 29, 30, 31, 32, 33, 124, 128, 157**

**Vanderpoel, John** (1857–1911), Instructor at the Art Institute of Chicago and author of *The Human Form*, a highly regarded work. He taught Georgia O'Keeffe. **xiii, 84, 85**

**Walkowitz, Abraham** (1881–1961), American painter. A long-time associate of Stieglitz, his first exhibition was at 291 in 1912. **20, 48, 113, 116, 117, 120, 130**

**Weber, Max** (1881–1961), American painter, born in Russia. His early work shows Fauvist and Cubist influence. In the 1930s, social themes entered his work. Later his work became increasingly abstract. He was the author of essays on art theory. **113, 116**

# PHOTOGRAPHIC SOURCES

**Frontispiece** and other Peter A. Juley photographs: Peter A. Juley & Son Collection, National Museum of American Art, Smithsonian Institute.

**Page: 4** Photograph: Private Collection, letter: the Collection of American Literature, Beinecke Library, Yale University, New Haven, Conn.; **Page: 5** Photograph: The University of Virginia, Alderman Library, Charlottesville, Va.; letter: the Collection of American Literature, Beinecke Library, Yale University, New Haven, Conn.; **Page: 7** *Camera Work, A Pictorial Guide*, Dover Publications, Inc., New York City, 1978; **Pages: 9 & 11** New York Public Library, New York City; **Page: 14** The University of Virginia, Alderman Library, Charlottesville, Va.; **Page: 19** The Art Students League of New York, New York City; **Page: 21** New York Public Library, New York City; **Pages: 23 & 25** the Collection of American Literature, Beinecke Library, Yale University, New Haven, Conn.; **Page: 34** New York Public Library, New York City; **Pages: 44 & 47** The Metropolitan Museum of Art, Alfred Stieglitz Collection, New York City; **Page: 53** State Historical Society, Madison, Wi.; **Page: 57** State Historical Society, Madison, Wi.; **Pages: 72, 73 & 79** Colonial Williamsburg Foundation, Williamsburg, Va.; **Pages: 82 & 83** The Art Institute of Chicago, Chicago, Ill., © 1988 All Rights Reserved; **Pages: 88, 89 & 91** The Art Students League of New York, New York City; **Page: 95** The Vassar Art Gallery, Poughkeepsie, N.Y.; **Page: 98** Colonial Williamsburg Foundation, Williamsburg, Va.; **Pages: 104 & 105** Panhandle-Plains Historical Museum, Canyon, Tx; **Page: 111** the Collection of American Literature, Beinecke Library, Yale University, New Haven, Conn.; **Pages: 114 & 115** *Camera Work, A Pictorial Guide*, Dover Publications, Inc., New York City, 1978; **Pages: 136 & 137** Private Collection; **Pages: 153 & 155** Panhandle-Plains Historical Museum, Canyon, Tx.; **Page: 162** the Collection of American Literature, Beinecke Library, Yale University, New Haven, Conn.; **Pages: 166 & 167** Private Collection; **Pages: 170, 171, 173, 176 & 179** the Collection of American Literature, Beinecke Library, Yale University, New Haven, Conn.; **Page: 181** The Art Institute of Chicago, Chicago, Ill., © 1988 All Rights Reserved; **Page: 185** the Collection of American Literature, Beinecke Library, Yale University, New Haven, Conn.; **Page: 190** Private Collection; **Page: 194** Carl Van Vechten Gallery of Fine Arts at Fisk University, Nashville, Tenn; **Page: 205** Albuquerque Museum, Albuquerque, N.M.; **Pages: 206 & 211** The Metropolitan Museum of Art, Alfred Stieglitz Collection, New York City; **Pages: 213 & 214** the Collection of American Literature, Beinecke Library, Yale University, New Haven, Conn.; **Page: 217** The Ansel Adams Publishing Rights Trust, Carmel, Cal., All Rights Reserved; **Pages: 218 & 219** *Off With Their Heads* by Peggy Bacon (Robert McBride, New York City, 1934); **Pages: 222 & 223** On loan to The Indianapolis Museum of Art by Eli Lilly and Company, Indianapolis, Ind.; **Page: 230** Private Collection; **Page: 227** The Ansel Adams Publishing Rights Trust, Carmel, Cal., All Rights Reserved; **Page: 237** Private Collection, courtesy of The Washburn Gallery, New York City; **Page: 233** Private Collection; **Page: 242** The South Carolina Historical Society, Charleston, S.C.; **Pages: 245 & 248** the Collection of American Literature, Beinecke Library, Yale University, New Haven, Conn.; and **Pages: 254, 257, 268, 271, 275, 277, 279,** and **283** Private Collection.

## Extracts from Books, Periodicals and Exhibition Catalogs

While all extracts are clearly cited in the text, we should like to acknowledge the following institutions and companies: The Art Institute of Chicago, page 238; The Beinecke Rare Book and Manuscript Library, pages 134–135, 154, 182, 188–189, 238–239; Cleveland Museum *Bulletin*, page 208; Harcourt Brace Jovanovich, page 221, copyright © 1975, *My Work and Days: A Personal Chronicle* by Lewis Mumford; The Museum of Modern Art, page 266; The Nation/The Nation Company, page 210, copyright © April 8, 1931; New Republic, pages 193, 195 and 196; New York *Times* Company, pages 207, copyright © 1930, pages 220–221 copyright © 1936, and page 253, copyright © July 14, 1946, reprinted by permission; and Oxbow Press, *The Meetings of East and West* by Dr. F. S. C. Northrop, copyright © 1979.

## Letters

The entire correspondence between Georgia O'Keeffe and Anita Pollitzer is part of The Collection of American Literature at The Beinecke Rare Book and Manuscript Library, Yale University, New Haven, Connecticut. Other letters from the Collection are to be found on the following pages: 123, 124, 139, 140, 141, 142, 143, 148, 149, 159, 160, 178, 224, 225, 249, 250, and 251.

Letters from The Ansel Adams Publishing Rights Trust are to be found on pages 225–226, All Rights Reserved; from Kay Boyle, 116; from the Cleveland Museum, Cleveland, Ohio, 208; and from the Sherwood Anderson papers, The Newberry Library, Chicago, Ill., 187 and 188.

Letters reprinted with permission from *Georgia O'Keeffe: Arts and Letters*, Jack Cowart, Juan Hamilton, Letters selected and annotated by Sarah Greenough, National Gallery of Art in association with New York Graphic Society Books, Little, Brown and Company, Boston, 1987 appear on the following pages: 197 (catalog letter no. 40); 210 (catalog letter no. 56); 220 (catalog letter no. 49); 231 (catalog letter no. 800); 246 (catalog letter no. 89); 256 (catalog letter no. 105); 258–259 (catalog letter no. 106); and 272 (catalog letter no. 100).

# ACKNOWLEDGMENTS

A lot of people contributed to making *A Woman on Paper* possible. Tenth Avenue Editions offers special thanks to Mr. and Mrs. William S. Pollitzer, for whom this book was truly a labor of love. Our sincere appreciation goes to Donald Gallup of the Stieglitz/O'Keeffe Archive at Yale University and to Patricia C. Willis, Curator of American Literature, The Beinecke Rare Book and Manuscript Library, Yale University. Our editor at Touchstone Books, Carole Hall, lent her enthusiastic and creative support at every stage in this book's development. Thanks must go to Tom Fenton, Pat Mutz and Ron Siegel at David E. Seham and Associates Inc., our typographer.

Tenth Avenue Editions also thanks the following individuals and institutions for their assistance: James Moore, Albuquerque Museum of Art, History and Science, Albuquerque, N.M.; Pamela C. Feld, The Ansel Adams Publishing Rights Trust, Carmel, Cal.; Kristy Stewart, The Art Institute of Chicago, Chicago, Ill.; Rosina Florio and Lawrence Campbell, The Art Students League of New York, New York City; Suzanne Brown, Colonial Williamsburg Foundation, Williamsburg, Va.; Fisk University, Carl van Vechten Gallery of Fine Arts, Nashville, Tenn.; Indianapolis Museum of Art, Indianapolis, Ind.; Ginger L. Howard, Eli Lilly and Company, Indianapolis, Ind.; The Nation/The Nation Company, Inc., New York City; Sarah Greenough and Laura Coyle, National Gallery of Art, Washington, D.C.; Diana Haskell, Newberry Library, Chicago, Ill.; Claire Kuehn, The Panhandle-Plains Historical Museum, Canyon, Tx.; Harlan M. Greene, The South Carolina Historical Society, Charleston, S.C.; Dennis Anderson, The Vassar Art Gallery, Poughkeepsie, N.Y.; G.A. Johnson, University of Virginia, Alderman Library, Charlottesville, Va.; Jane Washburn, Washburn Gallery, New York City; Myrna Williamson, Wisconsin State Historical Society, Madison, Wis.; Anita Duquette, Whitney Museum of American Art, New York City; and Richard Hart, The Beinecke Rare Book and Manuscript Library, Yale University, New Haven, Conn.

*A WOMAN ON PAPER*
was set in Memphis Medium and Light by
David E. Seham Associates, Metuchen, New Jersey;
calligraphy for the chapter openings was created
by Lydia Gershey from samples of
Georgia O'Keeffe's handwriting; and the book
was designed by Clive Giboire.